Painting *Vibrant*
Children's Portraits

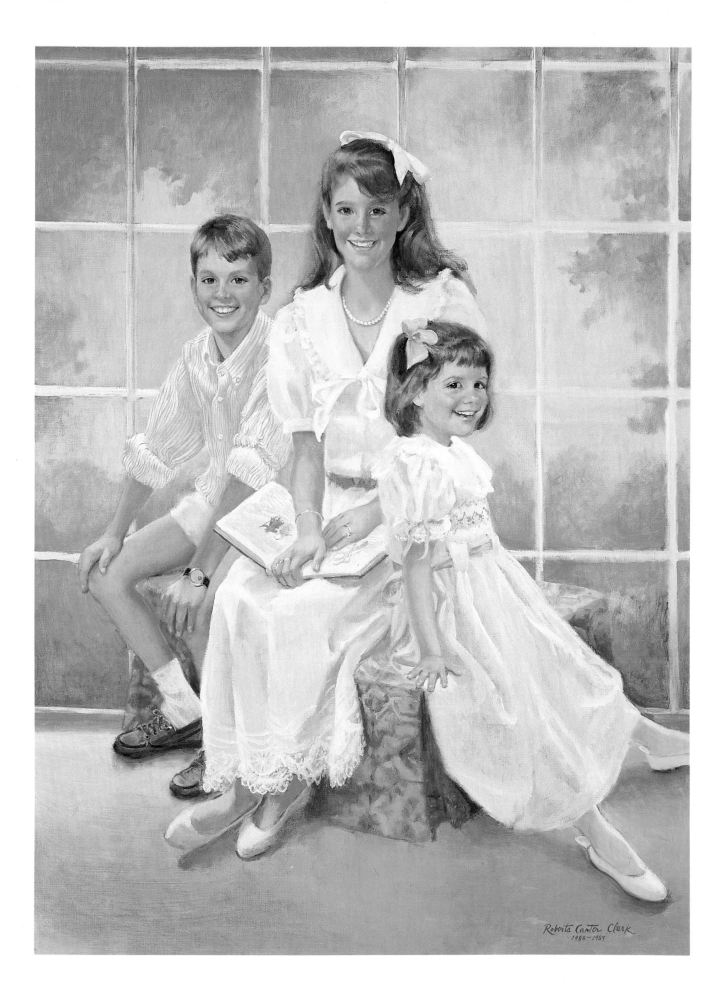

Roberta Carter Clark
1988–1989

Painting *Vibrant* Children's Portraits

Roberta Carter Clark

NORTH LIGHT BOOKS

Cincinnati, Ohio

Roberta Carter Clark was born and raised in the Midwest and has been interested in painting portraits since her teen years. She has studied with Guy Palazzola in Detroit, Thomas Leighton in San Francisco and Joseph Hirsch at the Art Student's League in New York. She credits Charles Reid with her ability to use watercolor and to teach that elusive medium to others.

Roberta has been affiliated with Portraits, Inc. since 1974 and presently lives in Little Silver, New Jersey. Her portraits are in the private collections of hundreds of families throughout the United States and in England. More portraits are in public and corporate collections, including universities, hospitals and banks.

She has juried both state and national exhibitions and teaches popular workshops from California to Maine to Hilton Head. She has received awards at several national exhibitions including the American Watercolor Society, and is a past president of the New Jersey Watercolor Society.

In 1990 her first book, *How to Paint Living Portraits*, was published by North Light Books.

Painting Vibrant Children's Portraits. Copyright © 1993 by Roberta Carter Clark. Printed and bound in China. All rights reserved. No part of this book may be reproduced in any form or by any electronic or mechanical means including information storage and retrieval systems without permission in writing from the publisher, except by a reviewer, who may quote brief passages in a review. Published by North Light Books, an imprint of F&W Publications, Inc., 1507 Dana Avenue, Cincinnati, Ohio 45207. (800) 289-0963. First paperback printing 1997.

01 00 99 98 97 5 4 3 2 1

Library of Congress Cataloging-in-Publication Data

Clark, Roberta Carter.
 Painting vibrant children's portraits / Roberta Carter Clark.
 p. cm.
 Includes index.
 ISBN 0-89134-781-X
 1. Children—Portraits. 2. Portraits—Technique. I. Title.
NC7643.C63 1993
751.4—dc20 92-44576
 CIP

Edited by Rachel Wolf and Kathy Kipp
Designed by Paul Neff

This book is dedicated to my children, Judi, Doug and Dean Fittinger, and to the families who have allowed me to share in the precious growing-up years of their children. Not only that, they have let me include these children as subjects for the illustrations in the book. I have so enjoyed working with all of them again.

Being an "only child" myself, I do not have a large family. This extended family has enriched my life beyond measure. I cherish the photographs that arrive every year as Christmas cards showing how the little children I once painted are becoming big children. It's astounding how little their faces change!

And I want to tip my hat to Mary Cassatt, who devoted so much of her life to painting young people. She has been the lodestar for people like me who want to hold on to the fleeting moments of childhood forever by painting portraits of the younger generation.

I want to express my deepest gratitude to my loyal and energetic friends—Sandy Kunz, Dorothy Ganek, Pat Dews, Pat Lafferty, Shirley Cunneff and Eleanor Dreskin. They were endlessly patient with me and seemed to understand the forced hibernation I need when I'm writing a book. Even though I couldn't get out to see them, they were always very supportive and encouraging in an endless number of telephone conversations. Beyond that, they carted my paintings to and from shows over and over again and never complained, even though they are all very busy artists themselves. A sweeping "thank you" to each of them—I couldn't have done this book without them.

And this book doubtless would not have come into existence without the interest and cooperation of David Lewis, Bonnie Silverstein, Greg Albert, and especially Rachel Wolf and Kathy Kipp, all of North Light Books. They have been wonderful to me and sustained me throughout.

Roberta Carter Clark

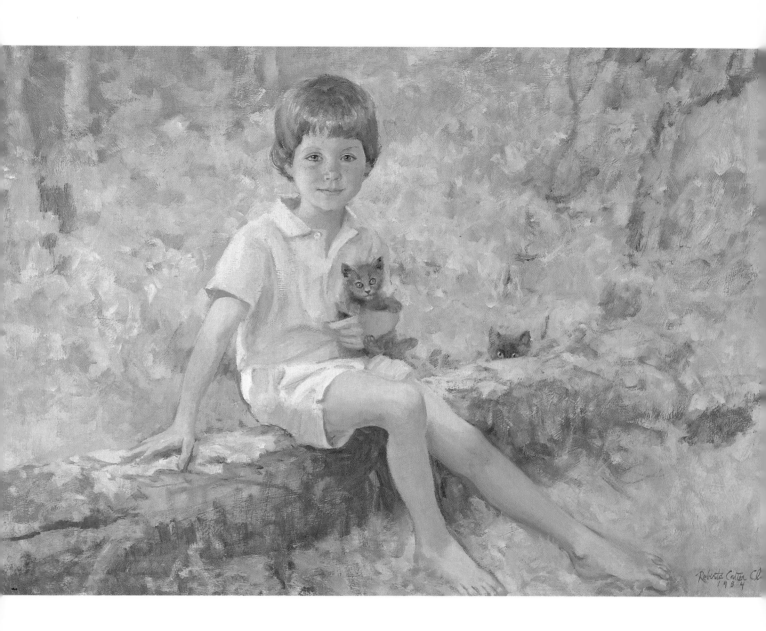

Contents

Introduction 1

1 **Drawing the Child's Head** 3
Colorful portrait studies and diagrams show you how to
block in a child's head in stages of growth from infancy to
the teen years.

2 **Drawing the Child's Features** 17
These helpful step-by-step lessons on drawing each facial
feature show how the features change as the child matures.

3 **Drawing the Child's Body** 29
Render the proportions of the child's body—including
hands and feet—as they change and grow with the child.

4 **Which Medium Would Be Best?** 41
Compare the possibilities of a single portrait subject done
in five different mediums.

5 **Working With Children** 53
These practical suggestions will help you work productively
with your child subjects (and their parents).

6 **Painting Children's Portraits Step by Step** 61
Follow the progress of these seven portrait
demonstrations—in watercolor, oil and pastel—from first
lay-in to finished portrait.

7 **Choosing the Pose, Size and Format** 97
Natural-looking poses and the right format and size help
ensure the success of your portrait.

8 **Clothing, Accessories, Backgrounds** 111
How to decide on formal or informal clothing, outdoor or
indoor backgrounds, hats, pets, eyeglasses, and more.

9 **Using Photography Wisely** 123
Advice on photographing children and then using your
photos to help you paint your portraits.

Conclusion 131

Appendix: Getting Started in the Profession 132
Practical advice on getting commissions, setting prices,
keeping records, etc.

Index 134

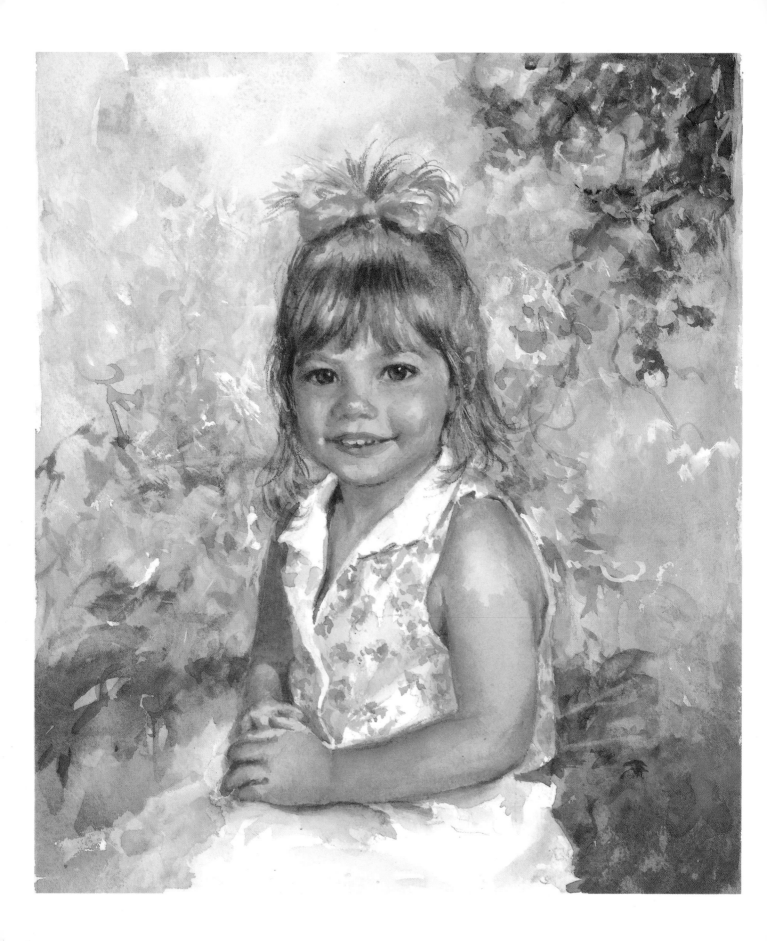

Children!

We all love children, our own and everyone else's. We want portraits of those little darlings too, whether they are imps or angels.

But how do we go about this? Children are always changing, growing up day by day. They are always moving, too!

To be sure, painting portraits of children is very different from painting adults. Children don't sit still very long, not because they are willful or uncooperative, but simply because they *can't*. Those untrained muscles are incapable of being controlled for sustaining a pose for any length of time. On the other hand, children are so much more natural than adults that they are easier to paint and far easier to work with—if you give them half a chance.

It does help if the artist can work fast to catch those fleeting forms, the guileless expression in the eyes and the genuine smile. But the quality you really need for painting children is *patience*. With lots of patience, a calm manner, a sense of humor and a real love of young people, you can look forward to making many new friends and making them extremely happy.

I've been painting kids for over thirty-five years, and I love working with them. They are wonderful to look at and infinitely less self-conscious than grown-ups, much more natural and spontaneous. But their eyes, noses and mouths are not yet clearly defined. Their faces are so much softer than adults': sweeter, gentler and—let's tell the truth—prettier. Above all, we must remember that a child is not just a small adult. He walks this earth as an explorer and experiences his new life with wonder. It is this innocence and freshness that we hope to convey in the portrait.

Another inescapable quality pertaining to children is change. Much of what you'll find in this book pertains to how they change. In this context, you'll find information on the structure of children's heads and bodies, their hands and feet, how they stand and sit, and what they wear. Children, especially the very young ones, don't pose. You have to be quick and inventive to work with young people, and I hope that some of the ideas presented here will stimulate your own ideas.

Among the subjects covered in my first book on painting portraits, *How to Paint Living Portraits* (North Light Books, 1990), were the proportions of the head, facial features and the body, as well as clothing, lighting and posing—nearly all of these discussions slanted toward painting adults. If you can, study that first book; it also contains a great deal of information on the hands, on color and on drawing drapery, which also applies to painting children's portraits.

A word of caution: Starting a child's portrait is rather like a roller coaster ride. You begin with eager anticipation and you may go up and down and around, but no matter what happens, you can't get off until you get to the end. If you start a child's portrait and get stuck when it's half done or never finish it, you not only disappoint the parents but you make them feel there must be something wrong with their child. And if you drag it out too long, the child could change so much that you'll have to begin all over again!

Some of you may want to paint portraits of children just for family and friends. Others may want to paint portraits on commission as a profitable venture. The popularity of children's portraits has increased with our changing times. Children's portraiture is a great way to earn money as an artist, so I have included information throughout the book that will help you attain your personal goal.

I hope this book will help you to portray the physical beauty and personality of children quickly and confidently, thereby enriching many lives, including your own.

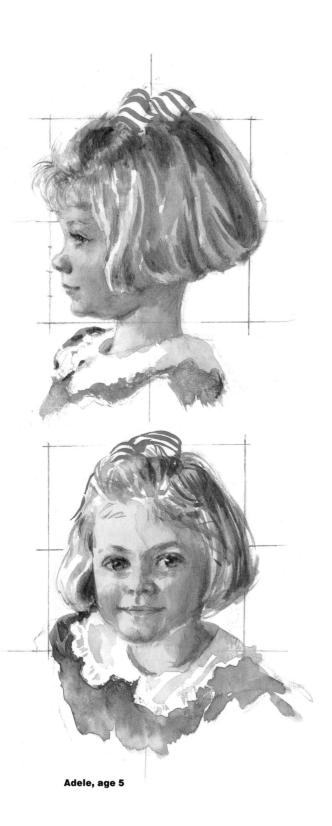

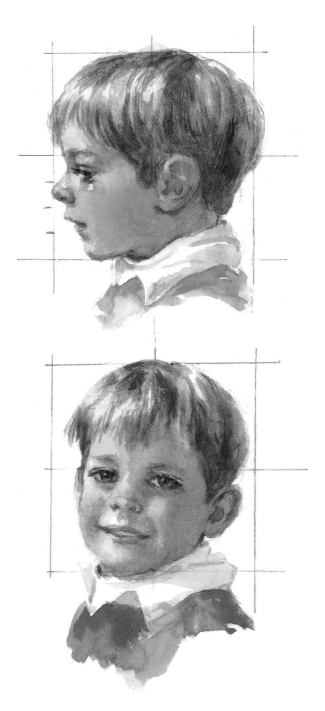

Adele, age 5

Charlie, age 5

Drawing the Child's Head

It's important for you to understand as much as you can about drawing a child's head even before he or she comes to pose. In this chapter you'll learn how to construct the heads and successfully establish the proportions within the heads of children from infancy to the teen years.

For the profile views, we will use a square format divided into four more squares by the horizontal eyebrow or eyeline and the vertical line that locates the crown of the head and places the ear. For the front views and three-quarter views, we'll start with an egg shape, find the center vertical line at the front of the face and then the eyebrow and eyelines curving horizontally around the egg. We need to know these structural block-ins by heart. We have to know how the eyes and eyebrows fit into the head shape; how the nose relates to the eyes and the cheeks; how the mouth relates to the nose and chin; and the jaw to the ears.

The numerous illustrations drawn in our four-square format show how the eyes "move up" as the child grows older. Each child is also shown in a front or three-quarter view to help you see what he or she really looks like. Alongside each head is a blocked-in head, drawn more freely. These drawings may not be as eye-catching as the more finished heads, but they are even more important. Without these preliminary blocked-in heads, you will be lost when you put brush to paper. (The small portrait studies in this chapter are in transparent watercolor.)

The Profile Diagram

We start with a perfectly square diagram divided into four more squares of equal size. Using graph paper makes it a lot easier to draw the squares without measuring. You'll need a pencil, a kneaded eraser and perhaps a ruler for the straight lines. Draw several squares first—at least as large as the one on this page. You can even photocopy them if you'd like to have a supply on hand. Practice these diagrams again and again until you can do them without much effort. Copy my diagram first, then draw your own children's heads in these same squares.

1. This baby is about one year old. Not many babies have obvious eyebrows, but I suggest you start blocking in this head by making a small eyebrow mark on the horizontal halfway line, 1—3.

2. Divide the lower portion of the left side of the square, at the face, into four segments, *a*, *b*, *c*, and *d*.

3. Place the eye above *a*, also the bridge of the nose, deeply indented, only *slightly* higher than the eye. Continue down, making a small cherry of a nose between *a* and *b*.

4. At *b* place the upper lip. Define the upper lip and draw a soft line back to the corner of the mouth. This corner of the mouth might be totally obscured by very fat cheeks.

5. Pull way back and draw the round soft lower lip just above *c*.

6. Add a round receding chin between *c* and *d*. Babies don't have much of a jawline or much of a neck either, but rather a soft roll of fat instead.

7. Place the ear behind vertical line 2—4 halfway back on the head. When a child gets older you can draw the top of the ear on a level with the browline and the earlobe level with the base of the nose. A baby's ears may be lower and farther back, as in our diagram.

8. Returning to the bridge of the nose, bring the line up to become the rounded forehead, starting at 1, curving around to 2 and then to 3, defining the skull.

9. At 3, the back of the head curves in at a level with *b*, the upper lip.

The infant's head does not project forward as the adult head does. When he is old enough to sit up and hold his head up you will see that the head balances delicately on a neck extending down to a very straight little back.

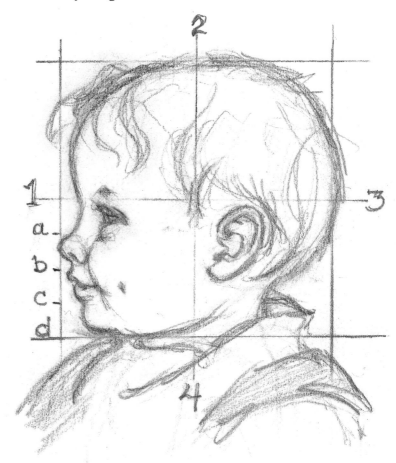

Michael
A Newborn

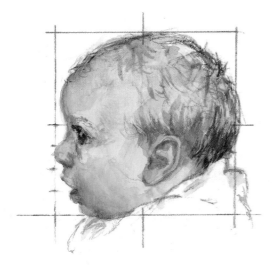

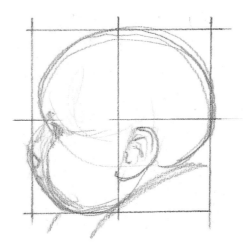

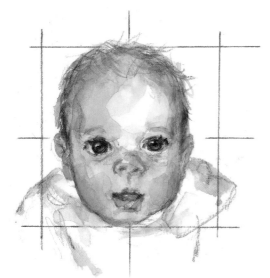

Michael, age 10 weeks

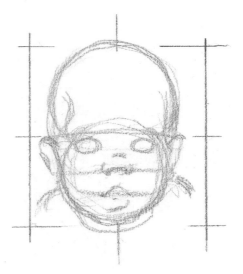

In the youngest child, from birth to age two, the face is only a small portion of the entire head, and the chin and jaw are not defined at all because there are no teeth yet. There is usually very soft fatty tissue in the cheeks and jowls. All the contours are soft curves, no angles or straight lines.

The eyes appear quite large in the tiny face because the eyeballs are already almost as large as they'll be when the baby is fully grown. Very little of the white of the eye is visible, but that which is seen is exceptionally clear and blue-white. The forehead seems high because the face is so small, and often there is only a bit of fuzz for hair.

Baby Michael is only ten weeks old. A child this young cannot hold his head up or sit up without being held. These early months are a time for sleeping, eating and growing. I think I would do a portrait of a baby this young when he is asleep.

Drawing Procedure

In these diagrams and in all my portraits I start with the outer shape of the head. Then I draw the browline halfway down the head, then the eyeline. Next is the vertical front-of-the-face line, and then the nose, the mouth and the chin line. Last I place the ears, and only then am I ready to really begin to draw my subject. This gives me a sound foundation and is far better than starting out at the top of the forehead and drawing down the head, just hoping that the features will all land in the right place!

Stuart
A Growing Baby

Stuart is eight months old and has already come a long way. He can sit up in a high chair or a swing. This is the perfect situation for you, the artist, as he is captive there, at least for a little while. You wouldn't believe these fat little cheeks and jowls if you didn't see them yourself. There still aren't any teeth, and there isn't much of a neck. A child this age would make a good sketch in watercolor or pastel if you can work fast.

Three-Quarter View

With Stuart I literally threw you a curve. He is shown in a three-quarter view, which is far more complex than the profile or full-face diagram for baby Michael. The red pencil block-in drawing alongside tells you how I have translated the flat profile diagram into a rounded, more three-dimensional view of Stuart's head.

The trick to drawing these lines, which seem to divide the head into four segments like a grapefruit, is to draw them as though they went through to the other side, or the back, of the head, as if the head were transparent. This takes some practice. Take the time to draw these "glass heads" over and over.

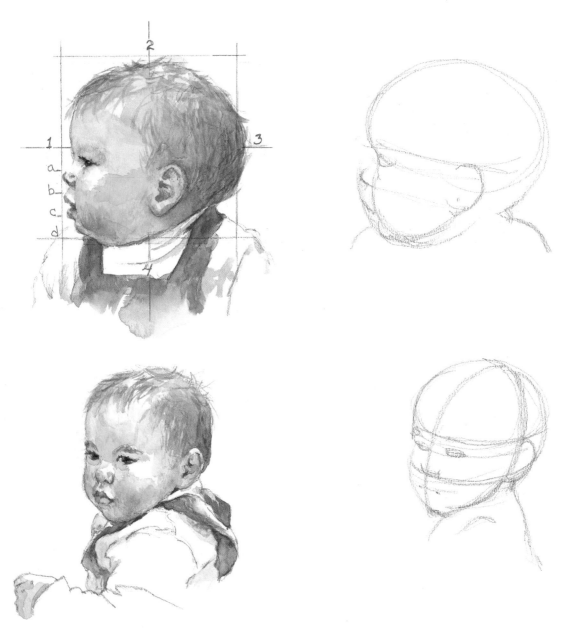

Stuart, age 8 months

Christopher
A Toddler

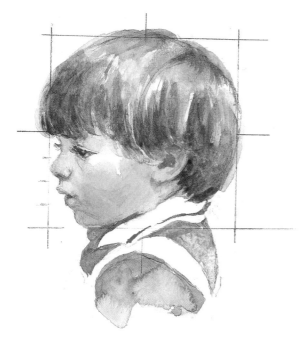

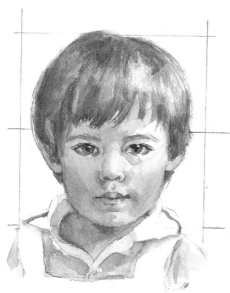

Christopher, age 19 months

Christopher is nineteen months old and looks quite different from Stuart—after all, he is almost a year older. He has both upper and lower teeth and you can see how much this changes the facial structure, particularly the jaw and the chin. All the features are more defined now and the head is no longer sunken into the shoulders, which allows us to see the little neck. The cheeks are still soft and chubby, and Christopher is still very much a little boy, a good subject for a portrait. It is not unusual for a child this age to be so serious; he is curious about everything around him and is absorbing enormous amounts of information. Christopher is walking, even running, and starting to talk. Of course he is too young to pose. You'll need photographs as an assist at this age. You might get a few good looks at him when he is sitting down having his lunch.

Rachel
A Three Year Old

At this age the child is fun to be with and to play with. Songs and word games are good entertainment for brief periods of time. These are the little kids who ask, "But where are my feet?" when you are painting a head and shoulders portrait of them.

In this profile view, the open mouth makes the lower half of the face appear longer than it really is. And just look how much of Rachel's head is covered by her hair.

In this front view, with the head bending forward and the eyes looking up at you, look at the block-in and see how deeply curved the brow and eyelines are in order to achieve this effect. Rachel's bangs falling right down to her eyebrows and her hair curving in at the sides really frame her face and make it look even smaller than it is.

At age three the child is becoming more of an individual and makes a more interesting portrait. I painted Rachel's portrait in oil. You can see it on page 52.

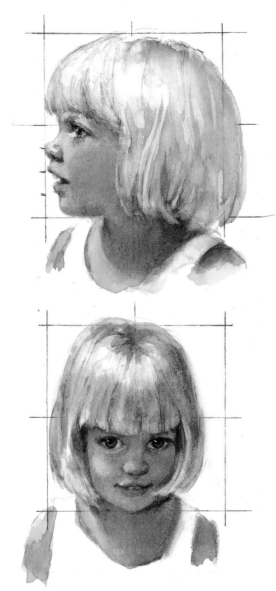

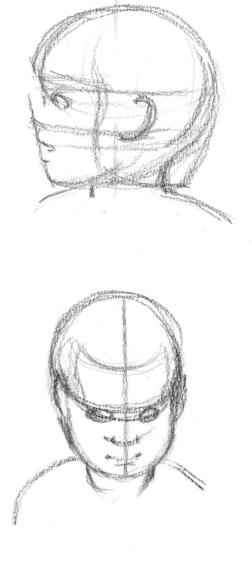

Rachel, age 3

Dane
A Five Year Old

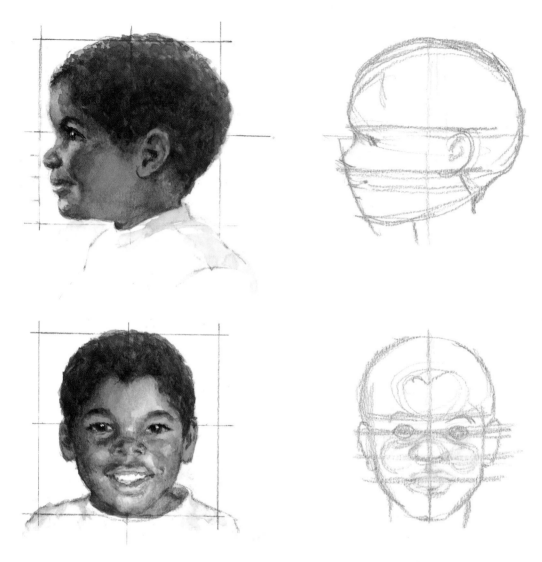

Dane, age 5

By age five, distinct personalities have emerged. These children are genuinely interested in the portrait you are painting of them. After you talk to them about what you are doing (which you could not do with the younger children) and tell them why you are doing it—for example, painting a picture of them because their parents love them—they frequently try to cooperate. They can pose if they want to. However, they do have a lot of energy and they don't all sit still very long.

The face and body of a five-year-old child has lost the baby fat, and he is considerably taller and thinner. The eyes have "moved up" a bit. They are no longer cuddly little cherubs, but you will still see the sweetness in their faces. Many parents believe the best time to do a portrait of their children is at age four or five, when their faces are quite developed but they are still really young children.

Dane would make a great portrait. He is a bright little boy and is very outgoing. His eyes dance and he is full of questions!

Jay
A Seven Year Old

At age seven all traces of the "little boy" are gone. The baby teeth are gone too, and have been replaced by the second teeth, at least in the front of the mouth. The new teeth look inordinately large in the face, but that is because they are the proper size for his grown-up face; his child's face will catch up. On occasion I have had to race to get a portrait done before the baby teeth come out. Each day brings the question, "Are they loose yet?" Then you may have the problem of one tooth being out and one in, or a large tooth next to a space, next to a baby tooth, and so on. Strange as it may sound, the status of a child's front teeth is serious stuff to the artist who paints children's portraits.

Jay has the unique complexion of the child with red hair, and the freckles, too. Paint them in with a color slightly darker than his fleshtone— not brown or dark, but perhaps a little more orange-red or sienna. And of course these freckles must look sprinkled on, not lined up in rows. (Some people tell the child they are angel's kisses.) Watch out, or the freckles may look like measles!

Jay's eyes are certainly one of his best features. The expression is very open and eager, and the eyelashes here are an important part of the likeness.

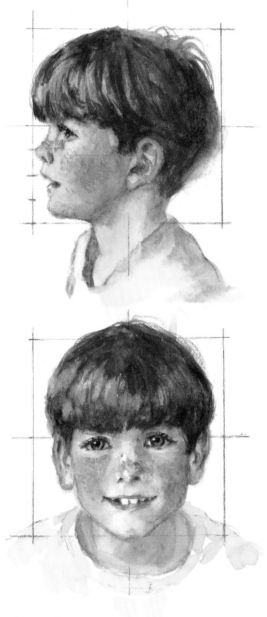
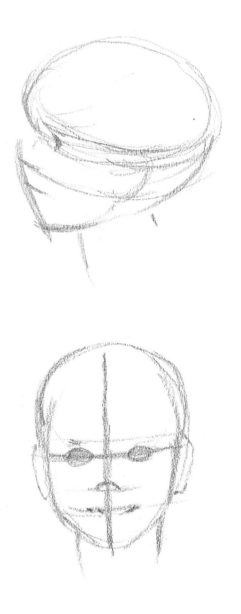

Jay, age 7

Rondia
A Nine Year Old

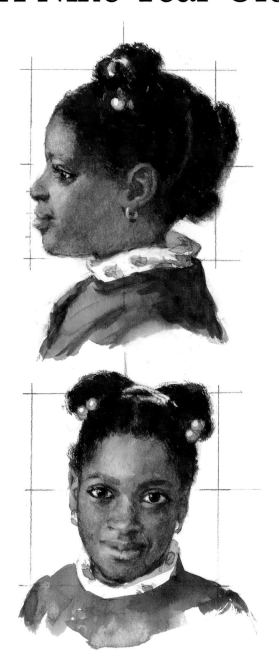

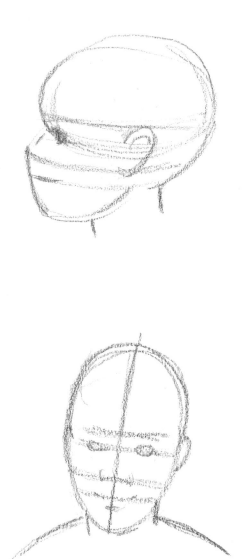

Rondia, age 9

Rondia is nine years old and you can see she is a self-possessed young person, sure of herself and of her abilities. One of the first things you notice about her is how well-groomed she is; there is not a hair out of place. Rondia does not customarily smile with her teeth showing, and somehow this gives her face a very soft and sweet expression. Her complexion is clear and smooth, and with her smiling eyes she would be a joy to paint. At this age, as her face lengthens, notice how her eyes are "moving up" to the browline. Nine- and ten-year-old children are usually still free-spirited and unselfconscious. Rondia appears to be much more mature than her years.

I enjoyed working out the colors for her complexion. I wanted it to be golden without being yellow, warm but not too pink, with light and clear brown tones. I used raw sienna, scarlet lake, cobalt blue and burnt umber in layers, not mixing them on the palette. Rondia's hair is painted with ultramarine blue and sepia layered one over the other with a nearly dry brush. Her little earrings added a personal note.

Molly
A Twelve Year Old

Molly is twelve and the proportions of her face and head are nearly those of an adult. I have drawn her profile from slightly below, looking up at her, and this places her eyeline higher in the four-square diagram. She is small yet willowy, qualities seldom seen together except in the very young. Her features are so even and perfect that she would be difficult to paint. The trap for the artist lies in interpreting those flawless features to show the real Molly instead of generalizing them into Miss Anonymous. The fun would be in keeping her as young as she is and not letting the portrait become too glamorous. We can see Molly prefers being natural, wearing her hair long and straight with an oversized T-shirt. At this age most girls are self-conscious to a degree.

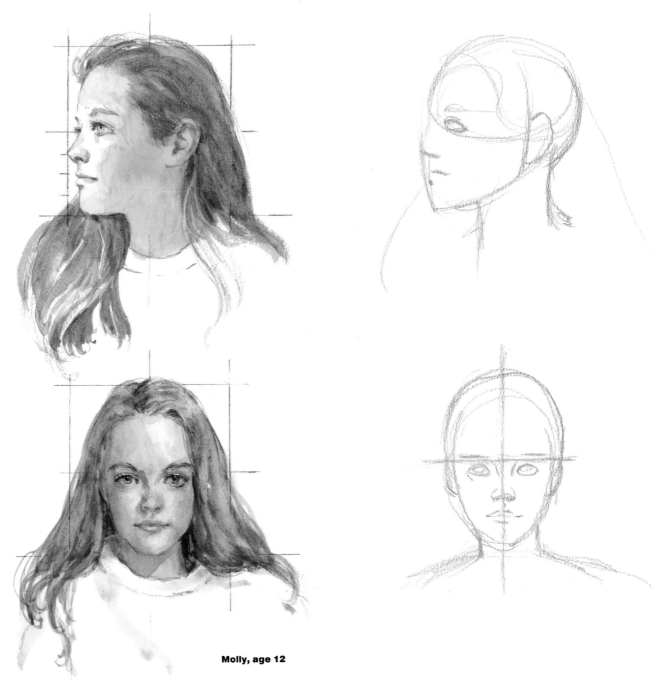

Molly, age 12

Richard
A Thirteen Year Old

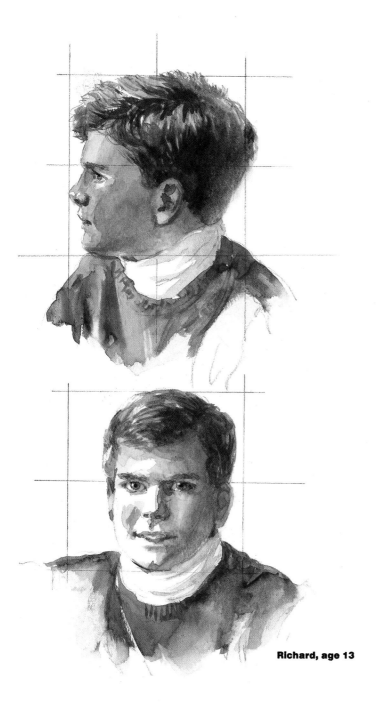

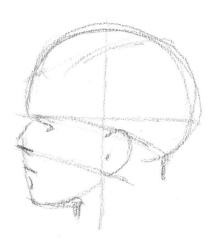

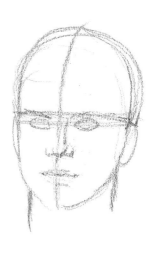

Richard, age 13

Thirteen-year-old children are a puzzle — some look like they are ten and some like they are sixteen. Their moods are just as changeable; they move back and forth between childhood and adulthood without apparent reason. Of course all this is due to the onset of puberty and the resulting hormonal changes within their bodies. It seems like the nose will grow for a while, then the ears, or maybe the lips; the youngster's features appear to be out of balance. Of course, he will outgrow all this. Richard is almost fourteen. He is good at athletics, his body tall and muscular. He is already shaving!

The puzzle is how to paint Richard so that he looks his own age. Though his body is well filled out and he appears quite mature on the outside, his eyes and the expression around his mouth — the uncertain smile — have a tentative look and tell us he is far from feeling sure of himself yet.

In my opinion, a young person this age should not be painted. I advise parents to wait a year or two until he really blossoms. The skin clears up, that sort of puffy quality disappears, and the features come together.

Lynn
A Sixteen Year Old

Lynn is sixteen years old. Young people this age have a very strong sense of what to wear so it behooves you, as the artist, to stand back and let the teenager work it out with the parent. Of course, they are not always right. Lynn and her friends wear their hair long and full, as in the front view here. I asked her to pull it up for the profile view, for her face is so small I felt it got lost in all that hair. Besides, I wanted to show her face, jaw, ear and hair relationship clearly. She al-most looks like a different person in the profile, don't you agree?

Young people this age make wonderful portraits. They look good in any kind of clothing, whether it is casual or formal. And they have good skin, clear eyes, and shining hair — perfect for painting. This age appeals to some parents because it is the last stage of their child's life before he or she passes into a more mature and grown-up look. And some parents begin to realize their child will be off at college and gone from the home and family soon, and want the portrait to remain behind. It is true, the portrait will be forever young.

I think this is my favorite age to paint. The young person is old enough to pose, she looks fabulous, and the challenge of getting her the right age is still there. The results are usually terrific.

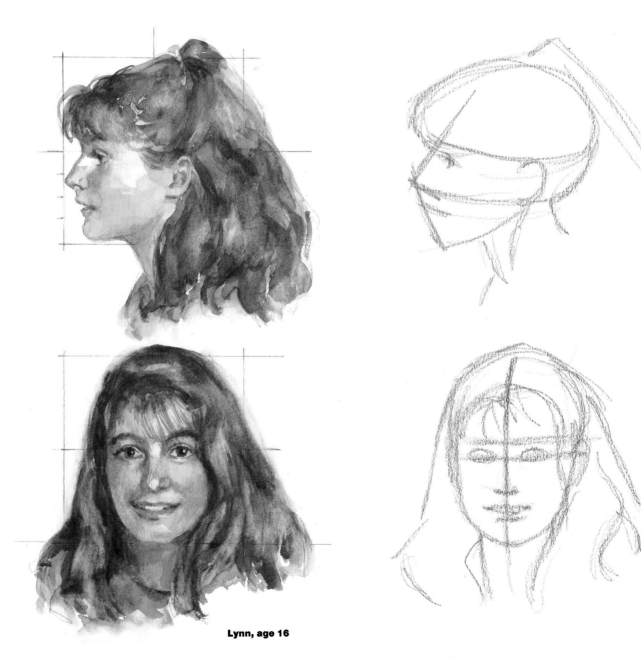

Lynn, age 16

Will
A Sixteen Year Old

Will, at the age of sixteen, is over six feet tall. When I first met him he was just four years old. The pastel portrait I did of him then appears at right. He doesn't really look that different, does he?

Of course, he has matured in twelve years. The proportions of his head are nearly adult. Only the softness around the mouth, cheeks and jaw give him away as being so young.

As he grows into adulthood, his face will become more angular, his features will become more defined. It would be interesting—and informative—to see him twelve years hence, when he is twenty-eight.

Will has always had light red hair and a fair complexion. He also has the blond eyebrows and eyelashes that go with it. These are a challenge for the portrait painter.

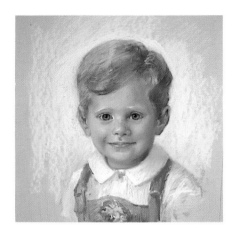

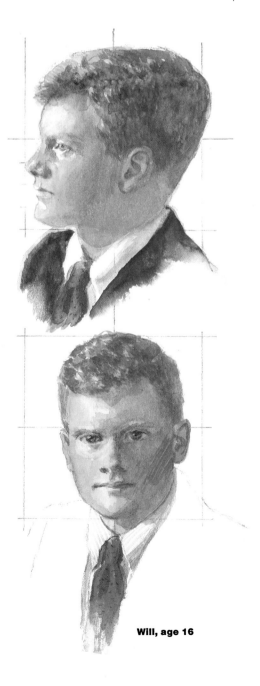

Will, age 16

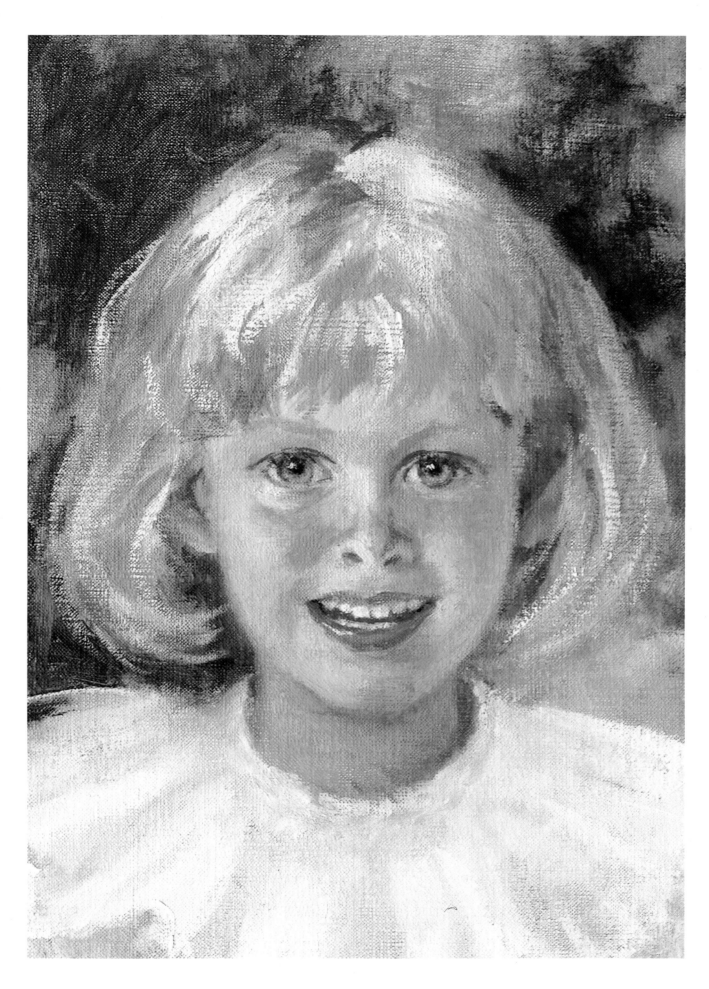

Drawing the Child's Features

Aurie, age 5
36″ × 28″
Oil on canvas

Now that we are beginning to understand how to construct a child's head and to block it in, let's go on to the features. Of course, the youngster's age influences the features too. In infancy, her eyes are quite large and round, but as she gets to be four or five years old they appear less dominant in her face. To me, the eyes are the most expressive part of any portrait, no matter what the subject's age.

Looking into a child's eyes, seeing the innocence and wonder there, is one of life's most delightful experiences. If you plan to draw and paint children you had best spend some time practicing eyes. Well-painted eyes with lots of expression in them will draw people to your work quicker than any other element. Beautiful skin tones and shining hair probably come next. Noses are not difficult in children's portraits, but mouths will confound you and frustrate you every time. John Singer Sargent, one of the finest portrait painters who ever lived, said, "A portrait is a picture with something wrong with the mouth," presumably because he heard this comment so often. Does this tell you something?

The Eyes

The first thing we notice about a child's eyes is their clarity. There they are, wide open, and studying you with great intensity. There is such a sparkle to them that we sense immediately when the child is ill or has a fever because the eyes look listless and dull. They are true indicators of all that is going on inside the little person.

Shape and Structure

The eye is a ball held in place by muscles and ligaments in an opening in the skull called the orbital cavity. The eyelids are there to protect the eyes and, therefore, our vision. The eyes are always shiny because they are wet—they are bathed in tears. The eyelids have some thickness, and when the eye is open the upper lid casts a small shadow upon the eyeball. The eyelashes keep dust from getting into the eye. When painting children, be careful not to add too thick, too heavy or glamorous eyelashes; they make the child look too old.

The eyebrows follow the bone formation above the eyes. Their purpose is also to help prevent dust and foreign matter from falling into the eyes. Many children have very light eyebrows that are not readily seen, but they are an important indicator of expression; without them the face may look "blank."

At the inner corner of the eye, beside the nose, is the small pink pocket called the tear duct. Every portrait painter since Gainsborough has emphasized a red or pink spot here—it must be important to do this. Perhaps it adds life.

The colored part of the eye is the iris. It takes on the appearance of a concave bowl because the outer edge is often a darker color than the interior area. The pupil is the black circle in the center of the iris. It is actually an opening into the eyeball admitting light to the retina, which enables us to see. In dim light the pupil grows larger, allowing maximum light to enter. In very bright light the pupil contracts to protect the retina from too much light. I have observed that some children have large pupils in any light, and some have very small pupils, showing more of the color of the iris. If the child's eyes are very dark you may have difficulty determining where the pupil ends and the iris begins. These eyes snap with vitality!

And then there is that shine, that little white dot that brings the portrait to life—the highlight. Putting this in is the most fun of the whole portrait! A rule of thumb is that you should place it in the iris area at ten o'clock or at two o'clock. That idea is all right if you are just practicing drawing eyes, but if you are painting a real person you must look for the source of light in the room and then place this highlight relative to that. The highlight is only a reflection of the room light on the eye itself.

A Baby's Eyes

Sometimes the only way you can draw a baby is when he is asleep. However, these intimate portrait drawings in pencil or charcoal or watercolor become priceless treasures when the child gets older, even if the eyes were closed when the portrait was rendered. When he is sleeping, the infant's eyes are just one carefully drawn line. Very fine eyelashes are present, even at birth. The eyebrows are there too, though not very distinct. Use a really sharp pencil for your infant drawing; it should be fine and delicate and clean.

Melissa, age 5
22″ × 20″
Pastel on sanded pastel paper

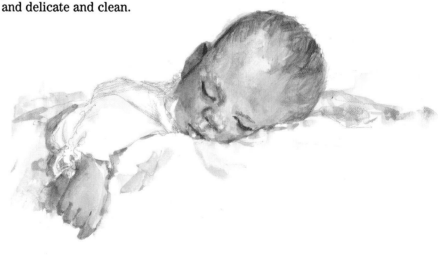

Drawing the Eyes, Front View

Let's start by blocking in the young child's eye as shown here. One caution: Be sure to draw or paint both of the eyes at the same time.

1. With a pencil, first draw the sphere of the eyeball, lightly, and the circle of the iris.

2. Then add the curve of the upper lid, the lower lid, and the tear duct. The curve of the lower lid is never the same as the upper lid. Small children hold their eyes wide open (usually because they are looking up at us taller grown-ups!). The fold in the upper lid hardly shows at all.

3. Then the pupil goes in. Add the eyebrow with short strokes, like fine eyebrow hairs. Shade the iris with short strokes radiating from the pupil, leaving a small spot of white paper for the highlight if you can.

4. Make the pupil really dark now, and add the slightest shadow beneath the upper lid, but not covering the highlight. (If the highlight is lost, see if you can retrieve it with your kneaded eraser.) This shadow pushes the eye itself back and under the lid and softens the expression. Without this, the whites of the eyes would be too light, making the eye appear to protrude. As the child gets a little older the eye elongates and more white of the eye is visible, but the shadow is still there.

5. Now we add the eyelashes. They are necessary, but we don't want the child to look as if she is wearing mascara or false eyelashes. In this front view some of the eyelashes are coming directly at you; you see them foreshortened. Use restraint. Maybe just a few will do the job. You have to decide. With your kneaded eraser, carefully erase any lines left from the eyeball sphere, and you're done.

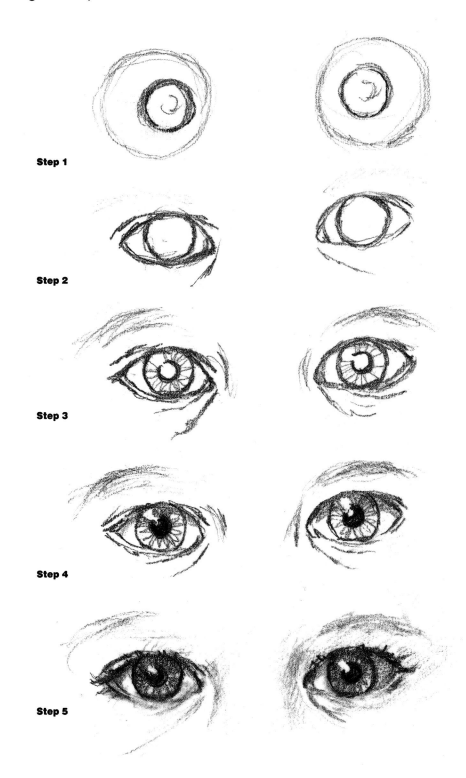

Step 1

Step 2

Step 3

Step 4

Step 5

Drawing the Eyes, Profile View

1. Lightly draw the eyeball sphere first. Seen in profile, the iris is no longer round; it's an ellipse—a narrow, vertical oval shape. Draw it in, shade it, and try to leave a white highlight close up under the eyelid. Now draw the pupil, a second, smaller, vertical oval shape at the front of the iris.

2. Draw the upper and lower eyelids, gently curving over the eyeball. The upper lid will almost certainly cover the top rim of the iris, and the lower lid might cover the bottom of the iris. Remember, the eyeball must sit *inside* the eyelids. The white of the eye is toned way down from white, as it is in the shadow of the upper lid and the eyelashes.

3. Now is the time to check for the highlight. If the eyelashes have obliterated it you'll have to lift it out with the eraser. Keep it small, up high under the eyelid, and in the iris. You're not going to have much room for it in this view, but if you leave it out the eye might look dull or sleepy. Make the pupil as dark as you can. The darker the area surrounding the highlight, the brighter the highlight will appear.

In these side views (the final three sketches), the eyelashes assume tremendous importance, whether the eye is looking straight ahead, up or down. You are seeing them from the side and there seem to be a great many of them, all growing forward toward the front of the face. Sometimes they even obscure all but the tiniest bit of the highlight.

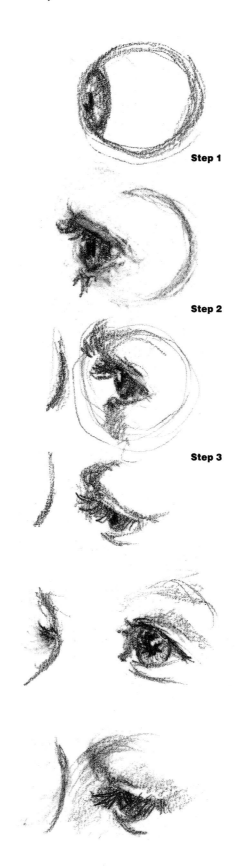

Step 1

Step 2

Step 3

Expressive Eyes

Smiling Eyes

When the child is smiling, the eyes are a little less open. Emphasize highlights for lots of sparkle. You may need more than one highlight to achieve the effect you want. Experiment. You may stumble on a way to portray smiling eyes that is all yours! Think of what you can do to create a merry expression in the eyes. Did you ever paint the sparkle on a lake or the sparkle of glass or crystal? Painting landscapes or still lifes will help you get more of the effects you want in your portraits. But you will really learn when you begin to study children's faces and try to put down what you see. If you can't see it, either with your eyes or in your mind, you can't paint it. Practice *seeing*, and you will progress, guaranteed!

Laughing Eyes

When the child is laughing, the eyes are even less open and there may be little pouches under them from the smiling cheeks pushing up. There are many lights in the irises; I frequently achieve these by using broken strokes. The eyelashes help too, radiating out from the iris. Laughing eyes mean twinkling, sparkling, dancing—anything but rigid. Sometimes I paint the pupil as a starry shape with the points going into the iris. This may sound ridiculous, but no one is even aware of my "stars" in the eyes except me, and I think they make the eyes more twinkly.

Three-Quarter View

In a three-quarter view the eye on the far side partly disappears behind the bridge of the nose. The iris may appear slightly oval rather than round because it is seen in perspective. You can draw the eyelashes in a way that helps direct the gaze—to the right, the eyes are looking down. To the far right, they are looking left.

This view requires more careful observation than the full face or the profile, for even a half-inch turn of the head to right or left changes your perception of the face a great deal.

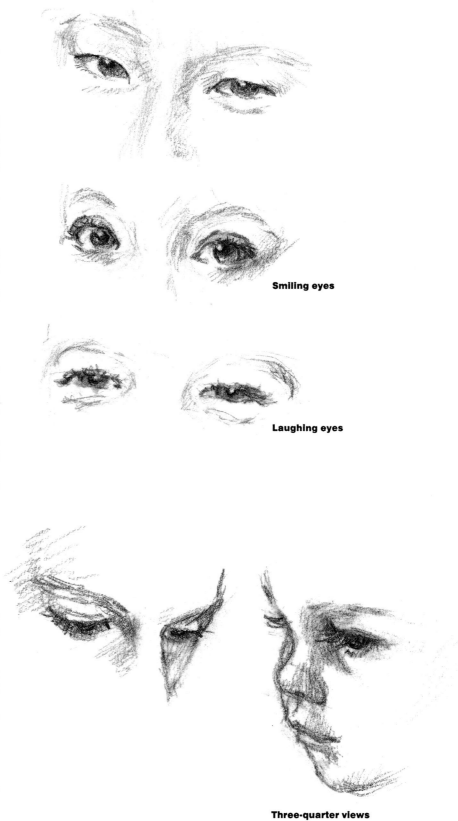

Smiling eyes

Laughing eyes

Three-quarter views

Drawing the Nose, Front View

Noses are considerably easier to draw than eyes. For one thing, they don't move that much. All they can do is wrinkle up, and it's highly unlikely you'll ever paint a nose wrinkling up! However, the nose is the central pivot of the face. In children, the nose doesn't usually project very much and I don't think it's necessary to model its form with definite shadows as you would on a portrait of an adult. We have to get it the right size in the right place and still not make too much of it. Underplay it.

1. Lightly sketch in a seagull-shaped mark where you think the nose should be on the face. Now move up to the "keystone" area, between the eyebrows. Draw in those two little curves, one on either side of the bridge of the nose where it leads up to the brow bone.

2. Draw the nose as a ball with two smaller half-ball wings on either side of it. You can draw an infant and an older child using this same principle. Place the *small* nostrils where the half-balls meet the central ball and slightly beneath these shapes. On an infant these nostrils can be really tiny; on a newborn they may be no larger than 1/8 of an inch in diameter. By the way, they are never black, and seldom very dark at all. In color they are always warm—rosy pink, coral.

3. You may see a slight shadow across the top of the central ball of the nose. Many cartoonists have used this idea when drawing children. Putting this in makes the ball of the nose appear more round and also makes the nose and cheeks project forward from the face. The fleshy ball of the nose should be warm in color—more colorful than the surrounding skin. It might be pinkish or orange.

4. Now search for the highlight on the ball of the nose and lift it out with the eraser. This highlight helps convey the shape of the nose, the roundness, and incidentally, it makes the child look scrubbed clean. You will see another highlight at the indentation at the bridge of the nose; putting that in tells where the scooped-out nose bridge is.

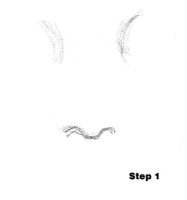

Step 1

Step 2

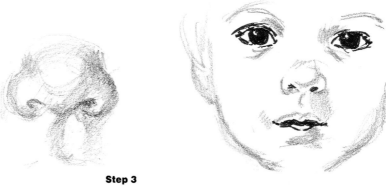

Step 3

Step 4

Here are a few more tips on drawing noses:

• As you can see in the sketches below, when a child smiles, the nose becomes wider.

• Be sure to keep the nostrils small and on the underplane of the nose, not too obvious.

• Sometimes there are freckles sprinkled on the nose. Don't make them too dark or they will look like measles.

• Please keep all your lines soft. There should be no hard black lines outlining anything on the child's face.

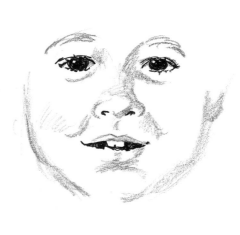

Drawing the Nose, Profile View

From the side it is easy to see the construction of the child's nose. The ball shape is very clear, as is the half-ball covering the nostril. The tricky part of drawing the profile nose is deciding just how far it projects from the facial plane. You wouldn't draw the profile nose all by itself without some suggestion of the forehead leading down to it and an eye to relate it to. You need the forehead line to help you decide where the bridge of the nose begins and then how deeply to scoop out that bridge area.

1. First, lightly block in the head shape. Make one mark where you want the nose to end, another for the ball of the nose, and another where you want the eye to be. Now move up to the forehead and decide where it becomes the nose—the keystone area. That is where the receding curve will start. Be sure to draw all three at the same time: the nose bridge, the eye and the ball of the nose. The relationship between these three elements will determine your likeness.

2. Look for an alignment between the front of the eye and the wing of the nose. I have drawn these as dotted line *n* (for nose) and line *e* (for eye).

3. Refine the scooped out nose-bridge area. When you are drawing an actual portrait, study this part of the nasal bone very carefully. Draw the rounded ball of the nose and the flared half-ball that is the wing of the nose. Tuck in the nostril, not too dark. While you are in this spot add the small area below the nose down to the upper lip. Does it curve in? Curve out? Usually this part of the face is really short on young children. And on many little faces it is so clearly defined as to appear chiseled out.

4. Clean up any sketch lines with your eraser, and there's your nose!

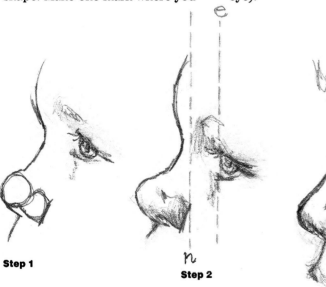

Step 1

Step 2

Step 3

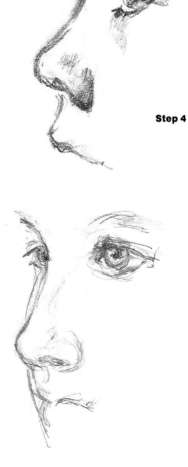

Step 4

Three-Quarter View

You may look up and see the child's head turned ever so slightly away from you and it is so beautiful that you *must* paint it. This to me is one of the most beautiful poses for a portrait, but it is just too chancy for a subject who does not, or cannot, hold her head very still. The far side of the nose may be hidden just a bit, the bridge of the nose may totally hide the eye, and the head looks so interesting, but you may never see that angle again.

Don't even think of attempting this view unless you have photos to assist you. You'll see examples throughout this book of successful three-quarter-view heads. They require intense concentration and extremely careful observation from the artist, but they are worth it if the portrait works out.

Drawing the Mouth, Front View

The mouth is challenging to draw, mostly because it is always moving. A small child's mouth is different every time you look at it. Here are some tips to get you started, but remember, you must keep the mouth really soft, with no hard edges. All the edges are rounded, not angular, and drawn with "curly" lines.

1. Think of the lips as having three oval forms to the upper lip and two to the lower lip. This will help you achieve the rounded softness of a child's mouth.

2. When drawing the mouth, place the outer corners first with dots. To help you decide where to put them, you may want to see if they align with another part of the face you have already drawn (see below). Do the corners align with the eye pupils? The outer corners of the eyes? Or with the wings of the nose? This is a really good way to decide how wide the mouth should be. By the way, this also works with smiling mouths.

3. Then, between the dots, draw the curving line between the lips, keeping it soft, not black, and broken here and there.

4. Now for the upper lip. In children, it is almost like a triangle, with an indentation at the top center. And add the little indentation from this lip up to the nose, particularly noticeable on a child's face. Unlike the adult's mouth, the child's upper lip may be fuller than the lower lip.

Then add the lower lip, softly curving. Sometimes the lower lip is defined only by the shadow beneath it.

Would you like a highlight on the lower lip? We will have to softly shade the lip tissue so we can leave the highlight the white of the paper. On a child's mouth, there may be highlights almost anywhere if the lips are very moist.

5. The mouth is there now, but let's go back and give some more attention to those dots at the corners we did first. Children's faces are so soft that these corners can be surrounded by fatty tissue and deeply indented. Some shadowing will show this. There might be some dimples near these corners as well.

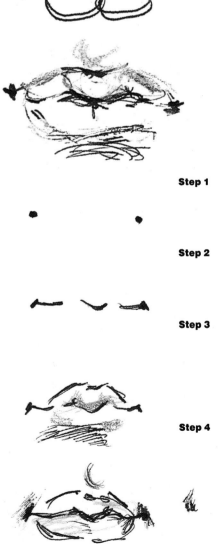

Step 1

Step 2

Step 3

Step 4

Step 5

Expressive Mouths

If the mouth is closed, we can draw a soft, broken line between the lips. If it's open or smiling, we have to create some space between the lips, darker but not black. Keep the edges of this dark shape broken, and definitely not hard. We don't want our child's mouth to look tense or rigid.

If the mouth is open, we might see some teeth—sometimes just the lower teeth, sometimes the upper teeth, and sometimes both upper and lower if the child is old enough to have them. Make them white and then tone them down considerably so they stay inside the mouth and don't look as if they are protruding.

You can get that "little child look" until the permanent teeth come in at about six years of age, sometimes seven. These new teeth look large in the face and change the child's appearance drastically. The tiny-tot look is gone forever. Six-, seven- and eight-year-old children make terrific portrait subjects, though they aren't cuddly-cute like the little guys.

Every now and then, when you are working with children aged nine, ten and older, you will encounter the problem of braces on the teeth. There is no question that they alter the contours of the mouth. The smile is certainly not a natural smile, and when the mouth is closed the lips push forward and appear fuller. I have painted young people with their braces on and tried to fake the lips, but no one can guess how they will look when the orthodontic procedure is completed. It's worth the wait to delay the portrait until the braces come off, if you can. The mouth and teeth look really beautiful then.

Adele, age 5

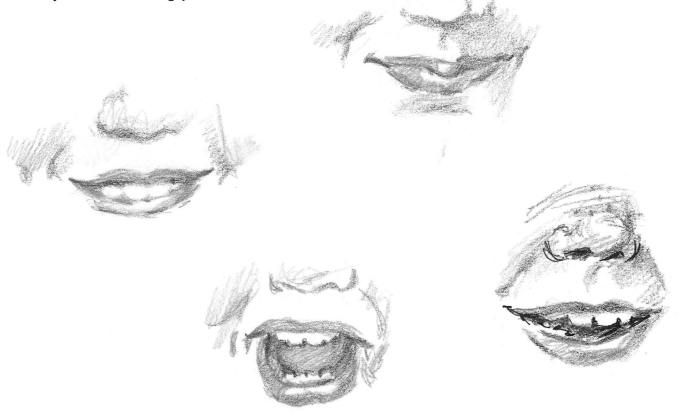

Drawing the Mouth, Profile View

1. Assuming you have already drawn the nose and are coming down the face to the mouth, I suggest you draw the line between the lips first and then the dot at the corner of the mouth. This line is almost always higher at the front of the face and it slopes down to the corner. Remember to break this line and keep it soft!

2. To help you decide where to place the corner of the mouth, you might want to align it with the wing of the nose, or the inner or outer corner of the eye. On a profile of a baby's or toddler's mouth, the fat cheeks may obscure the corner of the mouth and even part of the wing of the nose, especially if he is smiling.

3. Now draw in a softly rounded lower lip. On most faces, the upper lip protrudes beyond the lower lip, so you can start this lip further back on the lip line. Add the shadow under the lower lip and extend the face line down to form the chin. This shadow, because we are working with a child, would not be very dark or very large.

If you want to show a highlight on the lower lip you will have to shade both lips a bit so that your white highlight will show. There is not always a highlight there; indeed, sometimes the brightest highlight on the mouth is at the center front of the upper lip.

Three-Quarter View

1. Block in the upper lip by drawing the three oval shapes.

2. Tuck in the corners of the mouth. Easier said than done in this view! On the far side, the side turned away from you, the corner may not be visible at all. *Don't put it in if you don't see it.*

3. Add the shadow beneath the lower lip, and round off the form of the chin.

4. Look for highlights and add them.

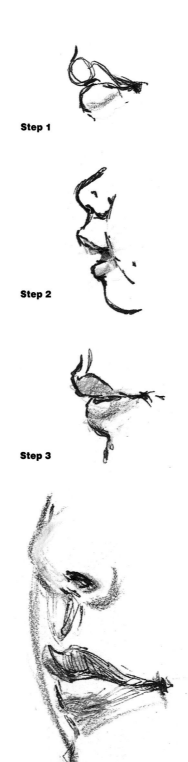

Step 1

Step 2

Step 3

Drawing the Ears

Ears are important too. One day you may be working on a portrait of a little boy; you know there is *something* wrong with it, but you can't figure out what. Very often it is the placement of the ears—they may be too high or too low. Placement of the ears helps to indicate the age of the child in your portrait, believe it or not. Fortunately, the ears are considerably easier to draw than the eyes or the mouth. At least they don't move or change with the child's expression! Don't wait until the head and face are nearly finished before you put the ears in. Draw them when you draw the eye shapes and the nose. This will help you get the ears in the right place.

Front View

1. Be sure to draw both the left and right ear at the same time. Think of each ear as a flat oval disk attached to the side of the head. Begin by drawing these forms.

2. Refine the outer shape of each disk into an ear shape. There seems to be a wider variety of ear shapes among children than among adults. The ears may stand out away from the head, or they can be quite round or very flat.

Add the inner line curving around the top to form the rim or fold, called the helix. This line never follows the outer shape of the ear exactly.

3. Define the bowl-like part of the ear, then the small bump at the lower edge of that bowl and the little flap in front that protects the opening of the ear canal. When you add some hair above the ears or at the sideburn area they will look more as if they really belong to the head. Any line between the side of the face and the ear should be drawn softly so the ears do not look pasted on.

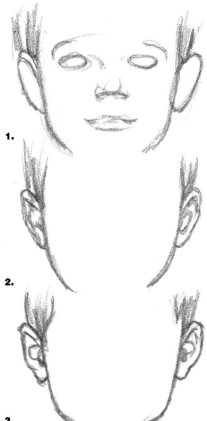

1.

2.

3.

Profile View

1. Begin with an oval disk. The top slants back toward the back of the head. Sometimes, in children, this slant is extreme.

2. Refine the outer shape of the disk to look like an ear shape. Add the inner line that forms the fold inside the top of the ear, the helix, and take it down to the earlobe. This line never parallels exactly the outer shape of the ear.

3. Draw in the circular bowl in the ear, the small bump at the bottom of the bowl, and the little flap at the front that protects the ear canal, and there you have it!

1. 2. 3.

Clark, age 4

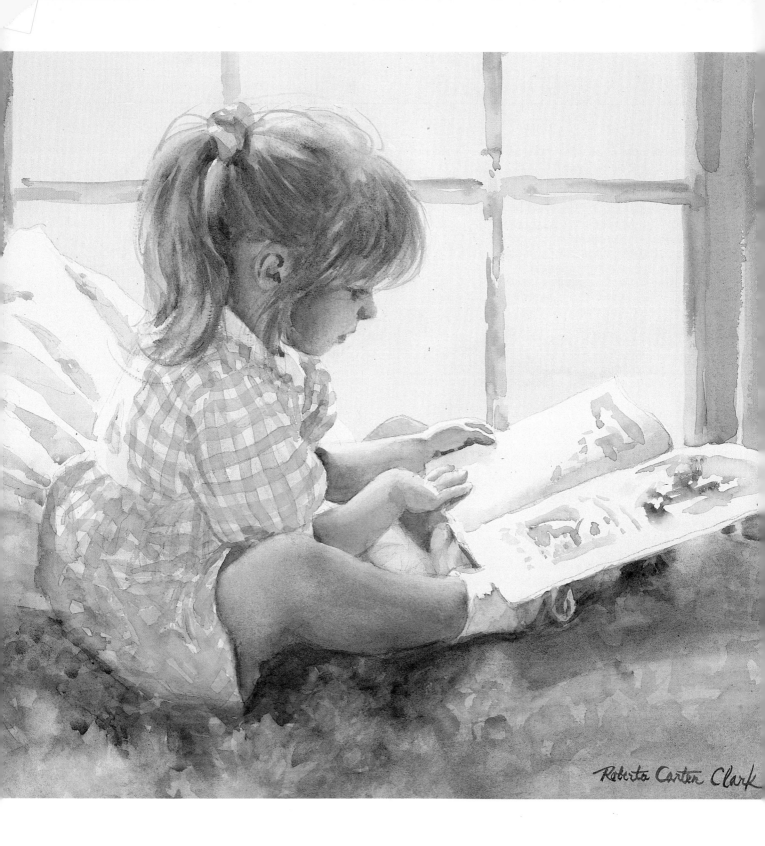

Drawing the Child's Body

Amanda Lee, age 4

If you are going to be doing children's portraits, I know you will want to do more than just their heads and faces. The inclusion of the child's upper body along with his arms and hands adds so much interest to the portrait. When you also paint the legs and feet, creating a full-length portrait, you have made something even more wonderful for the family's enjoyment.

If you were to paint adults, you would learn to draw the figure by working from life, either by having a friend pose or by joining a class where there is a model. However, I think there is only one way to learn to draw children's figures: Find children who will pose for you, either from your family or from among your friends and neighbors. You'll never find a class where there is a child model posing on a regular basis. Any time spent working from life will pay off enormously. You will develop your ability to see and understand the body's forms and all its interrelationships. After you've gained some proficiency with live children's figures you can practice drawing from photographs, and you'll be able to bring some validity and truth to them, too. Why not make learning to draw children's figures your project for the year?

You can use your own photographs of children, or those from magazines and catalogs to help you learn. The catalogs of dress patterns in fabric stores contain dozens of great full-length photos of children of all ages, and you can buy the out-of-date books for almost nothing.

Shape and Structure

There are no straight lines anywhere on the healthy child's body, only curved lines and soft contours, at least until the young one is five or six. Babies are roundest of all, for their bodies have more fatty tissue and the muscles are not yet developed. This does not mean that we can draw them as nothing more than fleshy blobs, shapeless and puffy. Both in the torso and the limbs there is a discernible rhythm of curves, one offsetting another.

As the child grows the fat diminishes, the limbs become longer and much more slender, and these curves become ever more subtle. Looking at the arms and wrists of children of all ages we can't help but notice how delicate and graceful they are. Careful observation is necessary if we are to draw them well.

It helps to draw the body first as if the child were in a swimsuit or underwear. Large sweaters, puffy sleeves and full skirts camouflage the body. It's always better to draw the body first and then put the clothes on it than to paint the pants or dress and hang the legs and feet from the hem. Clarifying the position of the knees beneath the clothing gives the figure a more believable structure.

The Torso

Young boys and girls have very similar torsos, sometimes with quite round tummies. Girls do not usually develop a waistline until they are about six or seven. Because of this, dresses with high waistlines are flattering to little girls younger than this. Boys don't have a waistline any more than grown men do; their pants sit low on the hips. For this reason, young boys and girls very often have straps holding up their pants or skirts until they are five or six years of age.

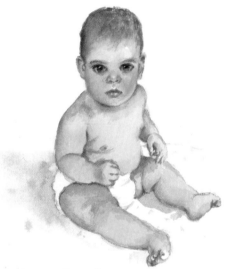

Ray, age 7 months

After a drawing by Francois Boucher, 1703-1770. Notice the curved outlines on the arms; they are not just lumps, but rhythmic ins and outs conveying solid forms very well.

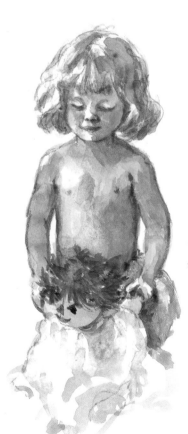

Julie, age 4

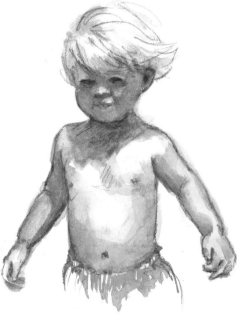

Nick, age 4

Hands

At birth, a baby's hands seem fragile and exquisite; we are amazed at their miniature perfection. By the time the child is two, the hands have taken on a pudgy quality with soft and rounded contours. The fingers do not look segmented yet, and there may be dimples on the back of the hand at the knuckles. During these early years, the fingers seem to bend and move almost independently of each other, almost as if each group of four fingers and a thumb were not yet a complete set. After age three, the fingers are less rubbery looking and you can begin to define them in segments.

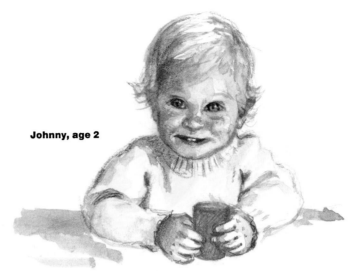

Johnny, age 2

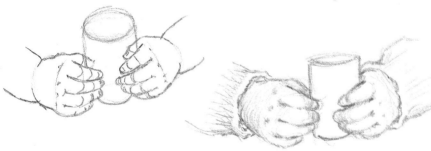

Even though the fingers of very young children don't appear segmented, you will have more success if you first block in the individual segments to help you achieve the correct length and proportion of the fingers relative to each other and to the hand itself.

Often babies' fingers will each seem to go their own way.

Nancy, age 11 months

Gradually, as the child matures, the hands grow longer. Some become slender and graceful, but some are still square and blocky. Draw the fingertips rounded or squared, but not pointed, and with short, shiny fingernails. Fingernails help the painter define the top side of the finger, which is especially nice when you want all the fingers on one hand to move together in a gesture. And they let you paint a small highlight on each nail, which becomes like a wee bit of jewelry.

Kyle, age 7

As children get older their fingers are more clearly segmented and the hands develop grace and character. The wrists lose the baby fat.

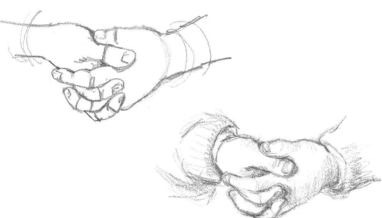

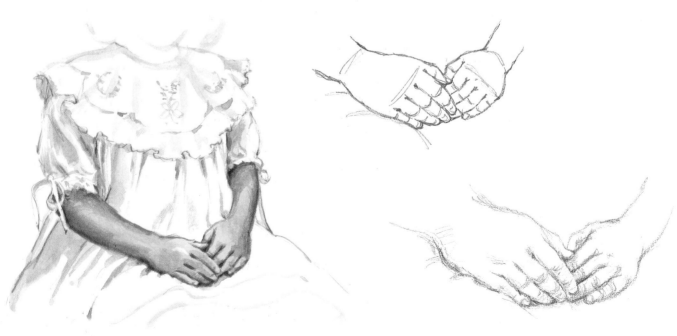

Aurie's hands, age 5

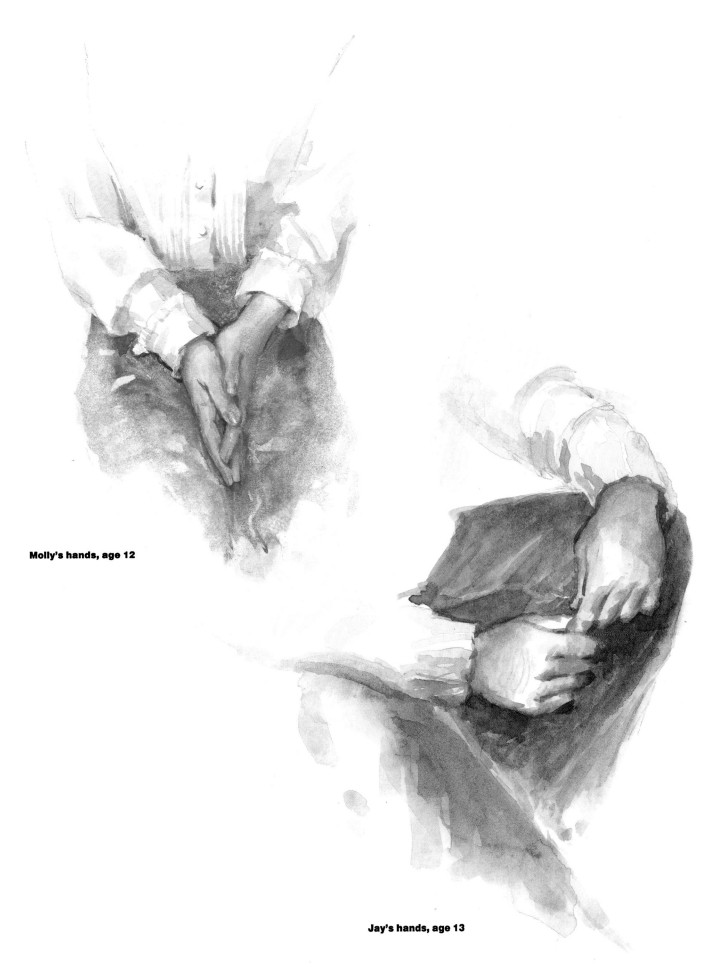

Molly's hands, age 12

Jay's hands, age 13

Legs and Feet

When you're painting children, you will have many opportunities to paint their legs and feet. These little legs and feet are delightful to see and they add so much charm to the portrait.

The legs and feet of babies and toddlers are rounded and chubby, with small round toes. Even the soles of an infant's feet are rounded until he starts wearing shoes and standing upright. Baby fat surrounds the knees and ankles. The legs are short and stubby relative to the body.

To draw the foot, think of it as a wedge shape that flattens out at the toes. When the child is standing, the outside of the foot from the little toe to the heel is flat to the ground. The main arch of the foot is on the inside. In children, this arch is only barely visible. However, when I am drawing or painting children's feet, I try to emphasize a difference between the outside and the inside of the foot to distinguish the right foot from the left. Yes, this does matter!

Notice that the big toe is often separated from the other four toes, rather like the way the thumb is separated from the fingers.

When drawing the foot, you may do better by blocking it in with straight lines. The feet should look strong enough to support the body. In an adult, the foot is one head-length long, but this certainly is not true of small children. You'll have to study the youngster's feet extra carefully to get them the correct size for her body. Yes, you've guessed it— feet are not easy to draw. Putting the small toenails in helps to indicate the direction of each toe and thereby helps us with the perspective of the foot. If you just can't get the feet right, put little sandals or shoes on them. You may find this easier (but not much).

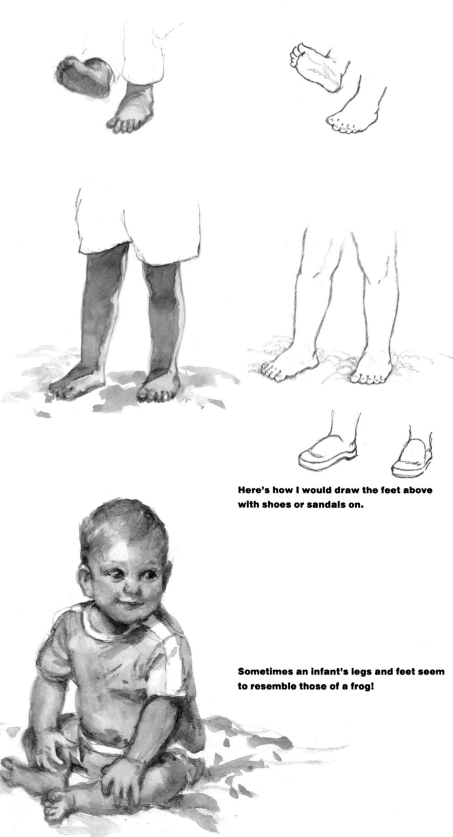

Here's how I would draw the feet above with shoes or sandals on.

Sometimes an infant's legs and feet seem to resemble those of a frog!

As the child gets older, the legs and feet, like the arms and hands, become longer, more slender and take on more muscle definition. Many children's legs become very slender, giving them a coltish look.

It's fun to paint a child all dressed up and then leave the feet bare. This keeps the portrait from becoming overly formal and reminds us that the child is not a miniature adult, but rather an unfinished one.

When you're ready to put paint to paper, remember: All the extremities of the body are *warm*. This means that the fingers and toes, ears and nose, are warmer in color than the rest of the flesh—more pink, rose or coral.

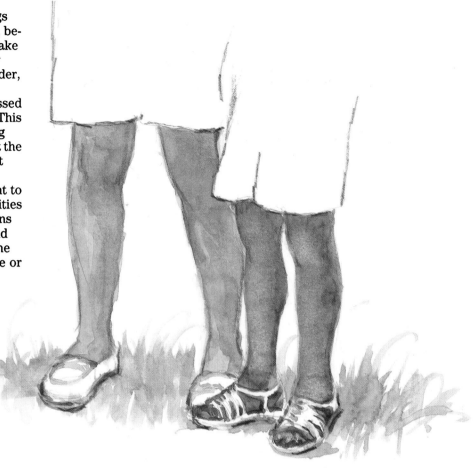

Age and Proportion

Because we want to do portraits of children, age and size are vitally important. Children are constantly changing as they grow older, and you don't want to paint a three year old and have it come out looking as if he were six. The secret is *proportion*—proportion of the head to the entire body, to the torso, to the arms and legs. The way to work with proportion is to think of the child's body in head lengths, just as you would if working with an adult body.

In the chart below, you will see children from babyhood to the teen years. As you study them, I think you will readily understand the concept of measuring a figure in head lengths. The baby has a very large head for his body; it is one-fourth his total height. We say the standing baby is "four heads tall," which is a misnomer because the baby doesn't "stand" at all. This relationship between head length and total-body length changes with each year of the young person's growth. Note that all of these figures are standing with their weight equally distributed on both feet. If the child

is standing with more weight on one foot, or if he is seated, the proportions change because the balance changes.

The halfway mark is also important and is shown on these figures by the horizontal orange line. Many times it helps you to draw the figure if you know where the midpoint should be. This keeps you from getting the torso too long and the legs too short—a common error. From the age of six on, the midpoint is almost always at the bathing suit line.

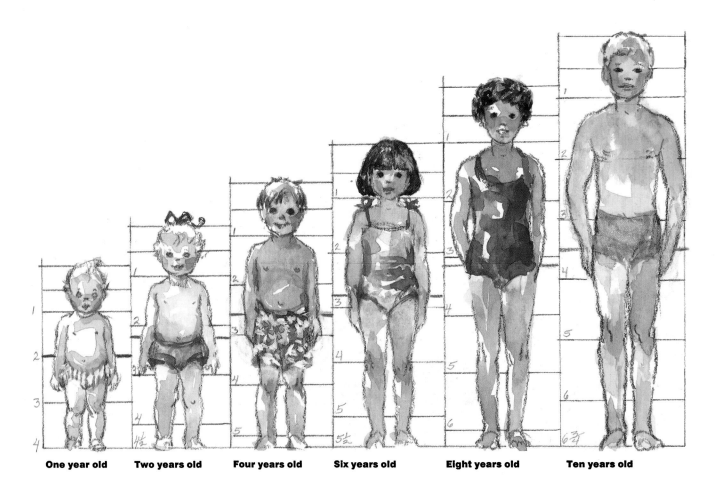

| One year old | Two years old | Four years old | Six years old | Eight years old | Ten years old |

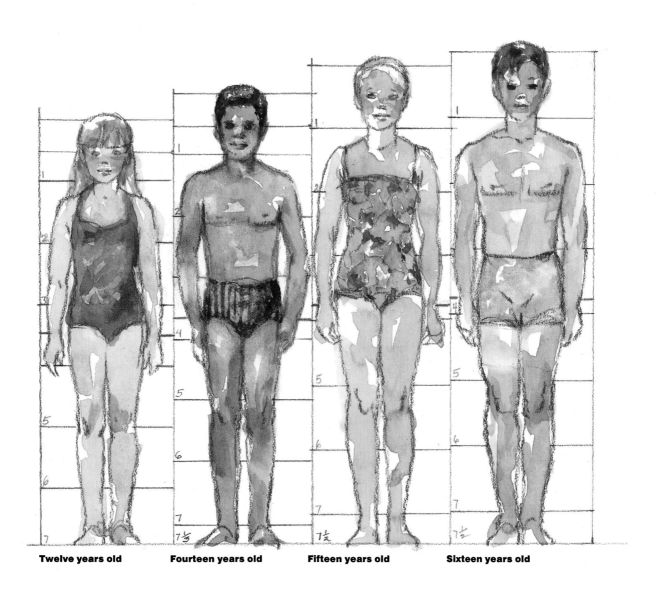

Twelve years old **Fourteen years old** **Fifteen years old** **Sixteen years old**

Visual Measuring From Life

You can learn how to measure the proportions, the head lengths, of any figure from life. On your paper, sketch the head shape where you want the head to be, and the size you want it to be in your drawing. The height of this oval shape will be your unit of measurement. Now, looking at the model, extend your arm and hold your pencil vertically, at arm's length, and have the point of the pencil coincide with the top of your model's head. Hold the pencil rigidly, and slide your thumbnail down the pencil until it is level with the model's chin. That is one head length. Leave your thumbnail where it is and move the *point* of the pencil down to the sitter's chin. Where your thumbnail is now equals the second head length. Is it on the chest? The abdomen? Mark this spot on your paper, as if you were sketching the second oval head shape. You can repeat this process for the third, fourth and additional head lengths. This same process can be carried out using a brush or a ruler instead of a pencil.

This method of measuring head lengths on your model is not meant to be precise. Look upon it as a method to plan your figure drawing in a general way to see how far down the chest, stomach, knees and feet might be, no matter what pose the figure is in. If the figure is seated, you can learn how many head lengths there are from the top of the head to the chair seat; it's so easy to get this distance wrong. This process also tells you how much of the figure will fit on your paper. If you begin to draw the child and, when you reach the knees you run out of space, you'd have to erase it and draw it over again. With this method, you know how many head lengths to allow for. The proportions stay the same, but you would draw the head smaller, and then continue head lengths for the figure.

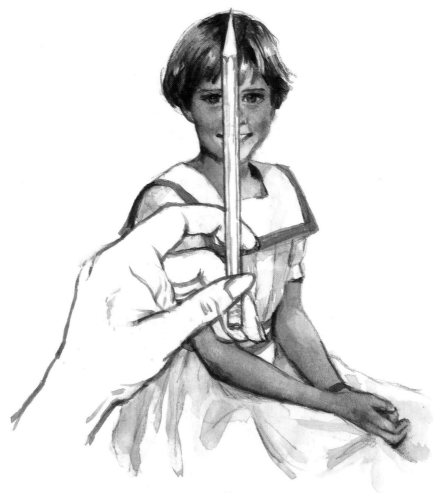

Measure your subject's head with your pencil. Then compare that "head length" to the other parts of the body to get everything in proportion.

Head Length Proportions From Photographs

You can take a small photograph and enlarge it correctly to a size you want to paint by measuring head lengths. With a ruler, measure the length of the head in the photograph. This is your basic unit of measurement, and the ratio between the small head in the photo and the large head you would like to have in the painting is the key. If you like, you can purchase an inexpensive proportional scale at an art supply store to do all the mathematics for you.

Then mark off the second head length on the photo, the third, the fourth and so on for the entire body.

You could also trace the photo first and do your measuring on the tracing, which is easier to see and to read, instead of marking the photograph. You can always compare the tracing to the photograph as you make your drawing or painting.

A second practical way to enlarge a photographic image to fit the size of your canvas is to use an opaque projector. When I use this method I project the image onto a large sheet of tracing paper, draw it with pencil, then transfer that to my canvas with red Saral transfer paper. I can check my work at any time by laying the tracing paper over my painting to see if I am getting too far off. And if there are two people in the portrait I can move the two tracings around until I

like the way the figures look together, then trace them on the canvas. This isn't cheating—you still have to draw well to get a good portrait—and it does save time.

You can also take the photo to your neighborhood copy center and have it enlarged on the copy machine to a size that is easier to work from. It will be in black and white, but you will still have the photograph for color. No matter how you handle this problem, you will still get better results if you can schedule a sitting from life at the end. This posing session is like having a safety net, for you will immediately be able to see what you have to do when the subject is right there with you.

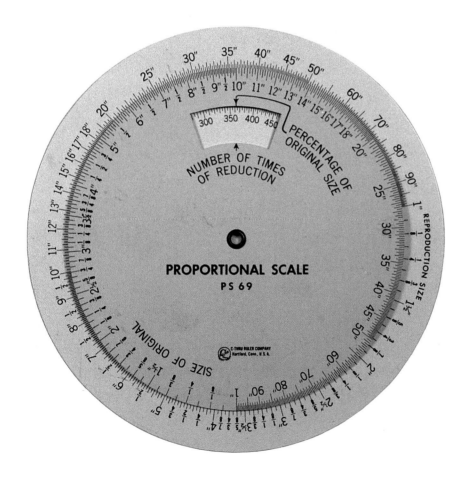

You can buy a proportional scale like this to help you enlarge or reduce the image when working from photographs.

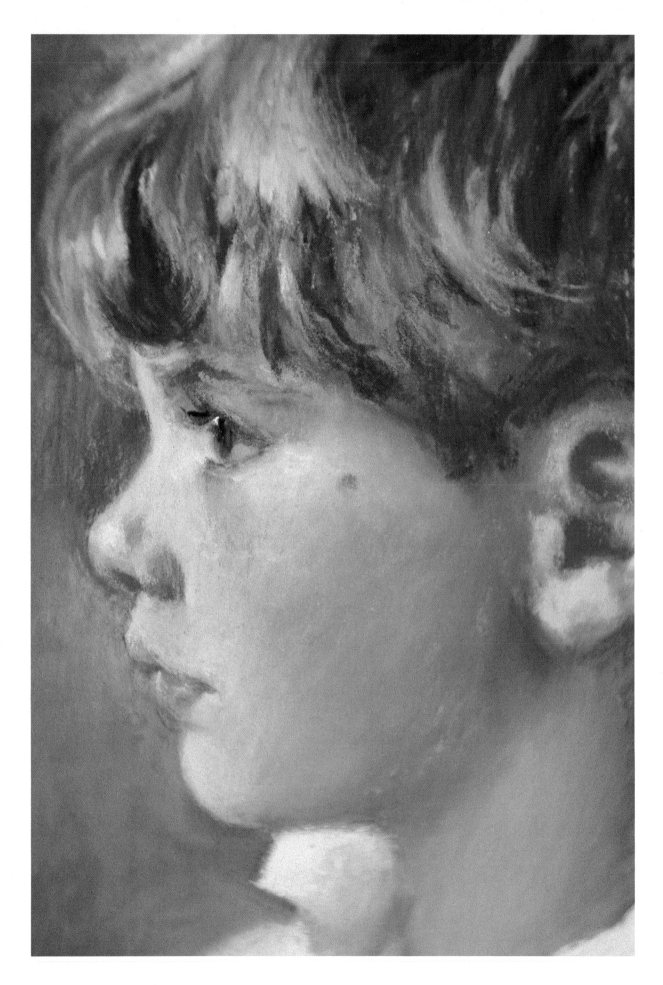

Which Medium Would Be Best?

Portrait of Robert, age 7, in pastel on sanded pastel paper (detail).

Let's say you want to do a portrait of a small child. You may be an oil painter, but you think oils could be too heavy. Perhaps time is a factor; you have to finish the portrait quickly and wish you could do a pastel or watercolor sketch. It will help you a great deal to learn to work in more than one medium. For one thing, it will make your life more interesting. Also, you will at some time run into a situation where only one medium will do, and you hope it is one you are comfortable with. Perhaps the best reason is that familiarity with each medium will help you with another. Charcoal helps you learn to see values and draw solid forms. Pastel helps develop your use of color. Oils give you the most options for sizes and techniques. Watercolor helps you loosen up and makes your color lighter and brighter. As you'll see, each medium has unique qualities.

In this chapter, we'll see the same figure in five different mediums on five different grounds. We'll be working from a photograph, but remember that all these media work as well, if not better, from the live figure. Our model is my young friend Robert, age seven.

All of the portraits in this chapter are the same size, and quite small: approximately 8½ × 7 inches. I almost never work this small, but I wanted the portraits to be printed actual size in this book so you could really see the differences.

Charcoal

Charcoal is probably the oldest medium. The earliest cave paintings by prehistoric man must have been made with bits of burnt twigs picked up from the fire. This basic medium is a good discipline for anyone to master. You will use it throughout your lifetime for sketches and finished studies.

When you are trying to develop your drawing skills and trying to make the head look round and solid, charcoal is for you. Charcoal is easy to erase with a cloth or kneaded eraser. In fact, you'll find you do as much work with your kneaded eraser as you do with the charcoal. With the eraser you can model the soft gradations from light into halftone and shadow and vary your edges from hard to soft.

Some artists use a cloth or a paper stump to blend the charcoal. I use my finger, but I try to keep the smoothing to a minimum so that my work looks like a drawing and doesn't become too slick.

Paper for charcoal shouldn't be too smooth. It must have some "tooth," or texture, to grab the particles. Try using charcoal on colored papers too, light blue or beige or pink. On midtone papers you can use white pastel or white Conté crayon for highlights. Charcoal even makes wonderful drawings on ordinary brown wrapping paper, highlighted with white. Spray your charcoal drawings with fixative when they are finished to keep them from smearing. And for inspiration, look at John Singer Sargent's charcoal portraits.

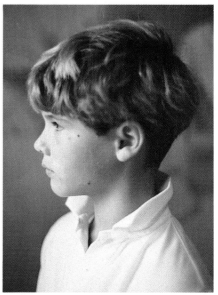

Here is the photograph of our model, Robert, age 7, that I used as the basis for all the portraits in this chapter.

For this charcoal drawing, the materials I used were:

• White Strathmore charcoal paper
• A stick of vine charcoal, extra soft
• A kneaded eraser
• A 6B charcoal pencil, extra soft
• A white Conté crayon for the highlight in the eye

Charcoal on White Strathmore charcoal paper.

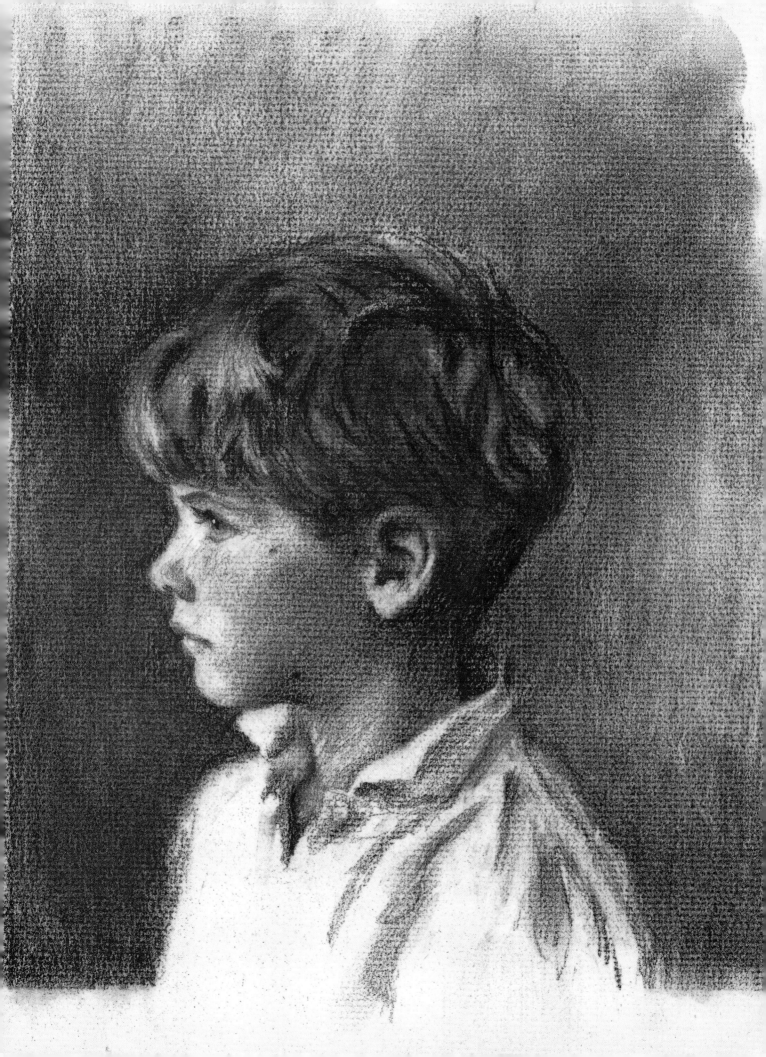

Sanguine Conté Crayon or Pencil

The dictionary defines sanguine as "the color of blood; red." This material goes back to Leonardo da Vinci, who used it on cream paper with white highlights. You may also want to study the unbelievably beautiful sanguine drawings done by Watteau and Rubens. They both used it masterfully on figures and heads, sometimes alone and sometimes with charcoal for a dark contrast or white chalk for highlights. Sanguine drawings are seldom seen today, which is why I am including this medium here. I want you to know about it, and I hope you will try it. To me, it bridges the gap between charcoal and pastel. I love the warmth of it.

Sanguine is a Conté crayon, and also comes in pencil form. It is very smooth, and you will love using it because it feels so good when you're drawing with it on paper.

Sanguine is as easy to use as charcoal—maybe easier—because it stays where you put it and doesn't lift off at the slightest touch. It erases well with a kneaded eraser and therefore can be modeled with the eraser to create subtle halftones and darks.

Sanguine can be blended with the finger, but I would keep this to a minimum as the strokes look better. With a sharp sanguine pencil you can keep your strokes so delicate that they look as if they were just breathed upon the paper.

Artists seem to have used this medium only on warm-colored papers, especially cream, but it might be interesting to see how it looks on light blues or greens. You can even try drawing with it on a paper stained unevenly with tea; I think it would look very old, like ancient parchment.

To me, this drawing of Robert has a classical quality. I worked hard to keep it restrained and to not carry it too far. I used the sanguine pencil because the drawing is so small. If it had been larger, life-size, I probably would have used Conté crayon. White highlights made with white Conté crayon were kept to an absolute minimum. Even then, the white crayon was never applied with much pressure, but barely glazed over the textured paper. I think the very slight shading behind the profile helps to make the face look more solid by giving the outline around the face a bit more substance. I did add some dark ochre pastel pencil touches, mostly on the shirt. The geometrical shape in line around the head finishes the drawing for me.

Conté crayon drawings need to be sprayed so they will not smear, so be sure to make all your changes before you spray; you can't erase after using a fixative.

For this sanguine drawing of Robert I used:

- A sanguine Conté pencil
- Canson tinted pastel paper, #340 oyster, lightweight
- Carb-Othello pastel pencil #35, dark ochre
- A white Conté crayon
- A charcoal pencil (for the eye)
- A kneaded eraser

Sanguine Conté pencil on tinted pastel paper.

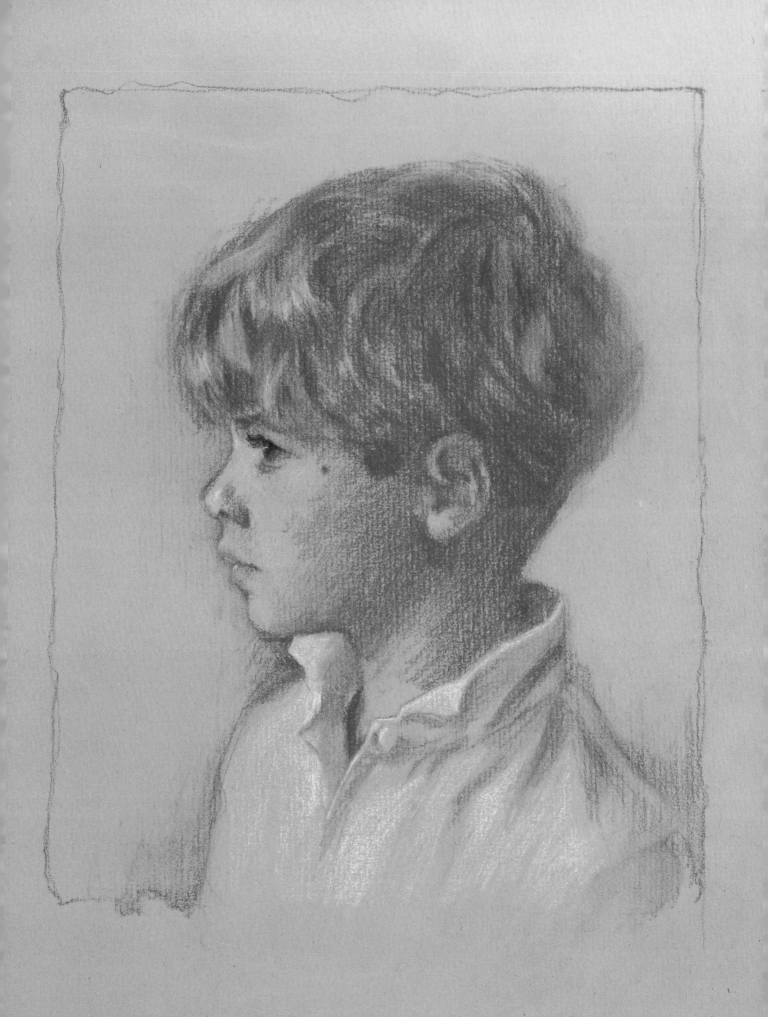

Pastels

Pastels are just about the perfect medium for children's portraits. The soft matte colors fairly glow and give you better fleshtones than any other medium. You can get results quickly and make sweeping changes very fast as well—important when you're doing kids.

Like charcoal and Conté crayon, pastels are a dry medium, so all you need are the pastel sticks (chalks) and a surface to draw on, and you!

Unlike the two previous mediums, pastels come in an enormous range of colors. A box of 90 colors is not unusual, and there are sets of 180 and more. The reason for having so many colors is that pastel is like a dry paint and, though you do layer one color over another to get the hues you want, you don't really mix pastels as you would paints. In a paint medium like oils or acrylics, you can mix a red with white to get the pink you want. In pastels you start with a pink chalk and then stroke another chalk over it, perhaps an orange for a coral pink or a purple for a lavender pink. And you would let the original pink show through to achieve a vibrancy of color. The more colors you have, the more variations you can get.

As a children's portrait painter you will never use all those brilliant reds, yellows, blues and greens you find in the large sets. And the darks will sit there forever. We are talking here of the sticks known as soft pastels, not oil pastels, or colored pencils, or watercolor crayons. For good darks, many artists use Nupastels, a small square type that is a little harder. These come in a wide range of colors, and because of their smaller size and hardness they can be used for finer definition of shapes, for lines and details. For really fine details, there are pastel pencils that can be sharpened to a point.

The paper for pastels should have some tooth (texture) to it; pastels would slide off a hard-surfaced smooth paper. Because it is necessary to build colors and values by adding more and more chalk, even a textured sheet of pastel paper can become so filled with pastel particles that the paper will not accept any more chalk. I prefer to use a sanded pastel paper that never gets filled up. It has a fine grit that can always hold more pastel particles, but it feels velvety rather than gritty. It is a joy to work on. Pastels also look best on tinted paper. White paper does nothing for them. For children, light- and neutral-colored papers work well.

Pastels do not tolerate erasing very well. It is far easier to use another color over the color you don't want. If you must erase, lightly dust the pastel with a quick flick of a towel, or press a clean part of a kneaded eraser on the offending area and lift it straight up again, over and over. Never drag the eraser or cloth *across* the pastel. It will only smear the colors and leave you with a sorry mess. And never get your pastel chalks or your drawing wet; they just don't take to water at all.

Another plus is the permanence of pastels. Because they are applied dry there is no chemical action going on. They never turn dark or yellow, but always look fresh. Their only enemy is dampness, which may cause the paper to deteriorate or mildew. But in my opinion, they are the most permanent of all the painting mediums.

They do smear, however, and must be framed under glass. And don't ever spray your *finished* pastel painting with fixative—it deadens the soft matte colors and destroys their luminosity and considerable charm.

The materials I used on Robert's portrait in pastel were:

• Sanded pastel paper, buff, 7/0 fine grit
• Six Grumbacher soft pastels, including flesh ochres, reds and burnt umber
• Six Rembrandt colors, including warms and cools
• Twenty-three Nupastels, including a large variety of warm colors from dark to light
• Ten pastel pencils, including white Conté and a range of neutrals and a red, a violet and a blue

from Carb-Othello

This seems like a lot of colors for such a small portrait. Most of the greens are in the background, and the ochres, browns, pinks and reds are in the flesh colors.

Pastel on sanded pastel paper.

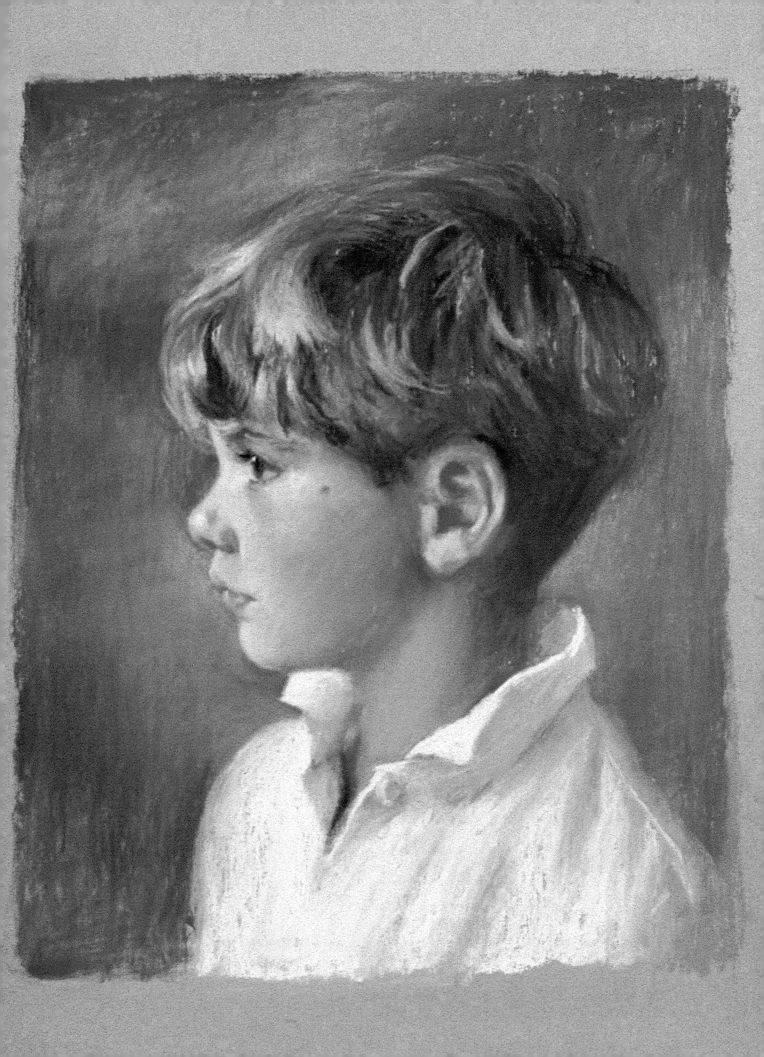

Oils

Oils are the most traditional portrait medium of all, but it is not easy to paint very young children in oils because they don't pose very well. The only way it can be done is to mix the fleshtones and have them ready on the palette before the child arrives. I have learned to do forty-five-minute oil sketches from life of any age child, but these are not finished works. They are preliminary studies to help me later in the portrait when I must resort to photographs.

Oils are not difficult to use. They work best when you do not thin them with oil or anything else, except for the *imprimatura*, the first wash used to tone the canvas.

If oils are new to you, it is best to start with a few colors and gradually add others as you feel you need them. You can actually do an entire portrait with titanium white, raw sienna, light red (an earth red) and cobalt blue. Portraits painted in oils have depth, richness and subtlety. The paintings last for generations and they are so simple to frame—oils need no glass.

I painted the oil portrait of Robert in two sessions. On the first day, I covered the primed canvas with yellow ochre thinned to the consistency of water with odorless paint thinner. After about an hour this was dry and

I then traced down my drawing with red Saral transfer paper. Using the paint without thinner, I laid in the light areas of the flesh with opaque color mixtures, white with varying degrees of yellow ochre, alizarin and orange. The lights in the hair were white tinted with a touch of yellow ochre and cobalt blue. Heavy white paint was laid in the light areas on the shirt.

Midtones and darks in the face were painted with the flesh mixture, with cobalt blue and blue-violet added. In the hair, burnt umber, sap green and yellow ochre were used. Very warm accents were added to the face with reds for the nostril and the ear.

In the background I used yellow ochre, raw sienna and sap green applied thinly enough to allow the texture of the canvas to be seen but heavily enough to hide the red lines. The paint was not thinned, just scrubbed on.

Now every part had been worked on and the little portrait was very wet; I put it aside until the heavy whites were dry.

During the second session I continued to develop the portrait with these same colors, refining every area, and doing my best to bring it to

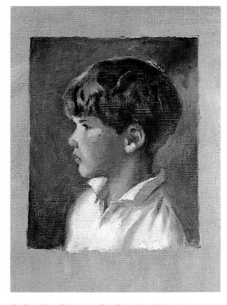

Robert's oil portrait after the first day.

a conclusion in about two hours. My theory of successful oil portraits is *opaque lights, transparent darks*. This very traditional approach goes all the way back to Peter Paul Rubens.

For Robert's portrait in oils I used:

• Oil paints: Titanium white oil paint mixed half and half with white alkyd paint on the palette (for quicker drying), cadmium yellow light, cadmium yellow orange, yellow ochre, raw sienna, scarlet lake, alizarin crimson, burnt sienna, light blue violet, cobalt blue, ultramarine blue, sap green and burnt umber
 • Brushes: Bristle filberts nos. 2, 4 and 6; half-inch flat synthetic and no. 3 round synthetic
 • Oil-primed finely woven linen canvas
 • Odorless paint thinner; paper palette; palette knife; paper towels
 • A hand mirror helps me to work with the photo, side by side and in reverse.

Oil on canvas.

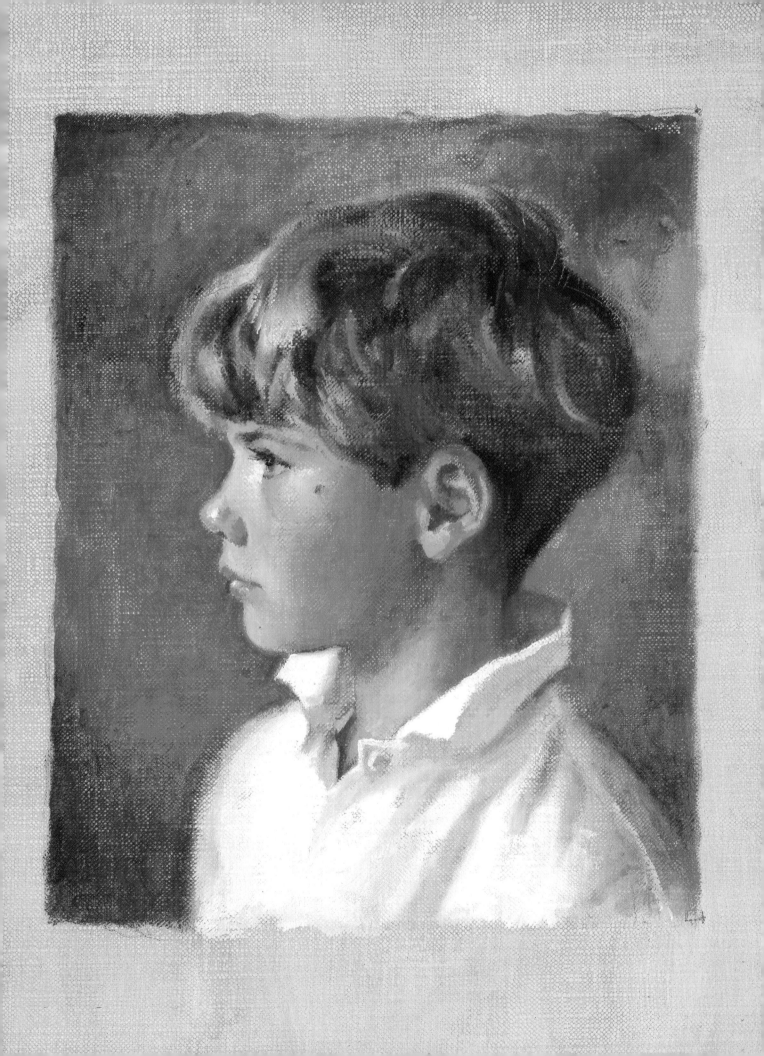

Watercolors

Watercolors give us luminosity and beautiful clear colors. More than any other medium, the watercolor technique takes time to learn as well as a considerable amount of practice. It's not mixing the colors or applying them that is difficult; it's understanding *when* to apply them. For good watercolor portraits, I have learned to slow down and to wait for one layer to dry before I add another. I've learned to hold back and to think about every stroke before I get in there with the brush again.

Another very important thing I've learned is not to use staining colors. Every color on my palette can be lifted if it isn't right. I like to be able to change my mind. And it has taken me years to learn to mix my colors, not on the palette, but on the paper. No one wants muddy watercolor paintings.

Watercolor portraits of children are fun to do—they can be as spontaneous and as surprising as our young subjects. You may have to do two or three of the same person before you get what you want, but that is better than overworking one painting. Watercolor paintings are at their best when they look fresh.

As with the oil portrait, I painted the watercolor of Robert in two stages. First I used wide masking tape to mark off the size of the portrait. The paper (on a board) was tilted to allow the washes to flow down the paper. I then laid on the initial wash of yellow ochre, quite watery. While wet, I dropped scarlet lake into it and carried this wash down over the neck and into the background, working around the white shirt. Working quickly, I painted cerulean blue across the top of the paper and let it run into the still-wet ochre wash. I let the paint dry.

During the second stage, I laid in the hair roughly with raw umber, cooled with cobalt blue, then added cerulean blue behind the ear. My intent was to keep the shadows luminous and filled with light.

The ear and cheek were painted with yellow ochre and scarlet lake. Raw sienna and cerulean blue were dropped into the shadow areas of the neck and between the eye and the brow. I drew in the features carefully with warm colors, using scarlet lake and raw umber for the nostril and ear accents. Shirt shadows were cerulean blue and raw sienna laid in separately.

I painted the background with stronger hues of cerulean blue, olive green warmed with yellow and orange, raw sienna, and a bit of yellow ochre behind the head.

Robert's watercolor portrait after the first stage.

For Robert's portrait in watercolor I used:

- 140 lb. cold-press Arches paper
- Watercolor paints in tubes (all Winsor & Newton except where noted): new gamboge, yellow ochre, raw sienna, raw umber, scarlet lake, alizarin crimson, burnt sienna, cerulean blue, cobalt blue, ultramarine blue, Prussian blue, viridian, olive green, mauve and burnt umber
- Brushes: Round sable or syn-

thetic fiber nos. 3, 8 and 10
- Cosmetic sponge; paper towels; water

Watercolor on 140-lb. Arches cold-press paper.

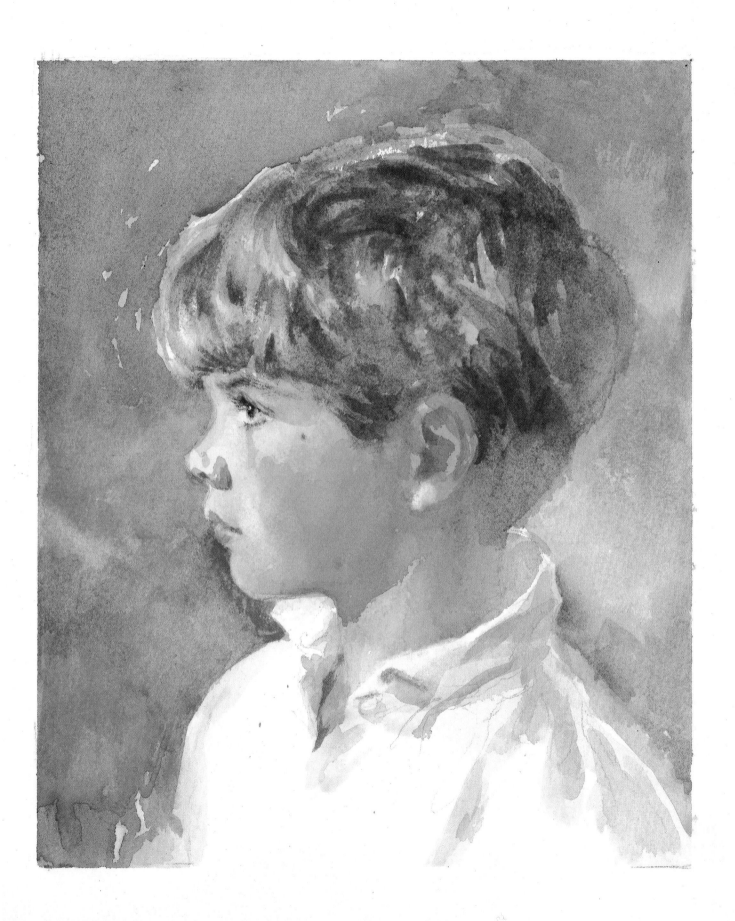

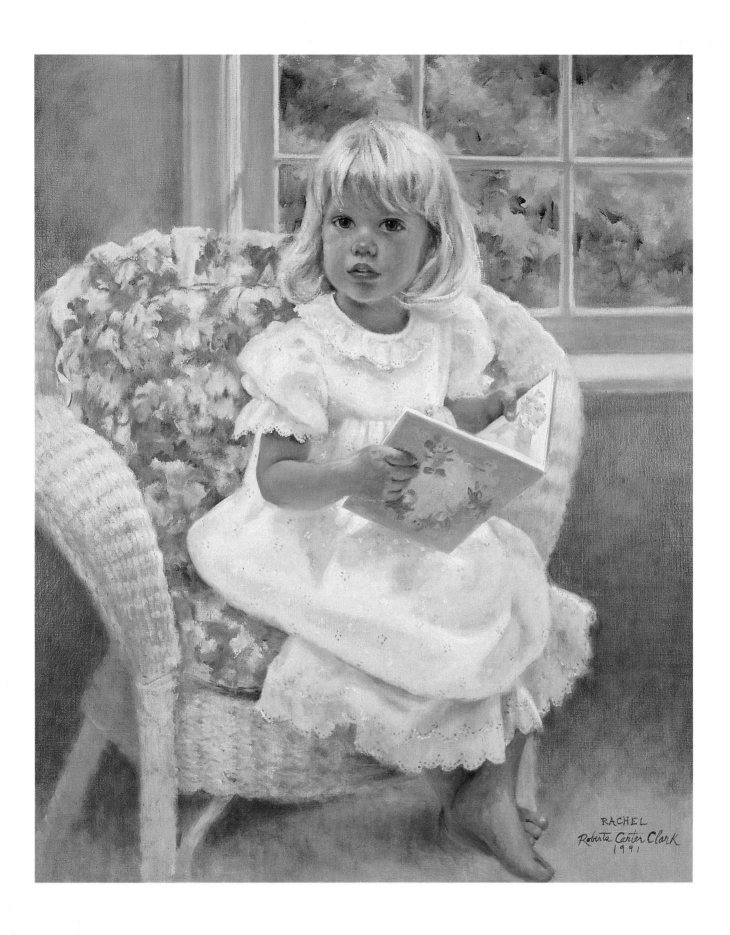

RACHEL
Roberta Carter Clark
1991

Working With Children

Rachel, age 4
Oil on canvas
30″ × 25″
Collection of Mr. and
Mrs. Lee Tashjian

The most difficult part of painting portraits of children is getting them interested in the project at hand and keeping them interested. It's a good idea to arrange an appointment first just to get acquainted. This visit should not be long. You can have the child and her parents visit your studio to see your work, of course, but the real get-acquainted visit should be at their home. The child will be more at ease there, and you can see what sort of things their family likes, the colors and style expressed by the furnishings. All this will help you plan your portrait.

It seems best if you and the parent just talk and let the child watch and listen. She may be quite shy and never come out from behind the parent, or she may ask a dozen questions. Either way, it is best if you appear to be concentrating on the grown-up, even though you are studying the child from every angle.

Most people enjoy showing you their home, and sometimes children will take you by the hand and lead you to their rooms to show you their toys. If this happens, you know they are beginning to have confidence in you. You must get across to them the idea that you are a new friend, that you like being with them and are looking forward to spending more time with them.

This initial visit also helps you relax when the time comes to really work with the child and the family at the first sitting. After all, you may be just as apprehensive as they are—you don't know them either, and they are expecting great things from you!

How Many Sittings?

When painting children from life, you should talk with the parents and let them know it's necessary to be a bit open-ended on the number of sittings. If you are using photographs as an assist, you may be able to eliminate a sitting or two.

You can bring your sketchbook along and, while you and the parents are talking, draw some ideas for poses so all of you can decide how much of the child to include. Head and shoulders? Hands? Knees? Feet? The place where the family wishes to hang the portrait often determines the size, and the size determines how much of the young person can be included. All this also determines the fee you charge for the portrait, and this is the ideal time to discuss this delicate matter. It is terribly important to decide upon the fee before you begin; this saves so much embarrassment and concern later. It is only fair for the client to know what the financial obligation is to be before you begin, and it is only fair for you, the artist, to know exactly how much you are to be paid for your work.

Another decision to be made during the initial visit concerns the medium you'll be working in. Each medium requires a different number of sittings.

• One sitting is enough for a charcoal or pencil sketch, with possibly a brief follow-up for final polishing. You might take up to two or three sittings for a charcoal or sanguine portrait with white highlights at the very end. You don't want to overwork it.

• Five to seven sittings should be enough for an oil portrait of a young person. This depends upon the age and the personality of the child, which govern the length of time he will stay with you.

• A portrait in pastel can take as long as an oil portrait. I used to think pastel was the quicker medium, but either I have slowed down or I've become more demanding for now it takes me as long as any oil.

• Two sittings should be enough for a watercolor portrait after you've completed the drawing. A watercolor isn't wonderful if it isn't fresh, with clean color. Just to be on the safe side, it might be wise to do several watercolor studies, then choose the one you like best.

No matter which medium you work in, you will have to decide how you want to pace yourself. You might want to see the child for two sittings a week, or maybe every day until the portrait is finished. The hardest way is to see the child once a week, say every Tuesday. The painting drags on too long and soon everyone tires of the project. Also, by the time Tuesday comes you have forgotten where you were in the painting a week earlier and you have to build your enthusiasm up from zero each time. You can't paint any portrait without enthusiasm!

Elizabeth and Caldwell, ages 3 and 5
Sepia pastel pencil on Canson tinted paper 20″ × 22″

This was a sketch for a double portrait, but now there is a new baby, so I'll have to do something different.

Posing

As have all the portrait painters before you, you'll have to use your ingenuity and think of ways to keep your young sitters in the same room with you. Keeping them looking at you takes even more cleverness. When work actually begins, the best thing you can do is talk with the child. Let the parent be there, but in the background this time. Over the years, I have developed the ability to talk while I work, and you should too. Most portrait painters are quite sociable—or they wouldn't be portrait painters. You'll find it absolutely essential to talk with your subject. If you don't, you'll find he either falls asleep or escapes from the chair, and when you look up he's gone. The idea is to get the child talking so you can just nod or smile and concentrate on your work. Try opening the conversation by asking about a pet, or brothers and sisters, or a favorite TV show or even a favorite color. In short, ask the child about himself. Incidentally, this technique works just as well with adult sitters.

Once in a while you'll have a youngster who will sing for you. You can have fun with this, especially if you know the songs too and sing along with him. Background music helps everyone relax and fills in the gaps when there is no conversation. Some parents bring the child's favorite tapes along. One of the things I love most about painting children is working with young families. You would be surprised at some of these little three and four year olds who love rock music with a strong beat. They are into a lot more than nursery rhymes. But absolutely no TV! Television keeps them in one place, but that mesmerized expression is too unnatural for a portrait.

If you work standing up, as I do, you'll have to raise the child to your eye level. I have a tall stool with a back on it that rotates—children really like that. If a child gets fussy, she might sit on the lap of the parent who agrees to sit on the stool. If you're desperate, it's sometimes just easier to get down on the floor with the child while she sits in a juvenile chair or plays on the floor with her toys. Of course, this means that you move all your painting gear down on the floor with you too.

Some youngsters will be doggedly determined to get into your paints and may even want to work on the portrait. No matter how nice you want to be, don't let this happen. If you allow the child to dab around with the brush even once, you will find your subject will want to paint, not pose, and you will have lost control of the situation entirely.

Very Young Children

For young children, I keep a box full of trinkets, little cars, games and mechanical puzzles. When the child is obviously getting bored, I put the box on a table in front of him so he can pore over its contents. Jewelry is a great idea for girls, for as they try on the earrings or necklaces they will look up at you for approval. Thrift shop jewelry is fine; anything that sparkles will do. If you want to make a friend for life, let the child choose one thing they can take home with them to keep each time they come to pose. You can keep them with you a little longer while they try to make the perfect choice.

After you get the hang of it, hand puppets worn on your nonpainting hand are terrific child-pleasers. Playing peekaboo—popping out from behind your easel—produces a marvelous expression of gleeful surprise on a very young face. John Singer Sargent used to surreptitiously dab

Elizabeth, age 7
Pastel on sanded pastel paper
28" × 22"
Collection of Mrs. Nan Hewson

Elizabeth's home was a Colonial house surrounded by trees and we could find no place light enough to work. At last, for additional light, we opened the front door and had Elizabeth sit near this natural light on the lowest steps of the staircase. This gave us a natural and graceful pose!

red paint on his nose when he needed to get that one last look to finish the portrait. The child would say, "You have paint on your nose!" and the artist would reply, "Oh, you must be mistaken, *I* would not have paint on my nose!" And the child would say, "But you do, you do!" This conversation would go on long enough to allow Sargent to catch that eager expression, that one last look we always need. I'll bet painting a moustache on your face would work beautifully.

After a while, many children will ask, "When will you be done?" or complain, "Aren't you done yet?!" When it looks like they are about to run out the door and I need more time, I let them wear *my* watch and tell them they can get down when this hand gets to that number. This works far better than telling the child you only want her to pose "for about ten more minutes" because children have no idea how long ten minutes is. Most children enjoy this game, especially when they see the hands really do move and thereby realize that you are not just humoring them. I think they are amazed that you would give them your watch to wear, too. But you better have an inexpensive watch—you can't get mad at them if they throw it.

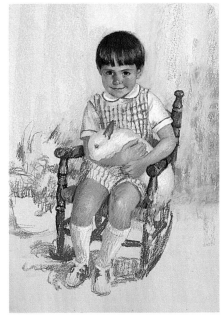

Jake, age 4
Pastel on buff sanded paper
28″ × 22″
Collection of Mr. and Mrs. John C. Pettit

(Above.) The bunny adds interest to this portrait, and I like the contrast with Jake's dark hair.

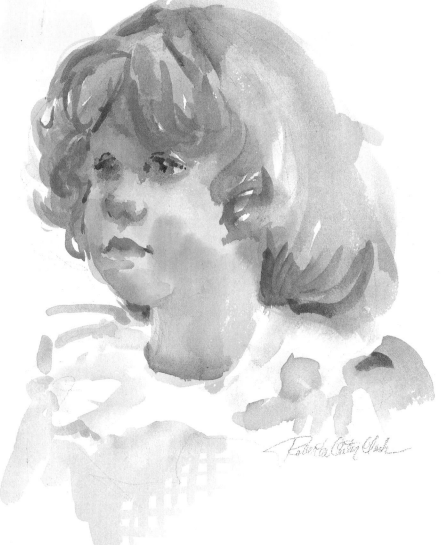

Janell, age 4
Watercolor on Arches 140-lb. cold-press paper
14″ × 12″

(Left.) I was enchanted by Janell's serious little face. She was about four years old, and this watercolor portrait sketch was the result of twenty minutes of posing.

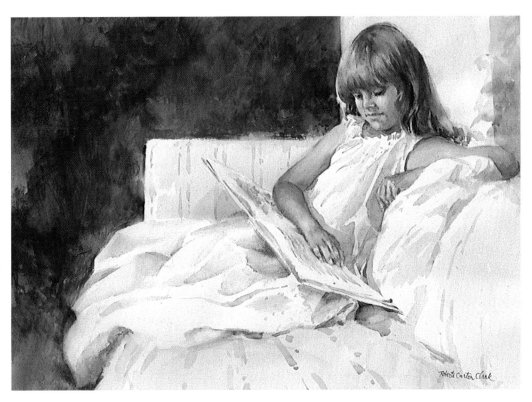

My small dog is one of the best assets I have. Somehow the children and the dog form an instant friendship that keeps my subjects in the studio a bit longer, and every minute helps. When I need them to look at me, I hold the dog under one arm and paint with the other hand. (This obviously wouldn't work with a big Labrador.) Of course, if the child is allergic to dogs, forget this.

Most anything goes for about an hour, but if your subject looks tired or not well or begins to cry, don't push him. You will be able to sense when the visit is over. You want the child at his best, and if his eyes are drooping from exhaustion, or glassy from a cold or a fever, or red from crying, there really is nothing more you can do that day.

Older Children, Ages Six to Twelve

No one really *loves* posing, but a good many are quite pleasant about it, for they want to please their parents, and they more or less relax into the routine. I keep a kitchen timer at hand and when the young person

starts fidgeting I set it for twenty-minute poses with five-minute rests in between. However, don't use the timer until you absolutely need it. It's distracting for the child and even more so for you to be always working against the clock.

At this age, children love riddles and jokes, and it is a good idea to keep a couple of riddle books around the studio. They also like to bring a friend when they pose — a very good idea sometimes (not at the first sitting, though). You will see the young person in an entirely new light with one of her peers, and the more they talk the easier it is for you to concentrate on your work — that is, unless they keep you laughing so much you can't continue. Some people this age are true comedians. Usually one visiting friend at a time is enough; a whole group can create havoc.

Snacks and beverages for the breaks between posing are essential for these kids, especially if they come after school. They are always hungry, and food seems to give the sitting more of a party atmosphere.

Kelly, age 6
Watercolor on Arches 140-lb. cold-press paper
22" × 30"
Collection of Dr. and Mrs. John Madsen

I attempted to do this child in a fluffy dress in pastel, but it was just wrong for her and for the family's home. Then, to please myself, I painted this less conventional watercolor from photographs I had taken of Kelly. Fortunately, her parents are interested in art and they welcomed this painting into their collection without hesitation. This painting has been in several shows as well.

Young People, Ages Thirteen to Sixteen

Teenagers are marvelous to paint, for they are enigmas, neither children nor adults. This group presents a genuine challenge for the painter: to portray the subject's actual age. Also, they are so attractive you can make terrific paintings of them. No need for flattery here; you can paint them just the way they are.

If you take your time with these young people you can become fast friends. Let them talk, and you listen. They are often intrigued by your ability and interest in art, and they shine when they realize you are interested in them. *Never* criticize anything a teenager says or does or expresses an opinion about. You can't even look shocked; they may be testing you by saying something outrageous. I've learned a lot from these kids, even so far as to appreciate their tastes in music. That's because I let them choose the radio station we listen to while we're working.

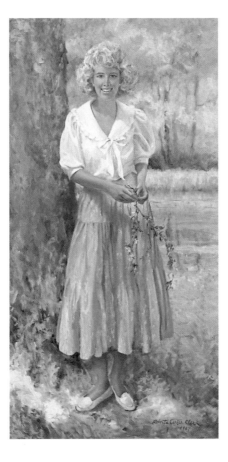

Lisa, age 14
Oil on canvas
68″ × 36″
Collection of Mr. and Mrs. Niels Johnsen

Lisa was fourteen years old when this was painted. The family had just moved into a new home with soaring ceilings, so the portrait had to be large.

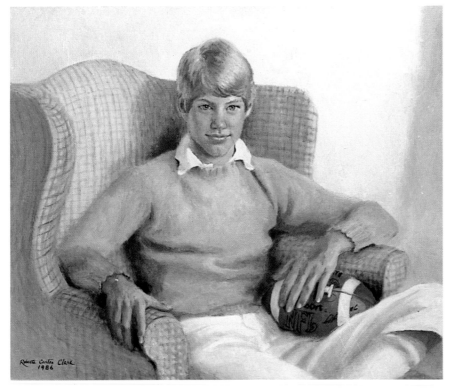

Alec, age 12
Oil on canvas
30″ × 36″
Collection of Mr. and Mrs. Frederick M. Genung II

Alec was a very athletic twelve year old, and he had so much energy he could not sit longer than twenty minutes at a time. I enjoyed painting him, particularly his wonderful hands and the masculine pose. The football was very special to him and had to be rendered just so, signatures and all.

Parents

Some parents want to stay while you are working to watch the portrait develop or because they feel they should be with the child. Provide a chair for your observer in a spot behind you so he does not interrupt your vision, and where he can see the child and the portrait at the same time. Not all artists are comfortable with this situation, but if it does not bother you to have someone watching your every move, it can work to your advantage. Parents are so emotionally involved with their children that they often do not really know what they look like. Seeing the portrait evolve, stroke by stroke, to become more and more like their child *as he really looks* on that particular day and in that particular light might save you some problems when the portrait is finished.

For some older children, it is easier if the parent drops him off and picks him up an hour and a half later, stopping in for a moment at the end of each sitting to observe your progress. Most parents are excited about the portrait, and this excitement can be an integral part of the success of the project.

Pint-Sized Picassos

Children who pose for you become portrait artists too, after they have spent some time with you and see what you are doing. Nine times out of ten they'll be very keen to paint a portrait of their mother or father, a doll or a pet, or even of you. Any child expressing this interest should be given crayons or watercolors and paper and be allowed to carry on—*after* he gets home. If children paint or read a book or color with crayons when they are with you, they will be looking down and you will not see their faces. Let them know you're interested in their artwork and that they can bring it to show you the next time they come.

Your Temperament

No matter what it takes, to paint children you must do your best to maintain a pleasant disposition. Make the posing session as much like a game as possible, even if it gets a little wild and silly. You may not know when you will need to see the child again or when you'll be finished, and you want her to feel good about coming back. You don't want her parent to have to drag her into your studio, kicking and screaming. If you maintain your patience, sense of humor and enthusiasm for the child and the portrait, it will be a pleasant and rewarding experience for all.

This portrait of me was painted by a four-year-old friend named Ashley who came to visit. I gave her a tiny watercolor box and she set right to work.

Painting Children's Portraits Step by Step

Coleman, Hannah, Claire and Campbell
Ages 8, 5, 1½, and 10
Oil on canvas
48″ × 54″
Collection of Mr. and Mrs. Michael Lewis

In this chapter you will find seven step-by-step demonstrations rendered in oil, watercolor and pastel. Each of these has its own wonderful qualities and requires a distinct way of working. And each medium also presents a bewildering array of fleshtone colors. Choosing the correct colors can make or break a portrait.

My basic skin tone mixture for watercolor is yellow ochre, scarlet lake and cerulean blue. However, I'll get nothing but gray if I mix all three together on my palette. I work in the flesh areas first on the paper with the two warm colors. Then I add cerulean blue in the second wash, sometimes when the first wash is wet, sometimes when it's dry. Cerulean is useful in making the edge of a form appear to turn away, or to indicate that place on a form where the light turns into shadow. There are two colors I never use in fleshtones: ultramarine blue, which turns every skin mixture gray, and burnt sienna.

My basic skin tone mixtures for oils are titanium white, raw sienna, light red, and cobalt blue. For very young children, a more delicate mix of white, yellow ochre, light red and viridian works well. For pastel portraits, my favorites are Grumbacher Flesh Ochre 16M (soft sticks) for the lights, and Nupastel Sandalwood (semi-hard sticks) and dark ochre for the midtones. For warms I use peach, red-orange and rose colors; the cools are light blue, violet, sind aqua or olive green; and the darks are cocoa brown and Van Dyke brown.

An Informal Portrait in Watercolor

Abby and Baby Hannah

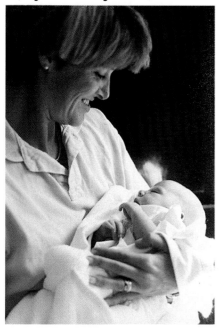

Baby Hannah was just one week old when I met her and took a few pictures. How do you do a portrait of a one-week-old person? She is so small and she is lying down or being held all the time. But I was captivated by her miniature perfection—such tiny hands and delicate features.

It seemed best to paint Hannah with her mother, but I didn't want a painting of a full-sized lady with a postage stamp of a child. I decided on this double figure close-up so I could bring Baby Hannah into the foreground and try to capture her newborn glow. I also wanted to convey her mother's love by concentrating on Abby's expression and supporting hand.

Step One

I made the drawing on heavy tracing paper with a pen, then lightly traced the drawing onto 140-lb. Arches watercolor paper with a no. 2 pencil.

Starting the painting process in a loose way, I applied the first watercolor wash of yellow ochre and scarlet lake over Abby's face with a no. 12 brush, purposely ignoring the outlines of the head. While this first wash was still wet, I dropped in cerulean blue at the top of the head and more

scarlet lake on the cheek area, then permanent rose over the upper part of the shirt, letting the colors flow down and blend. (I work upright on an easel, even with watercolors. The flow of colors, one into another, gives me beautiful transparent color that I cannot easily achieve when working flat on a table.) Then I let it all dry.

Step Two

More permanent rose was added to the shirt, leaving some white irregular shapes at the lower edge where the shirt meets the baby's blanket. Working with great care, I laid the yellow ochre/scarlet lake wash over the baby's head, leaving a soft edge at the crown. Into this I dropped some orange in an attempt to get that "candle glow" that babies have. I kept the color concentrated at the face. Even though it was a very small area, I wanted Baby Hannah's head to be like a shining jewel in this painting.

When the face was dry I added a light cerulean blue over the nearly translucent eyelids and to the area between her tiny nose and upper lip. I used this blue to "turn" the plane of the face away from me and to delineate the form of the head at the side and back of the cranium.

Then I went to Abby's hand. I wanted it to be darker and less bright, so I stepped down from yellow ochre to raw sienna and kept the color particularly warm in the lower part of the hand where it was receiving so much reflected light.

Step Three

Trying my best to keep the color transparent and luminous, I laid in the palest flesh-colored wash on the baby's hands and arms.

Abby's hair needed some raw umber definition. When the color started to look too hot I cooled it down with cerulean or cobalt blue washes. These colors also were used to define the back of her neck.

I began to define Abby's eye and nose with warm and cool layers, at the same time beginning to pull out the shape of the face from the first wash. Remember: *All the openings in the head* (the eyes, ears, nostrils and mouth) *are warm* and should be painted with warm colors: golds, oranges, reds, warm purples. Warm colors give the head a feeling of life. I lifted the shape of Abby's teeth with a barely damp sponge and a stencil I cut to that shape.

I needed some definition in the baby's blanket and dress, but I didn't attempt to copy all the intricate folds I saw. Pale washes of cerulean blue, cobalt blue, scarlet lake, permanent rose and yellow ochre were put on, one color at a time. In some places where the paint was wet, they intermingled. I just let the paint do it.

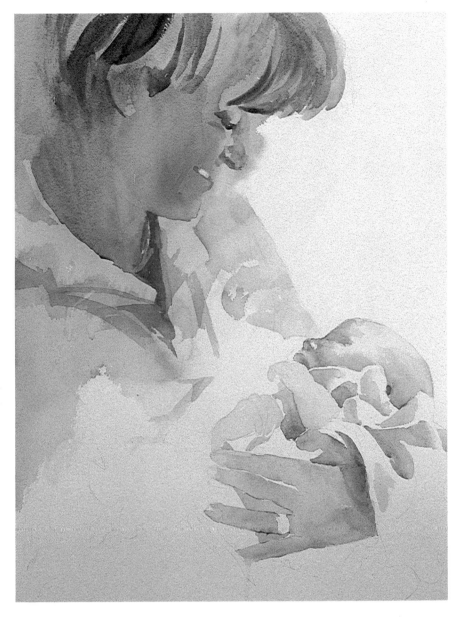

Step Four

To define the figure shapes, I laid in the dark background with cobalt blue and ultramarine blue, dropping some warms—raw umber, alizarin crimson—into it while wet. I painted warms and cools on the mother's hair, neck and face, then pulled darks over the hair, neck and collar areas and in the eye.

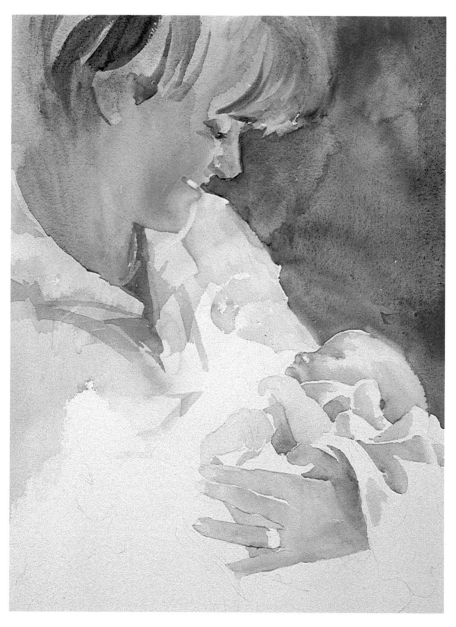

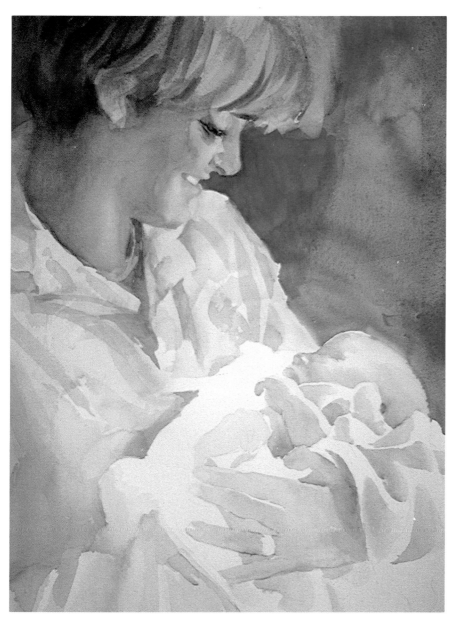

Step Five

The front of the shirt was laid in at last, defining the blanket edge. I let whites leak in and out because I didn't want any hard line between the mother and the infant that might suggest a barrier. I laid in a deeper, warmer fleshtone (yellow ochre and scarlet lake) in the shadow area of Baby Hannah's left forearm and hand. While this was still damp, I put in the palest blue halftone between the shadow and the light to give form to the little arm.

A few more pale washes were laid on the blanket toward the lower left corner to subdue that area, along with deeper color added to Abby's shirt there.

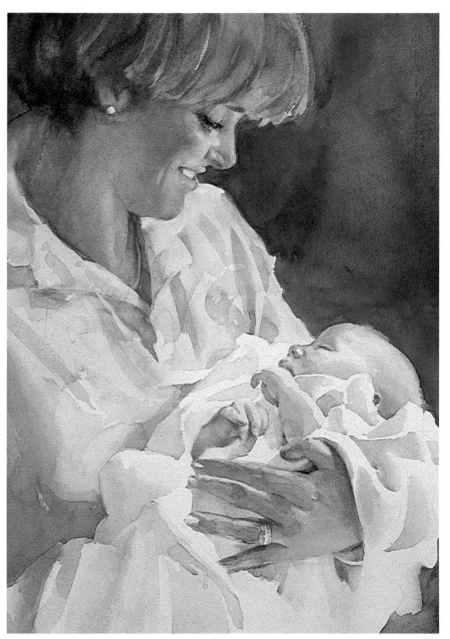

Step Six

I worked at finishing Abby's hand—always holding back, not defining too much—adding warms, cools, preserving the lights on the thumb, the fingernails, the ring and the second finger. I added more definition to Baby Hannah's features and right hand, trying hard to make the little finger project and yet not have more emphasis than the mother's hand. A small dark was added at the lower right corner to make the blanket edge as interesting as possible without becoming a distraction.

Next I warmed the blues in Abby's neck. I began to feel she was becoming too young and glamorous, so I restated the laugh line just left of her mouth and lifted out the pearl earring.

To deepen the background I added more dark washes so the figures would shine.

The Finish

Finally I checked all over the painting to lift out highlights and add accents. The background was blotchy and unattractive so I decided to have fun with it and do something different. Taking out a precut stencil made for wall decoration, I used it to paint darks over the blues, turning it frequently so the design would not look too mechanical. Now the uneven blue in the background became an advantage. This large area had interest but still dropped away from my figures, allowing mother and child to shine.

Abby and Baby Hannah
Transparent watercolor on 140-lb. Arches cold-press paper
20″ × 15″

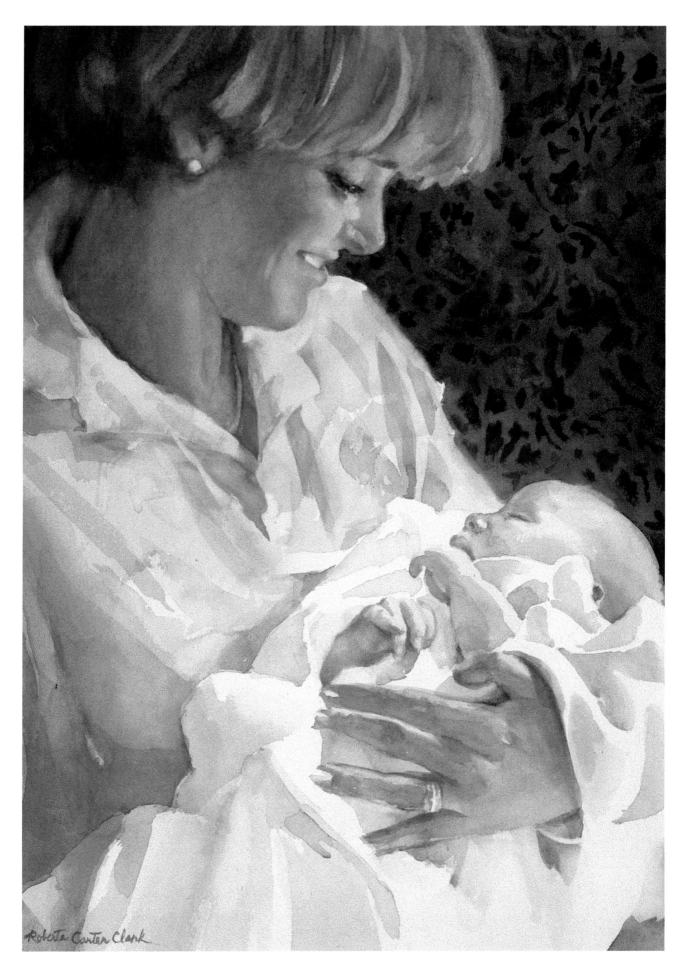

Roberta Carter Clark

Demonstration Two
A Double Portrait in Oils

Patrick and Robert

These boys are brothers; Patrick was three, Robert was seven. They were full of energy and I took numerous photographs of each of them, alone and together.

After studying the photographs, I selected the poses I thought would make a good double portrait. Then I drew several sketches from these poses. Because this was a double portrait, I cut out the figures and moved them around on a background to arrive at a satisfactory composition. Very often a really excellent pose of one child has to be sacrificed to make the two figures work together well. Finally the parents agreed on the pose (shown at bottom) and decided the boys should be painted as if they were at the beach.

Step One

I stretched the 40×50-inch canvas. Then, with a paper towel, I applied raw sienna thinned with odorless paint thinner to a watery consistency—my imprimatura—and let it dry.

With a no. 6 filbert bristle brush and raw sienna I drew the figures on the canvas. Getting the figures in the right place is of critical importance, and it is worth wiping the drawing off and doing it over again until it suits you and is in proportion to the size of the canvas. The boys posed some too, in a very informal way. As Robert was older and more amenable to posing, I started painting his figure first. I laid in the flesh areas with a mixture of titanium white, raw sienna and light red straight from the tube. I used the same colors for the darker areas and a bit of cobalt blue to cool the color in some places. Robert's hair was burnt umber in the darks and white, yellow ochre and cadmium orange in the lights. I made clear definitions between the lights and the darks; it was too early to start blending them at this stage.

I painted the shirt with titanium white with touches of yellow ochre and cobalt blue, allowing some of the raw sienna imprimatura to shine through in the halftones. A light blue was laid in the background to define Robert's head and shoulders.

I had to start on Patrick now. I was determined to develop both boys at the same time because I didn't want to get myself into a trap where one would be complete and the other barely started.

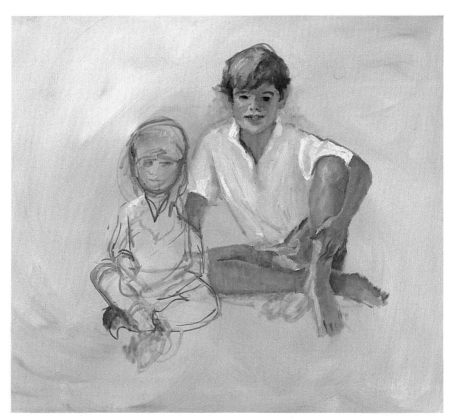

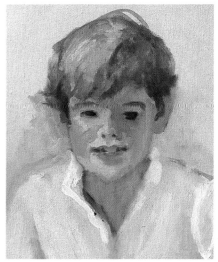

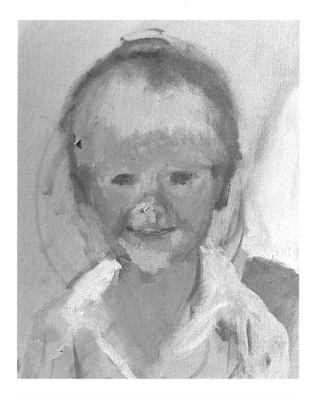

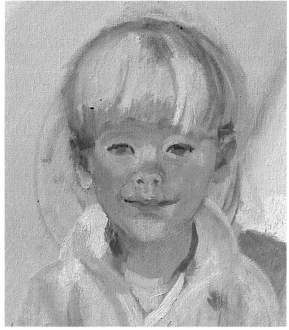

Step Two

I worked on Patrick now, trying to catch his elfin quality. I wanted to emphasize his white-blond hair and blue eyes in contrast with Robert's golden brown hair and brown eyes. For Patrick's hair I used white, lemon yellow, raw umber and a touch of cobalt blue. The yellow shirt was cadmium yellow, white and yellow ochre. His face went through three stages of development.

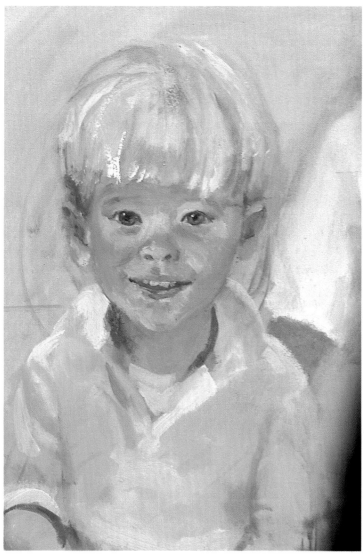

Step Three

Returning to Robert's face, the forms were developed with more subtlety, more drawing with the brush. His features were even more carefully developed. Some highlights were added to the shirt and in the eyes. The teeth were defined. A quiet blue was painted in the sky area (white, cobalt blue and yellow ochre) and some clouds added.

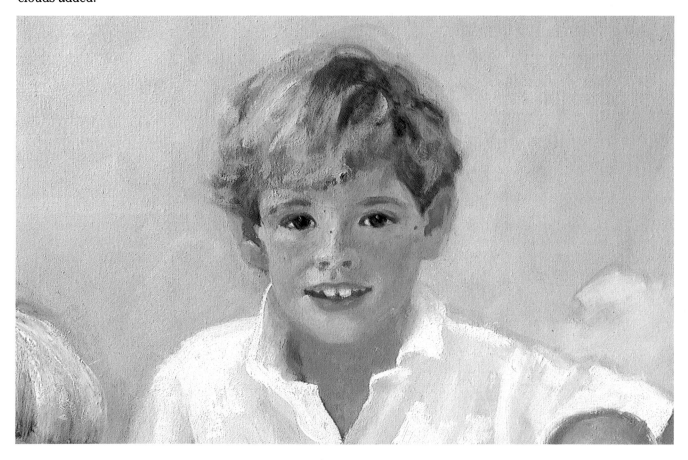

Step Four

After four days of work, it was time for me to leave their city and return home. Painting rapidly, to show the parents how the portrait would look when finished, I added these beach grasses—a big mistake! When I returned home and they were dry, I realized the grasses needed far more refinement and care in their placing. Then I had to get rid of them and I had a difficult time covering them.

Step Five

Almost every artist arrives at a place in a portrait's development where he feels *stuck*. I felt the portrait looked drab and dull—I needed to bring it to life. Taking a no. 10 bristle brush, white and thalo blue, I painted in a bright sky. The clouds were repainted with white, mixing light red and cobalt blue into it in the shadows. I repainted the water with white mixed with thalo green and a bit of ultramarine blue, then added some white waves turning over. I changed Robert's khaki shorts to red and intensified the yellow in Patrick's shirt. I began to feel better about the portrait.

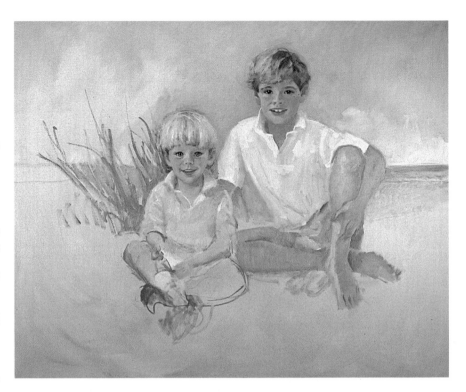

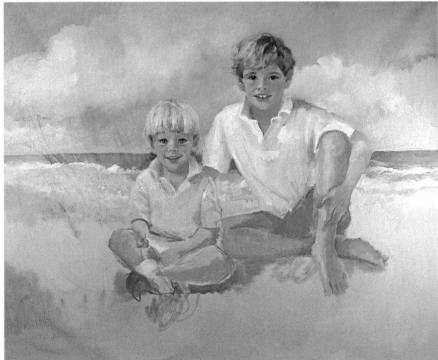

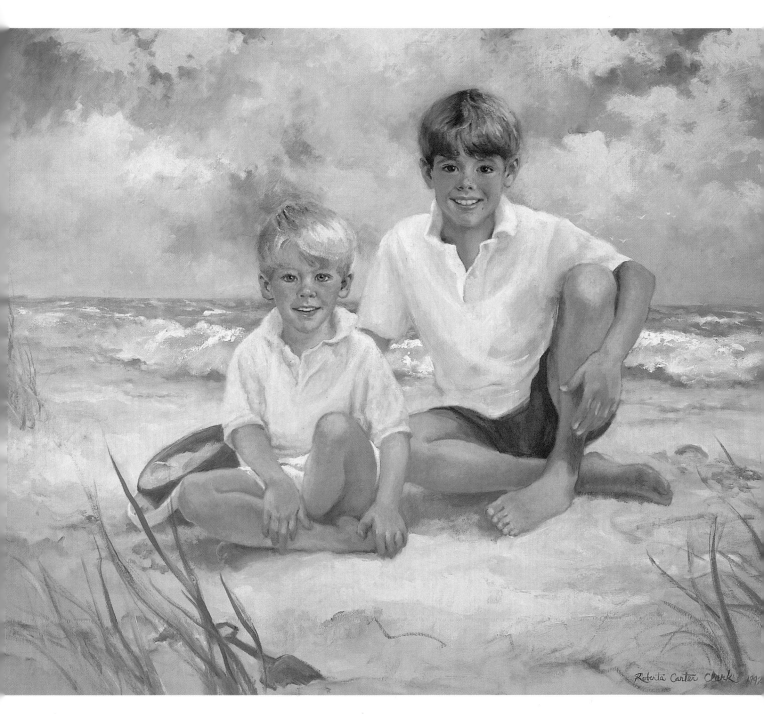

The Finish

I laid my brush across Patrick's eyes and found the right eye was lower than the left. It's not unusual to discover that features are out of alignment, especially after you've worked on the face for a while. I spent the entire day working on Patrick's face from several photographs and it began to look more like him. Then I spent a day refining Robert's face. I also worked on both boys' hands and feet.

The more I thought about adding the beach grasses the less confident I felt; I could ruin the portrait if they were not exactly right. Adding more activity to the sky seemed a better idea. I kept thinking it would have to be windy at the beach, and trying to get this moving feeling in the clouds was really fun. It took a whole day to repaint the sky and resolve the light on the figures. At last I decided the portrait was finished. This was not an easy portrait because I had only my photos to work from at the finish and I'd never seen these boys at the beach! Lots of trial and error on this painting.

Patrick and Robert, ages 3 and 7
Oil on canvas
40″ × 50″
Collection of Mr. and Mrs. Robert Glover

Demonstration Three
A Formal Portrait in Oils

Aurie

Aurie was five years old when I painted her portrait. I took many photographs of Aurie in different poses, different dresses. I liked the simplicity of this dress. I almost always prefer very young-looking dresses on little girls; dresses without waistlines appear more youthful. I chose three photographs for their poses, drew my sketches, and this pose was the parents' first choice.

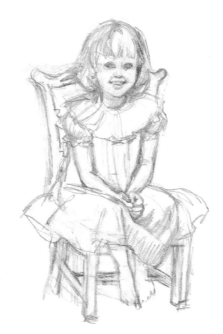

Step One

Aurie's mother likes any color as long as it's blue. I tried to please her by choosing the palest of blue dresses and a blue background. After stretching the canvas, I started with an imprimatura made up of ultramarine blue, light blue-violet, and cerulean blue, cut a bit with light red, an earth red.

Then with a no. 6 filbert bristle brush and raw sienna oil paint, I placed the figure on the canvas, using the sketch, the photograph, and a few brief poses from Aurie, a very lively child. I drew the head and laid in some basic fleshtones with a mixture of titanium white, yellow ochre and scarlet lake. Scarlet lake is a very powerful color; you'll need only a tiny amount in flesh mixtures. If it's too intense, switch to light red, the earth color. I used white, yellow ochre, raw sienna and raw umber for the hair. Lines suggested the shoulders and the body.

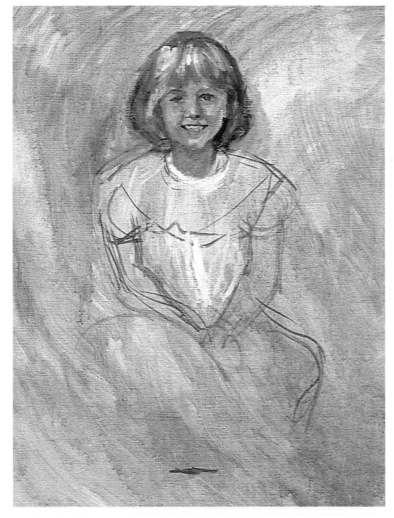

Step Two

I popped in the dark of the chair, which would be my darkest dark, and the whites in the collar, my lightest lights. Then I painted the flesh colors where the arms, hands and feet would be. I began to define the face a little more with a little darker mixture of white, raw sienna and scarlet lake. I used a touch of cobalt blue for the shadows. The shape of the face was defined by the darks of the hair, and using a no. 2 filbert bristle brush, I worked at refining the features. I added a few muted greens to the right of her head to help me establish a midtone value and to get another color into the painting. I kept the photograph I was using for reference taped on the canvas and had a few short poses of perhaps ten or fifteen minutes each from Aurie.

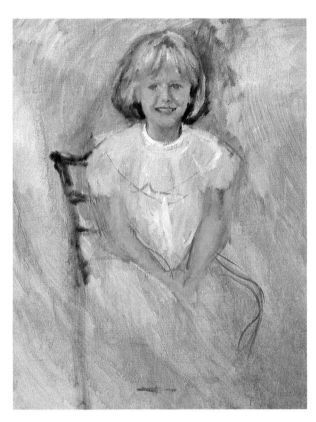

Step Three

I spent considerable time concentrating on the face. It is all too easy to get the portrait to look like any anonymous little blond girl. The difficulty lies in getting the exact combination of marks on the canvas that will make it look like *this* little blond girl. And analyzing her face over and over in your mind . . . Is her mouth a little wider? Her nose a little shorter? It helps to get away from the painting after an hour or two of intense effort. Or move it to another room and study it. Looking at it in a mirror helps too. Anything that will allow you to see it objectively is useful.

Remember, I do have my photographs for reference, and I am painting in Aurie's house, so even though she may not be posing, she does run in and out of the room and talk with me. I feel I get my best and fastest results working this way, i.e., from photos *and* from life.

Step Four

I took a few close-up photos of Aurie's hands and pushed hard to finish the dress, the chair, the arms and hands. To make the head stand out I painted a strong dark behind the light side of Aurie's head. In the beginning I was dead set against starting with the blue wash, but now I see this has given me a distinct advantage: The imprimatura needs only minimal attention and it becomes the background.

I stuffed the dress with a pillow and towels and sat it up to "pose." Then I worked on the detail on the collar and sleeves, the pale colors in the pattern on the dress, and the folds. From the photographs I added the feet and the light and shadow on them. The head might be finished. But does it really look like her?

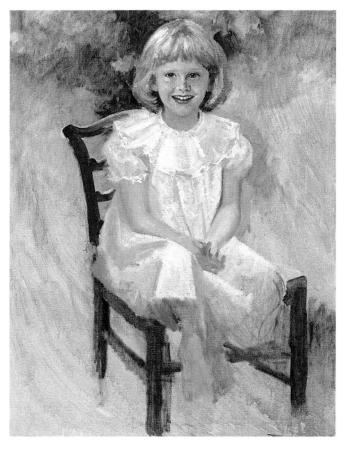

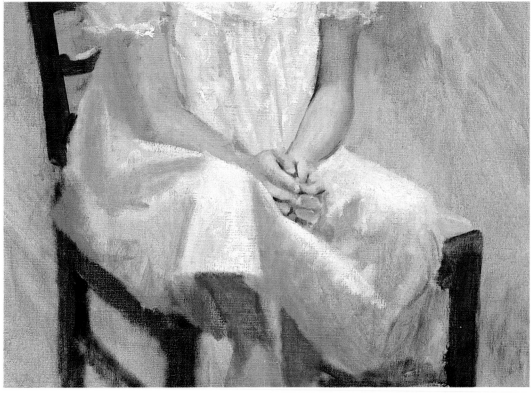

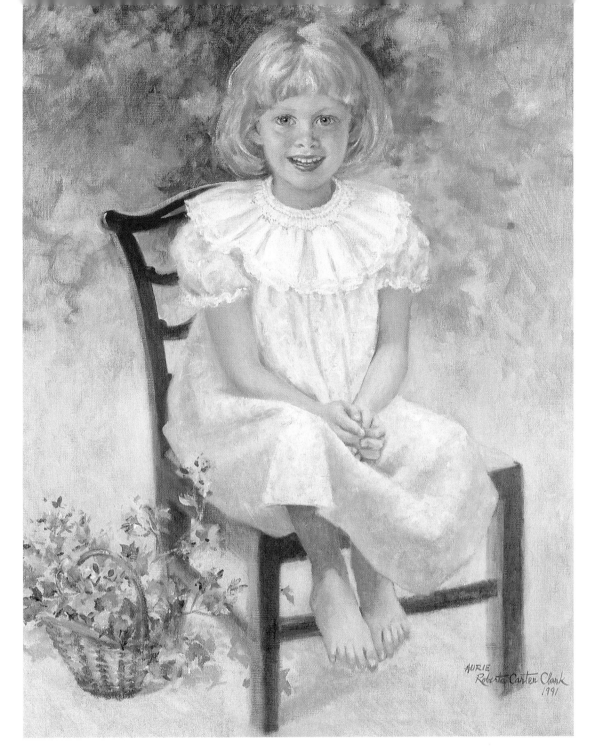

The Finish

On the day Aurie's portrait was to be completed, I decided the painting needed more weight at the level of the floor to anchor the chair. My solution was to add this small, delicate — but dark — basket with airy little flowers overlapping the chair and Aurie's dress a bit.

The slight shadow created by the front leg of the chair prevents the whole image from floating in blue air. By the same token I softened the end of the chair leg at the right and avoided getting into heavy dark shadows under the chair. Looking back at the sketch you will see that I lowered the back of the chair so it would intersect with Aurie's head and shoulders in a better way.

Finally I worked on Aurie's face. Now it really *does* look like her. Hooray! This was not easy as she was no longer interested in posing. We wheedled a few minutes out of her here and there throughout the day and the portrait was finished.

Aurie, age 5
Oil on canvas
36″ × 28″
Collection of Mr. and Mrs. Brant Davis

Demonstration Four
A Four Year Old in Pastels

Jay

Step One

It had already been decided that I should paint Jay in the same outfit—the white shirt and gray lederhosen—that his brothers, Will and Richard, had worn in earlier portraits I had painted when they were four years old. (These boys are all shown much more grown up in Chapter One.)

Starting this portrait of Jay from a photograph I had taken, I sketched in the head and shoulders with a sandalwood color Nupastel stick on sanded pastel paper. Using this same color, I laid in the shadow areas on Jay's face and placed the features, not even thinking about finishing any one part of the face. I drew in the white of the collar with white soft pastel and sketched in the straps over the shoulders.

Step Two

Using Grumbacher Flesh Ochre soft pastel, I placed the light areas in the flesh. The hair was sketched in with Nupastel Van Dyke Brown in the darks and with Flesh Ochre in the lights.

Step Three

I began to define the features with Nupastel sandalwood and Carb-Othello pastel pencil in dark ochre (just about the most useful color in their line for the portrait artist, a middle value golden brown).

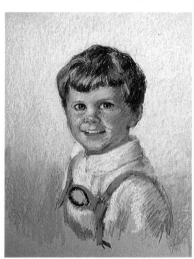

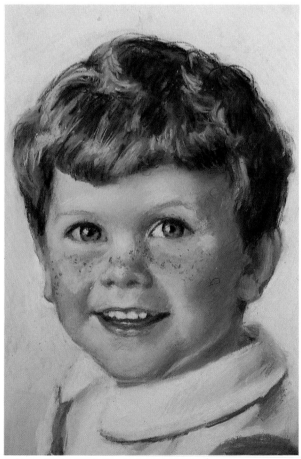

The Finish

When the portrait was this far along I had Jay's mother bring him to my studio and I finished the portrait from life. This is my favorite way to do a pastel portrait.

I spent time defining all the features, bringing them more into focus, hitting the highlights and the accents harder. I added sanguine Conté crayon touches to the eyes, nose and mouth, making them warmer. Then I went over the teeth and their outline carefully. Using the dark ochre pastel pencil, I sprinkled a few freckles on Jay's nose and cheeks. This has to be done carefully so they don't look like spots. The red trim around the collar helped tremendously, and so did the embroidered flowers. I added more pigment to the background and smoothed it out a bit with my fingers, but I don't blend the face and hair with anything. You can "kill" a pastel portrait with overblending in the skin; it takes on a rubbery or plastic look. This head and shoulders portrait was finished in three days, half the time of an oil portrait.

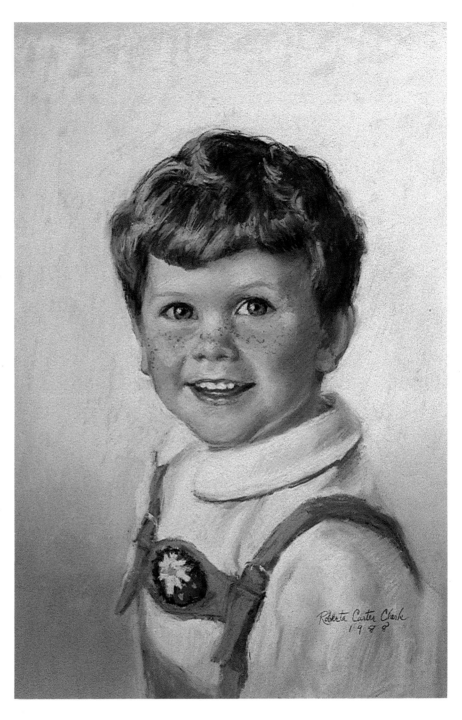

Jay, age 4
Pastel on sanded pastel paper
16″ × 12″
Collection of Mr. and Mrs. Peter Beekman

Demonstration Five
A Pair of Portraits in Oils

Carolyn and Gordon

It's hard to believe that both of these portraits were painted in one week. Gordon, age fourteen, and his sister, Carolyn, age sixteen, alternated posing periods. I didn't have to take photographs because they were old enough to pose. Their mother has an excellent sense of style and she greeted me with a fashion advertisement from a magazine as an idea for a pose for Carolyn. Originally I was concerned because her upper body was turned so far around, but now I really like both of these portraits immensely.

Step One—Carolyn

The painting was started with my customary raw sienna imprimatura. Then came the placement and the drawing of the figure on the canvas with a no. 6 filbert bristle brush and more raw sienna. My first consideration was the darkest dark, the mass of Carolyn's hair, and the lightest light, the white collar next to it. I laid in a neutral warm tan on the sofa and made the sofa arm round to integrate it into the spiraling design movement in the painting. In actuality, the sofa arm was square. The diagonal placement of the pillow shape also contributed to this movement. Then I roughly dashed in some reddish flowers behind Carolyn's head and defined her head shape with a mix of white, cobalt and a touch of yellow ochre, which I hoped would be an airy blue background.

Step One—Gordon

Gordon is an avid baseball player and an all-around athlete. I wanted his pose to convey his youthful masculinity. His mother was a bit perturbed when I used such a prosaic chair but the color, texture and height were just right for me. The procedure for Gordon's portrait was the same as for Carolyn's: first, the drawing with the brush and raw sienna oil paint, then the painting of the darkest dark, Gordon's hair, with burnt sienna and ultramarine blue and the lightest light, the shirt collar next to his face, with white, cobalt and ultramarine blue.

Next, I went right into the flesh areas. Many color combinations work for fleshtones. Titanium white, raw sienna, light red and cobalt blue make a fine flesh color family to start you off. I used white and raw sienna to lay in the light areas and added a touch of light red to make him look healthier. After the fleshtones I added more of the light blue of the shirt and the deep red of the knitted tie. Even that tiny dark of his belt was important for an accent. The watch helped give me the rounded form of the wrist.

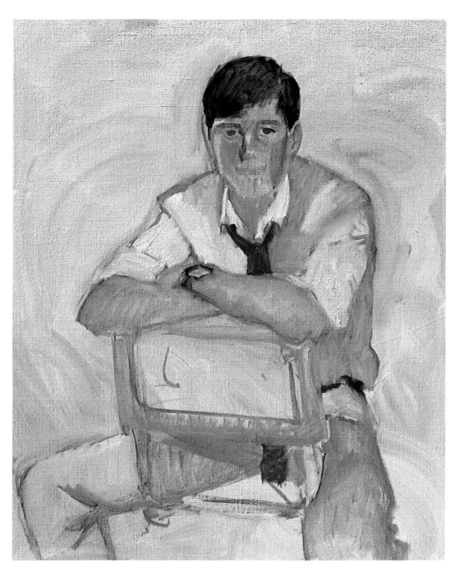

Step Two—Carolyn

In this stage, I worked mostly on Carolyn's face. She looks quite sophisticated for her age—young ladies often grow up fast—and I was trying hard to keep her youthful and not too glamorous.

There was lovely daylight flooding in from a large window high above and behind Carolyn and I caught this back-lighting effect with soft pale blues on her hair. This light is also used to advantage on the right side of Gordon's cheek (see below). I spread this light around in the background and eliminated the red flowers, which were making my painting unnecessarily fussy.

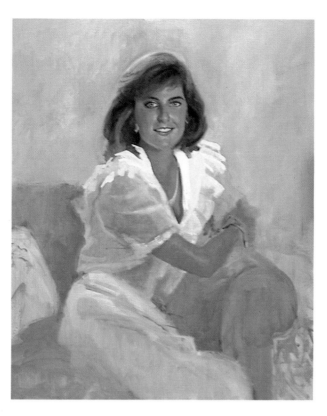

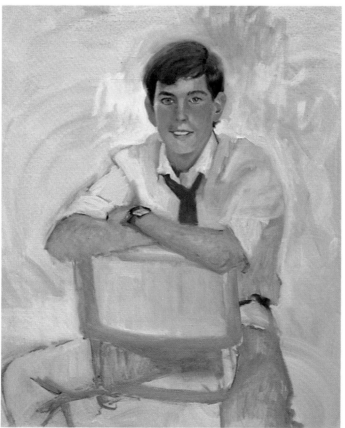

Step Two—Gordon

I began to develop Gordon's facial features. Working with as large a brush as possible, a no. 6 filbert bristle, I modeled the structure of the face, the forehead, nose and chin. I changed to a no. 2 brush for working on the eyes, mouth, ears and details of the nose. I added cobalt blue to the fleshtones in the shadow areas, then laid in with a bluish tone the narrow strip where the light turns into the shadows. Gordon's dark eyebrows made a beautiful design on his handsome face.

I love painting anyone with dark hair. It's so much easier than light hair because the shapes are so clearly defined. I just squint my eyes and look through my eyelashes and there they are.

More work went into the shirt, particularly the collar, and I eliminated the red tie showing below the back of the chair.

I defined the head shape by painting the greenish-white background around the head and shoulders with a larger brush, a no. 10 bristle.

Step Three—Carolyn

This may appear to be a relaxed pose but the twist in her body made it difficult for Carolyn to hold. We propped her up with pillows at her back. The addition of the second pillow made a far better shape than when her body was isolated and surrounded by sofa. Here the darks on either side of her skirt are emphasized to give her body form.

I used the light from the window to define the top plane of the arm— not so easy to draw in this position. Outdoors I found some sprigs of impatiens, a nice sort of irregular plant.

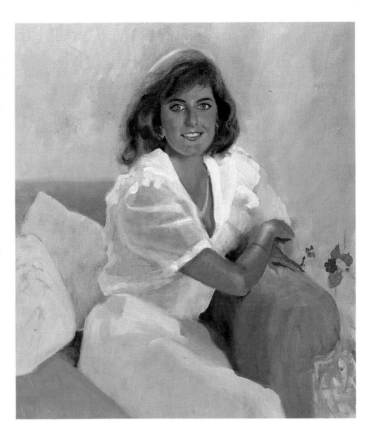

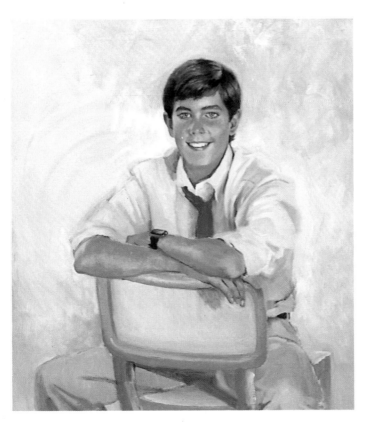

Step Three—Gordon

Finer and finer adjustments were made on Gordon's face until his steadfast gaze and natural smile emerged. The folds in the shirt and its sleeves were emphasized to convey the roundness and foreshortening of his left arm. Gordon posed while I painted the folds of the pants so that the left knee would project right at me. It is best to paint all those folds in one posing period if possible because the folds change every time the wearer gets up or sits down again.

I felt the painting lacked detail with neither hand showing so I added the fingers on Gordon's right hand and the shadow cast on the chair's back panel. The top planes and side planes of his arms were defined next, along with the bony protrusion of the elbows.

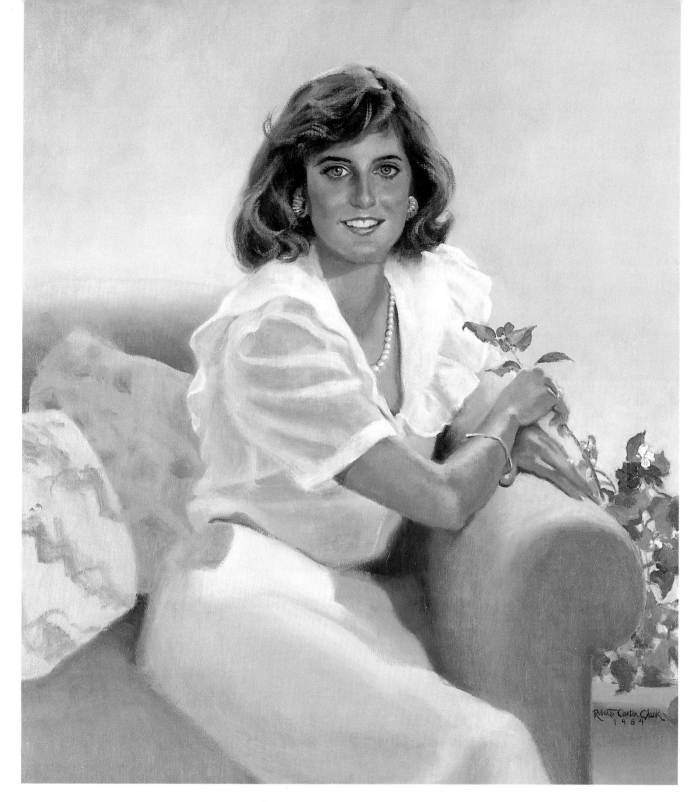

The Finish—Carolyn

I put all the finishing touches on Carolyn's face. You can see I tidied up her hair and worked on the string of pearls. Quiet colors made enriching patterns on the pillows. A touch of strong color, a green-blue, suggested a belt. I purposely painted it rather seen-and-not-seen so as not to cut the body in two. The back of the sofa, at the top, was softened—nearly obliterated—so that it would recede. The impatiens was designed to overlap Carolyn's collar and left sleeve, helping to push that shoulder and arm back. I "planted" the flowers in a clay pot, cleaned up the background, and the portrait was finished.

Carolyn, age 16
Oil on canvas
38″ × 32″
Collection of Mr. and Mrs. Harrison Jones II

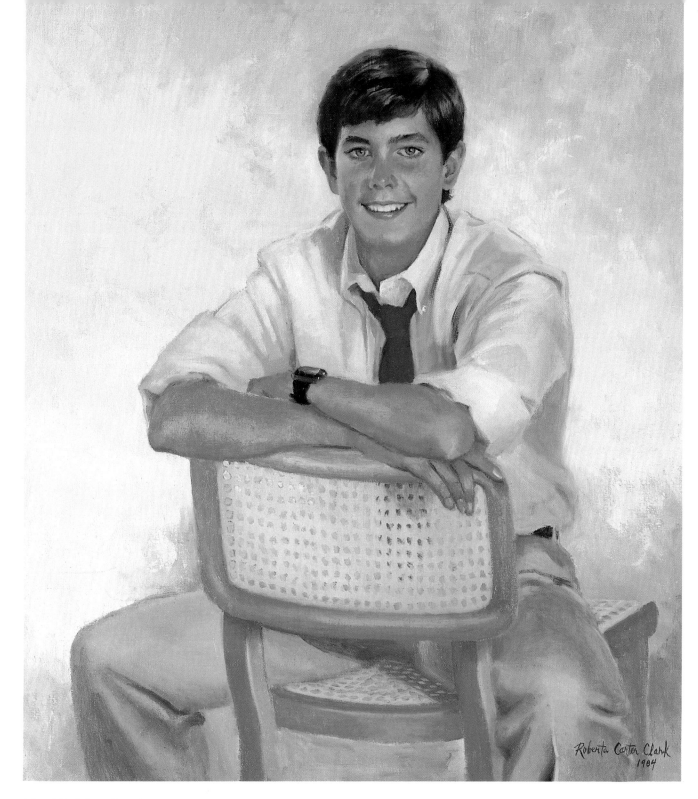

The Finish – Gordon

The background was kept simple. I
added some light greens at the top
and grayed down the greens behind
Gordon's waist and the lower half of
his figure. In painting the back-
ground, I gave careful attention to all
the edges of the figure. I had great
fun painting the caning on the chair,
especially where the blue shirt and
red tie were visible through the small
"holes."

Gordon, age 14
Oil on canvas
38″ × 32″
Collection of Mr. and Mrs. Harrison Jones II

An Oil Portrait From a Photograph

Grace

In this demonstration I worked only from a photograph. I chose the snapshot because it had so much life in it and I thought it would make a wonderful portrait of four-year-old Grace in her Easter hat.

Step One

I gave the stretched canvas a raw sienna imprimatura and drew the figure with a no. 6 filbert bristle brush and more raw sienna. With a paper towel I wiped out the light on Grace's left cheek. I scrubbed in a dark mixed from burnt sienna and ultramarine blue on the hair, cobalt blue on the dress, and sap green for the background.

Step Two

I added titanium white to the hat and the light area on the collar, and a mix of white with cerulean blue to the shadow area of the hat and collar, allowing some raw sienna to glow through. I redrew the features with raw sienna and burnt umber. Painting a few fleshtones of white, raw sienna and scarlet lake on the face, I took care not to get the skin too pink. I toned the face down with light blues. Grace came to visit after this step so I could really check the skin tones. Mine were definitely too cool, too grayed. Her complexion, I thought, was a creamy golden brown rather than yellow or pinkish. I could see no blue in the shadows, maybe violet.

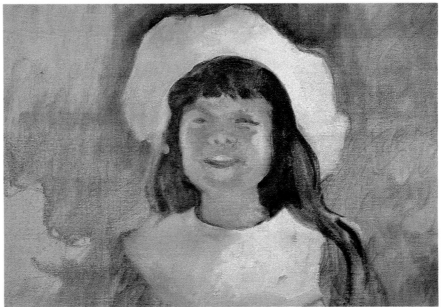

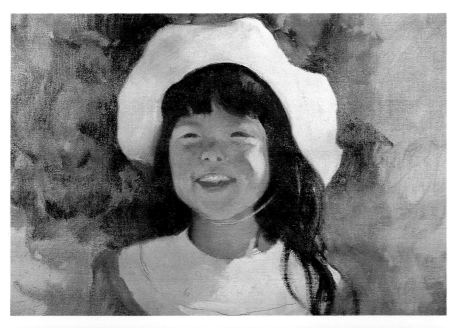

Step Three

After seeing her, I believed I could take a few chances with Grace's skin color because most of the face in the photo was lighted with reflected light. I used titanium white, raw sienna and cadmium orange, adding a little scarlet lake on the cheeks. To make the hat look very white, I darkened the background with sap green, ultramarine blue and burnt umber and *no* white. I kept the brushstrokes rough and uneven so some of the raw sienna imprimatura would peek through and contribute to the feeling of sun breaking through dense foliage.

I made Grace's hair as dark as I could with ivory black, alizarin crimson and ultramarine blue, then painted a white and cobalt blue mixture on the shadowed area of the collar. The bright lights on her face were painted with titanium white with a touch of orange to warm it. You can't paint sunshine with cool whites.

The Finish

After refining the shape of the hat I painted the small openings in the hat brim, so necessary for allowing the sunlit spots on Grace's hair and face. I worked some orange and white reflections of the fleshtones into the cool shadows on the collar. I had to wait until the white collar dried before I could paint the strands of hair over it. I did so want the portrait to have Grace's sparkle!

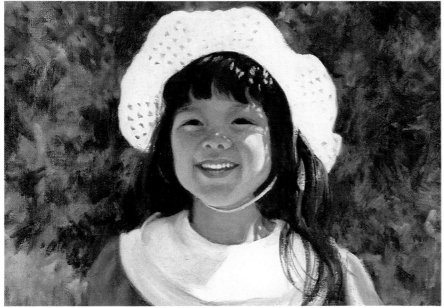

Grace, age 4, in Her Easter Hat
Oil on canvas
18″ × 20″

A Watercolor Portrait From a Photo

Julie and Her Dolls

This watercolor was painted from a photograph I took some time ago of Julie when I painted her portrait in pastel. She was four at the time. It is transparent watercolor on 140-lb. Arches paper.

Step One

The first step was the pencil drawing done on heavy tracing paper. After I traced my drawing onto the water-color paper, I started the painting process. I wanted the viewer to be able to differentiate between the skin tones of Julie and each of her dolls. The doll on the left, which had orange hair, was painted with a mix of aliza-rin crimson and yellow ochre. The baby doll on the right was painted with a very pale mix of these same colors, but less pinkish. Julie's skin tones required a warm glow, so I used a mix of yellow ochre and scarlet lake, occasionally cooled with ceru-lean blue. I painted at least three washes on her flesh areas, allowing each one to dry before applying the next.

I painted the baby doll's dress with cobalt blue and her high chair with raw sienna and raw umber. Then I used new gamboge for the yellow cushion on the chair in the background.

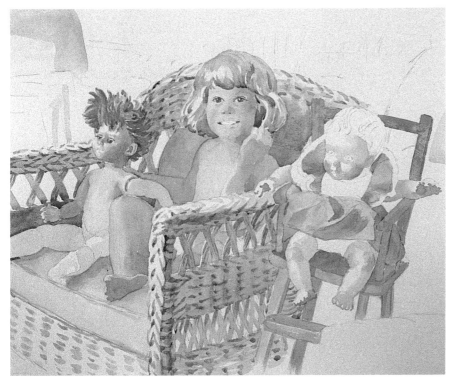

Step Two

The grays in the wicker chair were painted with cerulean blue and burnt umber. The orange hair came next, then Julie's hair, made with yellow ochre, raw sienna and cerulean blue laid on one color at a time. The lightest lights in Julie's hair are the white of untouched paper.

Step Three

Next I painted Julie's face and features and added more washes of raw sienna, scarlet lake and a touch of cerulean blue as a shadow tone to her face and her torso, arms and legs, hands and feet.

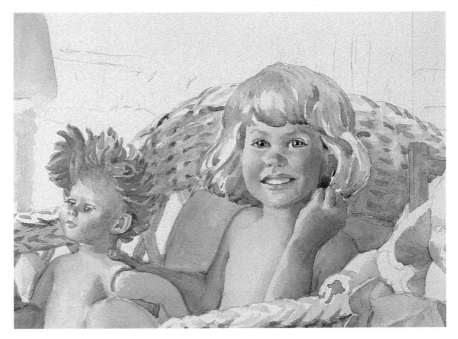

Step Four

I had to concentrate to keep all the white wicker furniture in order — which chair was in front of which, and so on — when I painted it. I stayed with cerulean blue and burnt umber in varying intensities and in various layers.

Keeping all the colors pale, I painted the baby doll's head.

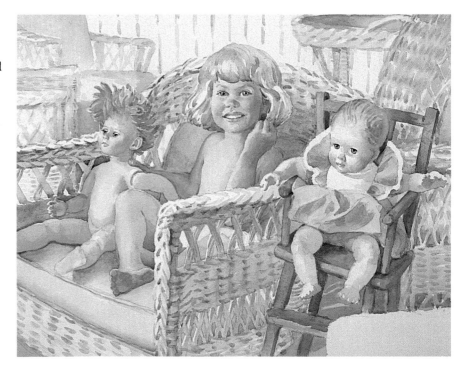

Step Five

The table behind the chairs was in the photograph, but after I put it in the painting I didn't like it. I lifted it out with a cosmetic sponge, then repainted that area. Who says you can't change a watercolor?

It seemed to me the porch railing at the back wasn't really working, so I added the various greens, made up of olive green, raw sienna and cerulean blue, which were allowed to mix on the paper rather than the palette.

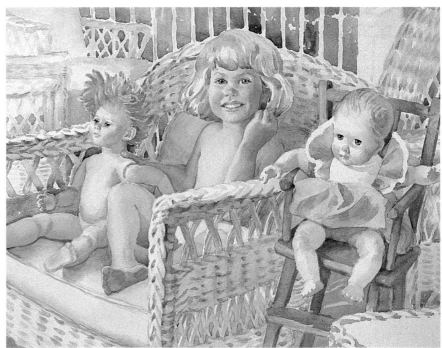

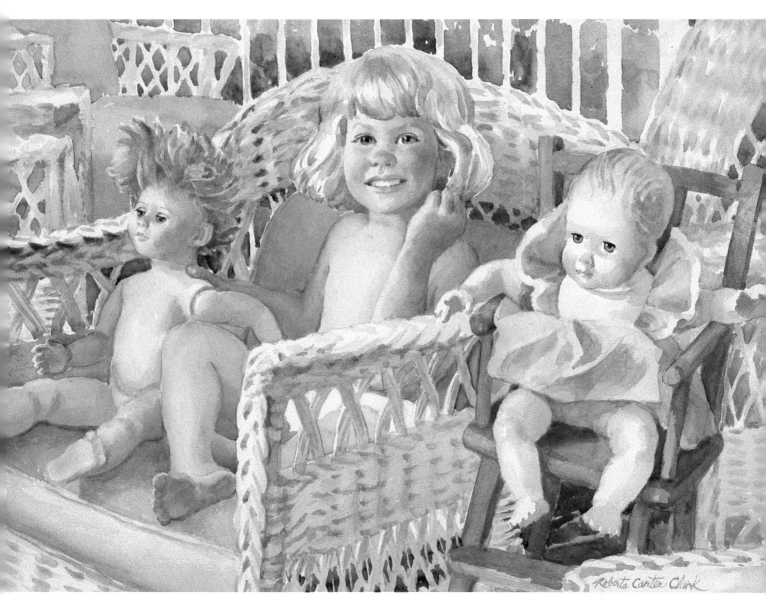

The Finish

After setting the painting aside for a few days I could see it with a fresh eye. It looked weak to me. I intensified all the yellow cushions with more new gamboge, adding yellow ochre and cerulean blue in the darker areas. Then I cut two inches off the bottom of the painting, allowing more attention to be focused on the heads. I added just a little more color to Julie's eyes and the painting was finished. I like this portrait because it is so different. It was quite a challenge with all that's going on in it, and Julie's pale hair made it even more so.

Julie, age 4, and Her Dolls
Transparent watercolor on 140-lb. Arches cold-press paper
18½" × 25"

Other Artists' Approaches

Painting from other artists' work is a valid and traditional way of learning. In this section I have selected four painters of children's portraits whom I admire and painted small studies from their portraits. You may enjoy working from the portraits of children painted by some of your favorite artists. Researching the painters and their methods at your library or museum can help you realize your own goals, but *painting* from their work is far more instructive than looking at their pictures or reading about their techniques. By the way, art calendars are a great source of excellent large reproductions to add to your files.

Pierre-Auguste Renoir (1841-1919)

This beautiful study of a child's head is from *Madame Charpentier and Her Daughters*, a 60 × 74-inch oil portrait in the Metropolitan Museum of Art in New York City. At the start of his career Renoir painted on porcelain, and throughout his life many of his paintings had that translucent glow of glazes applied in numerous small strokes. The images were built up slowly and it is said he took forty sittings for this family portrait of a mother with her two daughters. Georgette, this little girl, was six years old and sits on the back of a St. Bernard dog in the portrait!

Painting this little head from a reproduction made me more aware of Renoir's aims. He did not bother with highlights in the eye and shadows under the chin. Nor was he interested in painting a head that looked three-dimensional in the conventional sense. He wanted to achieve in paint the delicate translucency of the child's skin and the shimmer of her lovely hair and lacy dress. Renoir's way of working looks easy, but I learned it is considerably more difficult than it appears. The main lesson I learned from this study was to keep the fleshtones extremely light and uncomplicated.

Oil study after Pierre-Auguste Renoir
Oil on canvas paper
12″ × 9″

John Singer Sargent (1856-1925)

Certainly this American artist was one of the greatest portrait painters who ever lived. Sargent was educated in Europe. His family traveled constantly, and he was twenty years old before he even visited the United States. He liked to paint what he could see, not from his imagination or fantasy, which seems to me just about perfect for a portrait painter. Sargent's vision was selective. If something didn't help to make his painting more elegant, he didn't include it. He never painted any detail just because it was there. It is said he could be charming with children, natural and easy, without talking down to them.

My study is from an oil portrait of Miss Helen Sears that Sargent painted in 1895. This sensitive and striking painting is large, 65¾ × 35¾ inches, and presently hangs in the Museum of Fine Arts in Boston. Any number of artists have painted children with flowers, but only Sargent could paint white dresses as brilliantly as this. The paint itself is very heavy, applied with large brushes and great flair. The dark background makes the whites shine even more. Notice how the edges of the child's hair get lost in the shadows. Doing this study taught me how a nearly black background makes all the light colors and values shine.

Oil study after John Singer Sargent
Oil on canvas paper
12″ × 9″

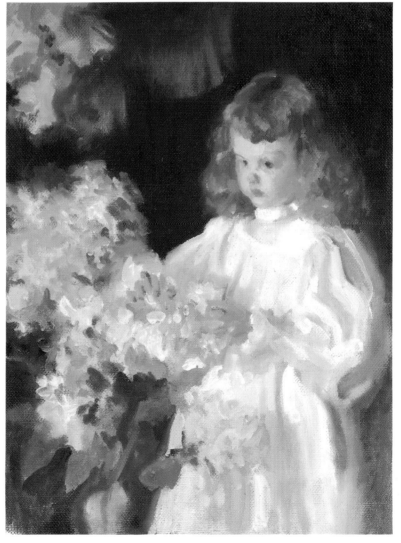

Mary Cassatt (1844-1926)

I can't recall ever seeing a Cassatt painting, drawing or print without people in it. Friends, family and neighbors were her models. Although she never married or had children of her own, her mother-and-child paintings, pastels and etchings will stand forever in the history of art.

This little study is from Mary Cassatt's *Sleepy Baby*, a 25½ × 20½-inch portrait in the Dallas Museum of Fine Art. Those of you who work in pastel will be interested in her sparkling technique, which contributes so much to the feeling of these soft delicate forms. Notice how the strokes travel *across* the forms, from side to side on the arms rather than lengthwise. Even on the torso, legs and face you will see how this direction was important to Cassatt.

The other attribute I want you to note is her shining color. I have seen only one show of this artist's work, way back in the 1960s. I remember being shocked by her use of blue in her fleshtones or as underpainting for warm flesh colors. She was a contemporary and friend of the Impressionists, all of whom were experimenting with color.

The pastel from which I made this study was painted in her mature years. She is so sure of herself; not one form is outlined. Working from this Cassatt pastel taught me how courageous she was with color, far more than I could ever be without her guidance.

Pastel study after Mary Cassatt
Buff colored sanded pastel paper
14″ × 12″

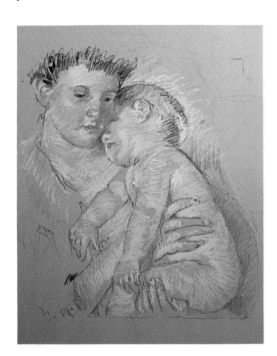

These are the colors I used in painting this pastel study. Notice how many blues there are.

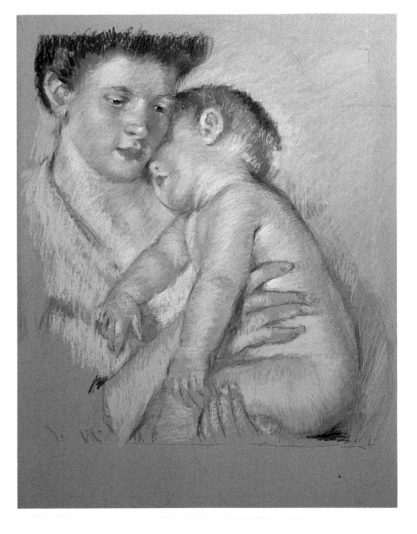

Berthé Morisot (1841-1895)

Berthé Morisot was indirectly related to Honoré Fragonard, married to the brother of Edouard Manet, and a superb artist in her own right. Like Mary Cassatt, who was her friend, she was restricted by the social conventions of her time to painting the world in her home. Her daughter, Julie, her sister and her niece were favorite subjects. Both of these artists portrayed domestic life, but Morisot did venture out to paint the landscape, and she was particularly adept at painting the figure within the landscape.

I wanted you to see this study of a girl of about twelve or thirteen because it was painted with an absolute minimum of drawing, finish, shading or rendering of solid form. It has all the immediacy and tonal simplicity of an oil sketch. The light touch and painterly brushmarks remind us of Morisot's involvement with the Impressionists and her breaking away from more academic teachings.

The face appears to be one color and value from side to side. Were eyes ever more simply painted? Painting this small oil study taught me to try to keep it simple.

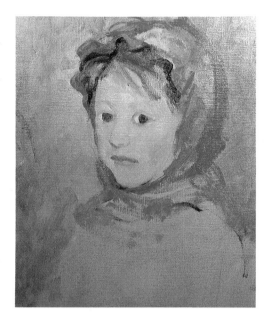

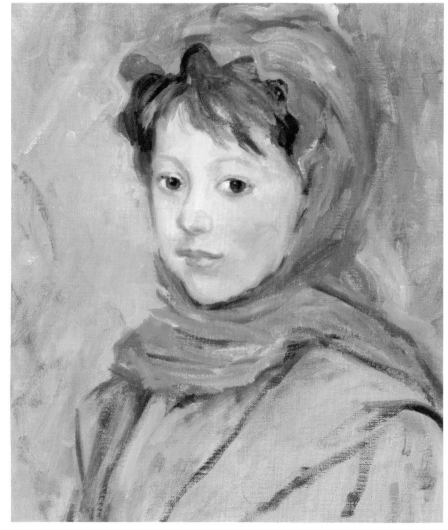

Oil study after Berthé Morisot
Oil on canvas paper
16″ × 12″
The oil colors I used here were titanium white, yellow ochre, raw sienna, scarlet lake, cadmium red medium, alizarin crimson, cobalt blue, ultramarine blue, burnt umber and ivory black.

MOLLY

Roberta Carter Clark
'99

Choosing the Pose, Size and Format

Molly, age 8
Pastel on sanded
pastel paper
40″ × 30″
Collection of Mr. and
Mrs. Charles Ballou

The pose you choose to paint has a great deal to do with the success of the portrait. It should look natural, not posed, stiff or stilted. Of course, the variety of poses available to us is endless.

When you get together for the first posing session with a child who is old enough to sit, take the time to study him from different angles. Walk around him; ask him to turn his head to the right, the left, to look over his shoulder, then straight ahead. You may want to try a different chair. Or should he stand? You'll definitely want to see him in different lights, near various windows, an open door, places where the light on the face is good.

Draw several small sketches of attitudes you find interesting. And this might be the time to take a few photographs to pin down the pose. It is worth taking the time to work with the subject to get the "right" pose. Very often the young person will become more relaxed as he begins to feel comfortable with you, and one pose will lead to another. After you have five or six sketches from which to choose, I can guarantee the sketch from the first pose will be the least interesting, which is a good reason for doing several. If you sense your subject is really getting into it, keep going and do a few more. Who knows, the best pose may be yet to come!

Very Young Children

It isn't wise to attempt unusual poses for portraits of very young children. Something that might look darling in real life could become cloying if the family has to look at it for many years. The head is usually best held straight up rather than looking back over the shoulder or cocked in a disarming way.

• For little children, a profile works if the parent is good at reading to them or talking with them to keep the child looking in the same direction for a while. (Not all parents are comfortable doing this.)

• A full face is within your reach as you are the one who entertains him. This is the most traditional pose. With tiny kids you have to be happy with what you can get.

• A three-quarter view might be more interesting, but you have to beware of getting two or three views mixed up together. You don't want to get the forehead turned to one degree and the nose to another, the chin and mouth to yet another. If you ever try this view and you get into trouble, you'll know what I mean. The face gets "twisted" and it takes everything you've got to get it right again.

Carefully align all the features with a pencil by holding it straight upright in front of the child's face and then in front of your drawing and compare what you see. Which part aligns with which other part? Are you off anywhere? Looking back over your shoulder at the child and the portrait at the same time in your hand mirror is the best check. You will know immediately if the features are out of alignment; then you can fix them.

You'll also have to decide whether to have the child in the portrait looking at you or looking away. When the painted image looks directly into the eyes of the viewer, the viewer is immediately involved. Conversely, he may feel more of an observer if the painted eyes look off into the distance or at something else. These averted eyes allow the subject to appear to be a more private person, lost in his thoughts. Neither of these approaches is right or wrong, but the effect of the portrait is definitely different.

Elizabeth, age 4, a three-quarter view in watercolor

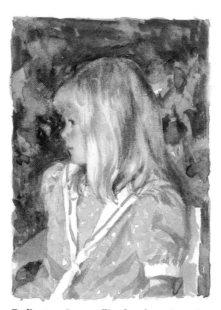

Emily, age 5, a profile view in watercolor

Ryan, age 1½
Pastel on sanded pastel paper
20″ × 16″
Collection of J.R. Hutcheson

Ryan was just eighteen months old when I painted this traditional full-face view.

Katie, age 4
Pastel on sanded pastel paper
28″ × 22″
Collection of Mr. and Mrs. George Elvin

Katie's lowered gaze lends a quiet, thoughtful feeling to this portrait.

Paired and Multiple Portraits

It is likely that you will sometime have the opportunity to paint the portraits of two children in the same family. This presents some different problems. The decision must be made about whether they should be painted together in one painting or separately. If two paintings, it is customary to paint them facing each other, i.e., one body turned somewhat toward the right, the other toward the left. (See the paired portraits of Emily and Betsy on the next two pages.) In this way the portraits will look fine together and also hold up later on, if the family should hang them in different rooms or if each person wants her own portrait when she grows up.

If the children are painted together, the artist must plan an interesting composition that shows each person off well, and the finished painting could be quite large. There will be times when there are three or four or more children to be painted together or separately, which is quite an undertaking!

There are two ways parents look at this concept of multiple portraits.

Some parents want all the children painted at the same time, the same year. Some want each child painted at the same *age*, say age four. This means all the portraits on the wall in this home will be of four year olds, no matter when the children were born. You will be brought back to the same family over and over as each child reaches that age. I have no strong feelings for or against either of these plans; it really is the parents' decision.

Layne and Slate, ages 3½ and 5
Oil on canvas
29″ × 38″
Collection of Mr. and Mrs. James D. Fluker

In this case the parents decided on *one* painting. Believe me, this portrait was not painted on the beach! It was July when I visited this family and the sand was so hot it burned our bare feet. We went out early, before the midday heat, and took some photographs. I painted small sketches of the children's heads from life indoors, then took all the material home and painted most of the portrait. The heads were finished from life at the family's home, indoors.

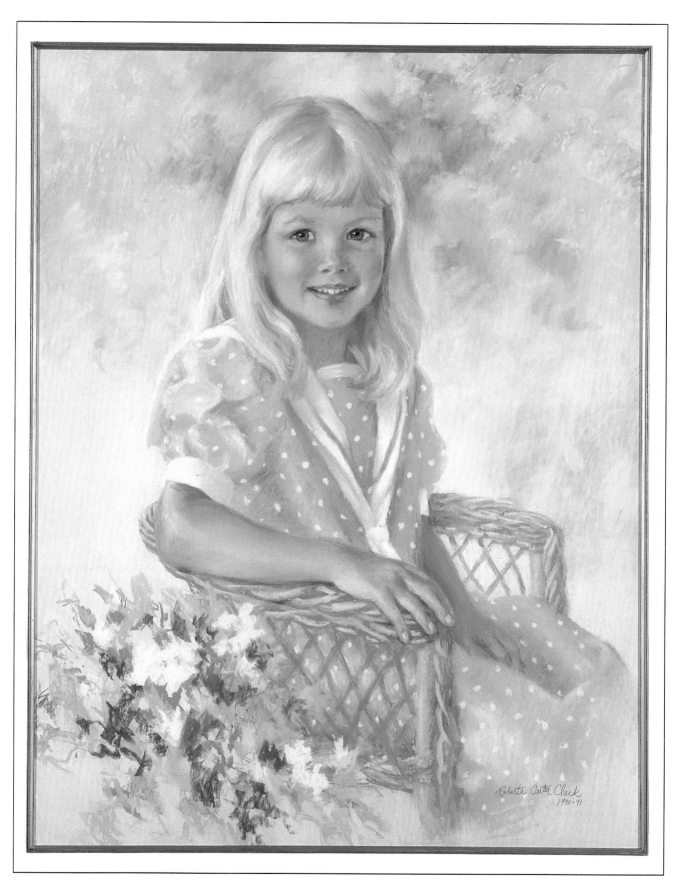

Emily, age 4½
Pastel on sanded pastel paper
28" × 22"
Collection of Mr. and Mrs. Sam Starkey

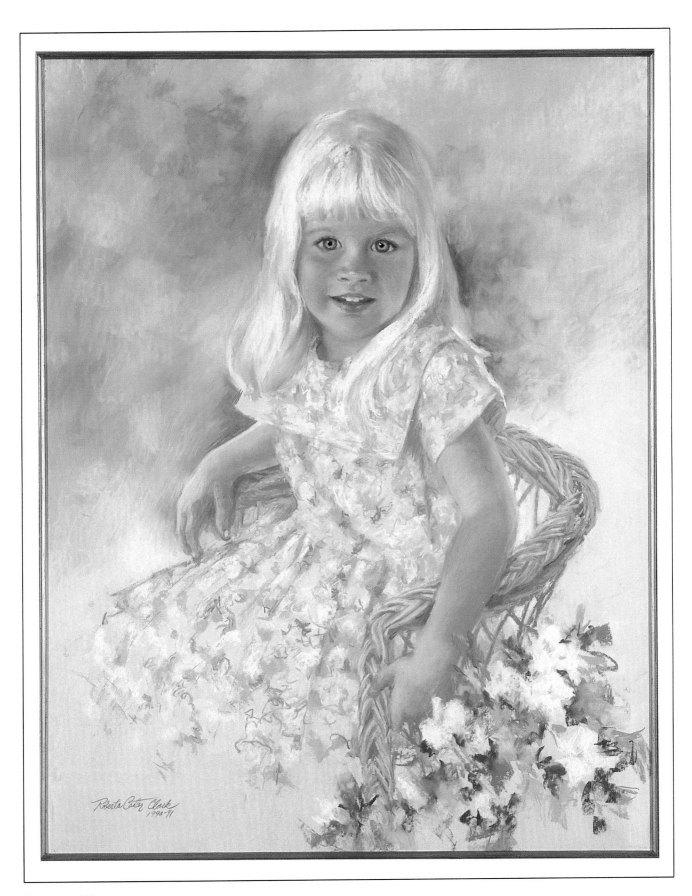

Betsy, age 3½
Pastel on sanded pastel paper
28″ × 22″
Collection of Mr. and Mrs. Sam Starkey

Using a Viewfinder

When you are thinking about the pose you will have to consider how much of the child will be in the portrait. Just the head? Down to the waist? To the knees, or to the feet? Something in the background may provide an important element as well. For instance, if the child is in a wing chair, you must decide whether to include the entire chair—which makes a painting of a large chair and a small child—or to cut the chair off somewhere. But where? One time-honored method of composing your portrait is to look through a viewfinder when studying your subject. You can make your own by cutting a rectangular $1 \times 1\frac{1}{4}$-inch opening in a piece of dark-colored paper about 5×7 inches in size. Or you can use the cardboard frame of a 35mm slide with the film removed. When you hold this twelve inches from your eyes and look at your subject, it becomes an instant frame for the figure.

You can hold it vertically or horizontally. In fact, the decision to paint the portrait as a vertical or a horizontal shape is one of the first you must make. Moved closer to your eyes, the viewfinder will allow you to see more of the figure and the surrounding area. Held at arm's length, it lets you see less of the figure, maybe only the head.

Look through this little frame as you walk around your subject. It will help you decide how much of the subject you want to include in your painting and how you want to compose it. You can block in your preliminary sketches as you look through the viewfinder. Once the basic lines are down you can set it aside and continue the drawing as usual.

Posing Outdoors

A portrait artist can get good ideas from sketching or photographing the subject against the sky, a tree, some rocks or a gate—any one or more of these could provide effective design elements for your portrait. But to paint a portrait with several days of posing outdoors is another matter. The light changes from minute to minute. The weather, wind and insects all make the job more difficult. Also, the sun's glare causes the child to squint and thereby look unnatural. For an outdoor portrait I do my sketches first, take photos second, and then paint the portrait indoors. After all, the portrait will always be in a house (we hope) and must look its best indoors, not outside.

However, painting landscapes outdoors from time to time will help you create a convincing outdoor feeling in your work whenever you want it. The outdoor light is totally different and you do have to practice as it is virtually impossible for anyone to paint a true landscape from a photograph if they have never painted from nature.

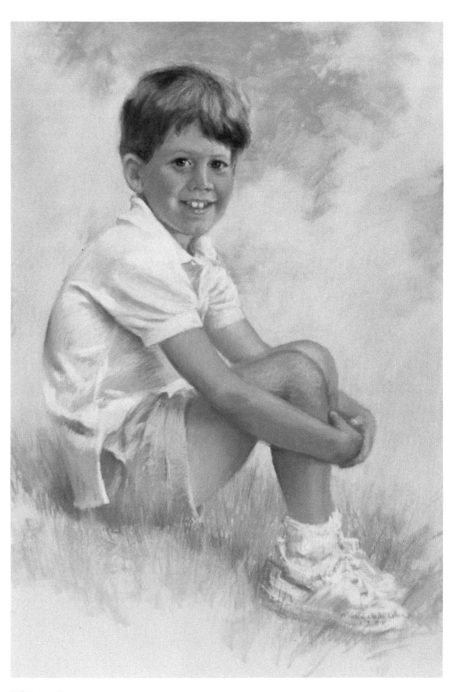

Witt, **age 7**
Pastel on sanded pastel paper
28″ × 22″
Collection of Mr. and Mrs. Charles F. Hance

Deciding on the Size

The pose is frequently determined by the size of the canvas. For instance, if the parent has already made the decision to have the portrait over the fireplace, and the mantel is quite high, you have two choices: You can paint a smaller portrait in a vertical format, or you can use the space available and design a larger portrait in a horizontal format—not an easy task when you're designing a portrait of a single person in a horizontal shape. After all, you can't paint the subject lying down! (Not usually, anyway.) This means you might have to utilize a good bit of background. At any rate, it is a problem you will have to plan for before you start. Don't forget to allow enough space for the frame, plus a few inches around the frame so it won't touch the ceiling or the mantel.

On the other hand, the size is sometimes determined by the pose. For example, when you are sketching the child, you may discover one pose so superior to the others that you'll want to select the right size paper or canvas to accommodate that pose. Of course, this is the most desirable way to work, painting the portrait the size you want it rather than choosing a size to fit a particular space. But you owe it to yourself to see where the portrait will be hung *before* you do anything else. Otherwise, you may never know how the portrait will look in its final setting.

When you are painting portraits for someone else, they will surely present their ideas about what they want. Most of the time the people you'll be working with will know very little about art and have very little feeling for what makes a good portrait. When you take on the job of painting their child or children, it is your responsibility to give them the best painting you can make portraying a person they love. Take the time to think through your ideas on the size and format of the painting before you begin any of it, then present your ideas in a clear and confident manner. I don't mean you shouldn't consider their wishes, but you have to act like you know what you are doing. They'll respect you for it.

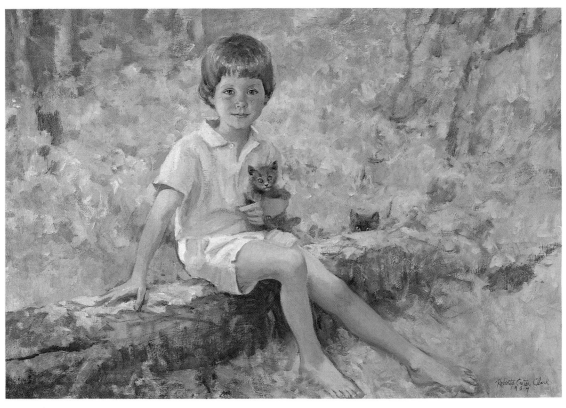

Bonneau, age 5
Oil on canvas
32″ × 48″
Collection of Mr. and Mrs. Bonneau Ansley Jr.

This portrait was pure joy to paint because Bonneau was so cooperative. His mother bought the kittens for the portrait, and he posed outdoors first for photographs. I painted the portrait indoors with Bonneau scrambling up to sit on top of a chest so he could be at my eye level and stretch out his leg.

Specific Sizes

There are many reasons why a particular size portrait may be selected over another. To see more of the child: for instance, head and shoulders, head and hands, or head, hands and knees. Or to show a beautiful or meaningful background. Or because a certain size may be needed for a specific area in the home. Perhaps the parents want the portrait to hang in the area with another portrait already finished. Here are some suggestions for choosing an appropriate size.

• A 14 × 18-inch size can be almost completely filled up by the head and shoulders of a child. In Richard's portrait, at right, his clothes and the top of his head are touching, or nearly touching, all four edges of the paper.

• A 16 × 20-inch canvas can comfortably accommodate the head and shoulders of a child. Kristina's portrait has quite a lot of background left untouched.

• A 20 × 24-inch canvas is large enough for the figure of a young child seated and allows the head to be the proper size on the canvas (see Sabrina's portrait, right). It looks right over a desk or a piano but one painting this size is too small over a sofa; a pair of portraits this size could be used there. Even three portraits this size look all right in a large room.

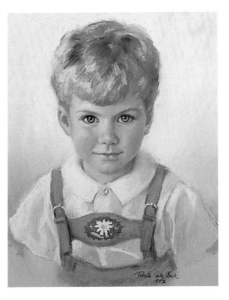

Richard, age 4
Pastel on sanded pastel paper
18″ × 14″
Collection of Mr. and Mrs. Peter Beekman

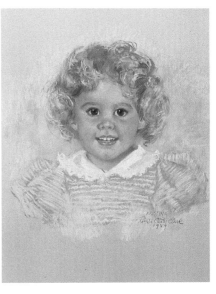

Kristina, age 3
Pastel on sanded pastel paper
20″ × 16″
Collection of Mr. and Mrs. Mark Mahoney

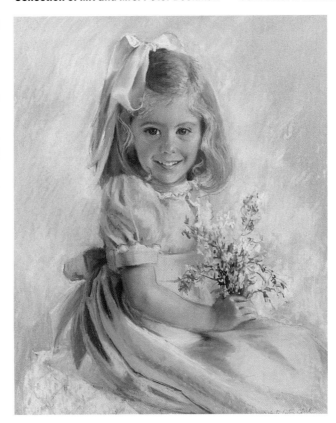

Sabrina, age 4
Pastel on sanded pastel paper
24″ × 20″
Collection of Mr. and Mrs. David Killebrew

• A 24 × 30-inch canvas is a size that has been used for many years. A half-figure, such as C.B. with his dog Shanghai, or a seated figure shown in its entirety, such as Lauren or Sarah, looks comfortable in this size. A 24 × 30-inch is better over a sofa than a 20 × 24. This size is too large for a pair when hung together, except in a very large room, but very good when hung on opposite walls or on either side of a doorway.

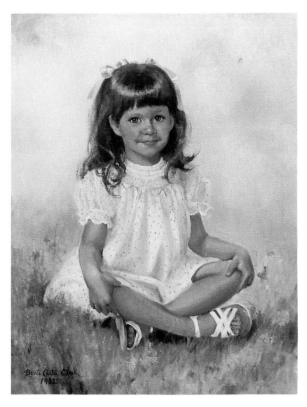

Lauren, age 4
Oil on canvas
30″ × 24″
Collection of Mr. and Mrs. Bussey Bonner

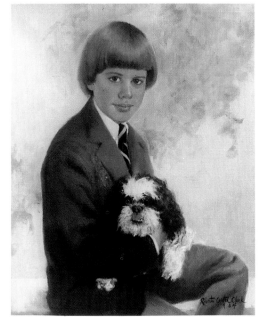

C.B., age 10, and Shanghai
Oil on canvas
30″ × 24″
Collection of Mr. and Mrs. Carter Booth

I was apprehensive about the jacket, but Shanghai, who *hated* posing, saved the day by breaking up the large dark mass.

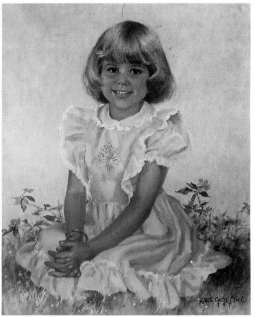

Sarah, age 6
Oil on canvas
30″ × 24″
Collection of Mr. and Mrs. Carter Booth

• A 30 × 36-inch or larger canvas is a *large* painting. A young child could be shown standing full length in this size, or an older child could be seated and the knees included, as in Edie's portrait.

• Even square compositions are fun to do for a change. The head-and-shoulders portrait of Day worked well as a square.

Please realize that all these measurements are standard sizes, but they give you and the parents a place to start when you are making this important decision about size. Two inches added in either or both dimensions can make all the difference in a portrait you want to paint.

When a family is trying to decide on the best sized portrait for their home, I find it very helpful to cut a piece of brown wrapping paper to the size we are considering and then tape it up on the wall where the portrait will hang. It can be left there for a day or two until the family can decide if it is too small, too large, or just right. Any steps you take to avoid problems further along are worthwhile. A little extra care taken now, at the beginning, makes for happy relationships later.

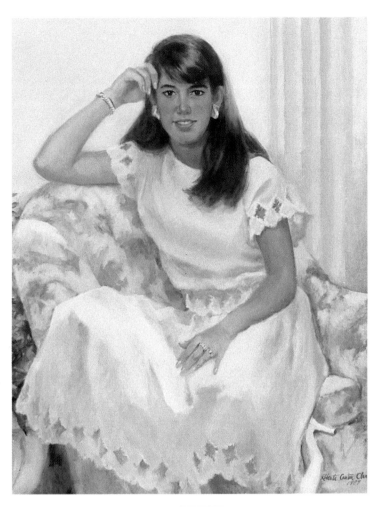

Edie, 15 years old
Oil on canvas
42" × 36"
Collection of Mr. and Mrs. Vance Lanier

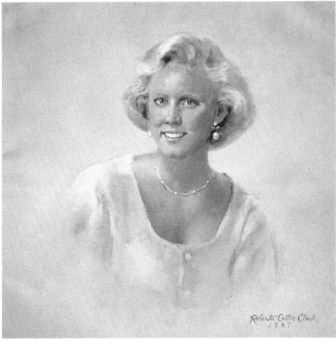

Day, 16 years old
Oil on canvas
26" × 26"
Collection of Mr. and Mrs. McKee Nunnally

A Full-Length Portrait

You may paint portraits for some time before you want to do a full-length painting. They are not so easy to carry out, but the results are worth the effort, especially in terms of establishing your own self-confidence.

You need a large room to hang a full-length portrait and a large room to paint it in too. You must be able to stand back far enough to see the entire figure without the distorting effects of perspective. If you are at a normal distance for painting a child, say six feet away, he will look fine down to the waist if he is standing, or to his thighs if he is seated. But when you look down to his feet on the floor, the angle of viewing is too steep. Painted this way, the figure would look distorted. If the room isn't large enough to let you stand farther back, let the child stand on a platform about fourteen inches high. This brings the lower half of his body up closer to the level of your eyes, so you're not looking down so sharply.

You can't avoid this distortion by using photographs either. The camera is still at your eye level and, if anything, will distort the figure even more, for the camera lens has less flexibility than the human eye. You could achieve satisfactory results by placing the camera on a tripod ten feet or more from your subject, at the waistline of the child's figure. You will get a smaller image on your film though, and to be useful, the image would have to be considerably enlarged.

A multiple portrait like this demands all your skills. I started with oil sketches of the children's heads, then took photos, which allowed me to work out an interesting and pleasing design. As you can see, we decided on white dresses for everyone, with different colored sashes. Several sittings and a year later, the portrait was delivered; it looks beautiful in the room.

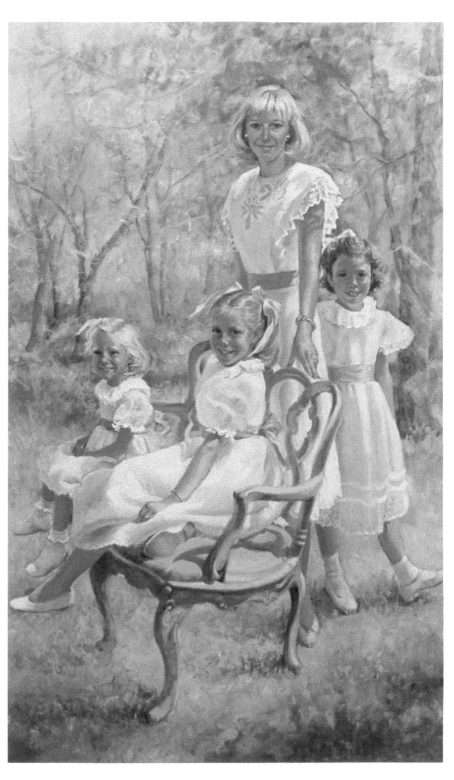

Morgan, Polly, Dierdre and Katie
Ages 3, 9 and 6
Oil on canvas
76″ × 46″
Collection of Mr. and Mrs. Allen Morton

Size and the Artist's Fee

If you want to do portraits for other people and get paid for them, you will find that the size of the painting has a lot to do with the fee you can expect to receive. We all know it doesn't make sense to price a portrait "by the square inch," but that system seems to be prevalent. Many portrait painters have their fees listed on a card by size, as shown below, with one set of fees for adults and another for children.

So, there we are: The size determines the fee, and the fee determines the size, logically or not. See the Appendix for further discussion of fees.

Available Materials

Another factor to consider in determining the portrait's size is the material you are going to paint it on. Standard widths for readily available canvases are 45 and 54 inches, and at least two inches—one inch each side—will be wasted for selvages that must be cut away before stretching. When you are planning a large portrait, think 40 to 42 inches or 50 to 52 inches in width and you should have no difficulty. Canvas is available up to 120 inches wide and even wider, but when you work that large you will need help stretching it, and the logistics of framing the portrait and transporting it could be overwhelming.

Drawing paper, pastel paper and watercolor paper are all available to us now, not just in large sheets, but in rolls. This gives you many more options than ever before for doing oversized portraits. If you like working large, just be sure to check out the art supply stores or catalogs first. There's no point in planning a wonderful, mural-sized portrait if you can't find a surface to paint it on.

Miniature Portraits

Tiny miniature portraits with heads only one to one-and-a-half inches in height date all the way back to Elizabethan times. I have painted a few and found that they are not as easy as they look. I can do them only from photographs. If this branch of portraiture interests you, you'll find a ready market for your work. It would be difficult to know what amount to charge for them, though. They are so small that parents may think the fee should be considerably lower than for the life-sized portrait. In reality, a larger head is far easier to paint. I like to paint miniatures for gifts, not to sell. Then I don't have to deal with the fee problem. People do like them!

***Adele*, age 20 months**
Watercolor miniature on all-rag board

Head and shoulders, 14 × 18 inches	$ _____
Bust, 16 × 20 inches	_____
Seated, 20 × 24 inches	_____
To knees, 24 × 30 or 25 × 30 inches	_____
Larger, full length, 30 × 36 inches	_____
2 Figures	_____
3 Figures	_____

Portrait artist's fee card.

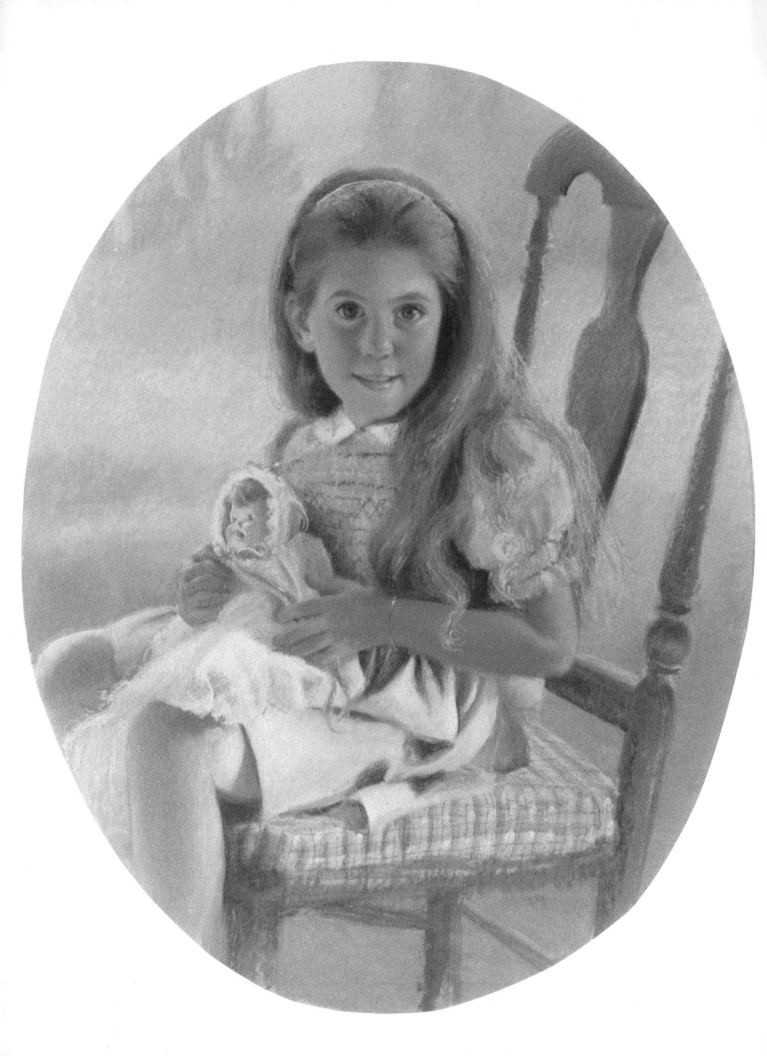

Clothing, Accessories, Backgrounds

Jennifer, age 4
Pastel on sanded pastel paper
26″ × 22″ oval
Collection of Mr. and Mrs. Alan Young

After you have decided upon the pose and the size of your work, the next consideration is the clothing your subject will wear in the painting. The clothing in a child's portrait is important and parents spend a considerable amount of time deciding on what the young one will wear. Classic clothes give us traditional, conservative portraits. For little girls, smocked cotton dresses, printed or plain, have been popular since the 1920s and continue to be so. Tiny boys often have these same details on cotton suits in pastel colors. For a more formal look, dark velvet dresses and suits with white or cream-colored elaborate collars are just the thing for some people. A word of caution about dressing a small child in clothes that are too formal: The child must look like a child—not a small adult. I never have any luck painting tiny girls in long dresses. I'm not sure why, but I think it's because the proportions look wrong to me, that is, the head looks too big with the mass of the dress, and I miss seeing the legs. Occasionally I enjoy painting children wearing party clothes with bare feet to make the portrait more youthful and informal. One of the most charming portraits I ever saw was of a small boy wearing overalls, one strap slipping off his shoulder, barefooted and sprawled in a formal, velvet-upholstered Victorian chair.

Choosing the Clothing

Some children have very definite ideas about what they will and will not wear, for a portrait or any other occasion. Some girls will *never* wear dresses; some will *only* wear dresses. There is no point in alienating the child whose cooperation you really need, and very often the child's choices turn out to be exactly right. After all, her strong feelings about her clothing are an expression of her personality, and that's what we are after: her personality.

I often suggest a sundress or sunsuit; these outfits give you the opportunity to paint the delightful necks and shoulders, arms and legs of small children. Annie's portrait, below, has a summery feeling because of her tanned arms and shoulders and her blue sundress. When a boy gets to be five or six he may prefer a polo shirt and shorts. If they are white, they give the portrait a sunny, fresh look. White cotton dresses on girls of any age give the same effect. For Mary Elizabeth's portrait, below, a simple white frock was chosen. White clothing is interesting for an artist to paint; you can use tints of any color—pink, cream, blue, green—to indicate shadows, light, and reflected light on the whites. For boys, you may want to try an open-necked shirt under a sweater with a pair of blue jeans or khakis. This combination looks good on any age. For younger boys, you can expect some discussion about short pants versus long ones. As for me, I'd rather paint knees and skin than fabric and its wrinkles or folds.

In different regions of the country, you will find quite different ideas of what is or is not fashionable for children to wear. For example, what is considered good taste for children in Boston may be considered far too plain in Dallas or Atlanta. And what is considered charming in London might not do in California at all. You have to arrive with an open mind in an area that is new to you.

Don't be surprised when you find yourself going shopping with the family to choose just the right garment. In fact, they will probably ask for your opinion, and that's good. After all, you're the one who has to paint the outfit they buy—and make a great portrait out of it, too. You may feel that very elaborate dresses and fussy hair ribbons overpower a particular child, but they might be perfect for another. Some parents like zippy bright colors; some prefer pastel hues, for a sweeter look. You will develop your own ideas on the subject of clothing and this can become an important part of your style.

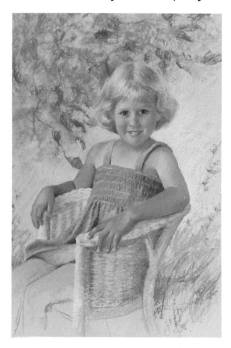

Annie, age 5
Pastel on sanded pastel paper
28″ × 22″
Collection of Mr. and Mrs. Charles F. Hance

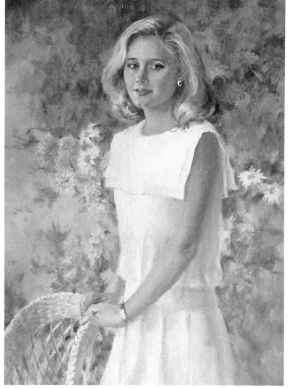

Mary Elizabeth, age 16
Oil on canvas
40″ × 30″
Collection of Mr. Frank Kenny

Color Substitution

Every once in a while a parent will say to you, "This is the dress I want Nancy to wear, but I could only get her size in green. Couldn't you just paint it pink?" This sounds simple enough, doesn't it? When I was just starting out I would accommodate this request, but it is not simple at all to transpose one color into another, and now I never make a color substitution if I can help it. It isn't difficult to mix pink paint to the color intensity and value of the green, but it is impossible to visualize how this child would look in pink when she is wearing green. The color of the clothing reflects into the face and affects the fleshtones throughout, not to mention hair and eye color. Patrice and Russell are sister and brother and have the same coloring, but see how the pink of Patrice's dress reflects pink tones into her face, while Russell's blue sunsuit reflects cool tones. Be good to yourself and don't jeopardize the success of the portrait by trying to transpose colors. The child can always wear something else.

Stuffing the Clothes

There will be times when you will want to work on the detail or the folds of a dress or a shirt, but you could never ask the child to pose long enough for you to paint them. I have a method that allows me to finish the child's clothing to my satisfaction without burdening the subject.

Between sittings I borrow the clothing the child is wearing in the portrait. Then I take small pillows and stuff the dress or shirt or coat with them and prop the whole thing up on a stool or chair in the same pose and in the same light my subject was in. If there are long sleeves, I roll up towels for stuffing them. This headless "doll" will "sit" as long as I need it, and it never moves or complains. Although people are startled to see you working with this headless image, everyone usually thinks it is pretty funny. Aaron's pink-and-white striped blazer took some time to paint because the folds and creases were complicated by the stripes.

I know one portrait painter who does dress an actual doll in order to paint the child's clothing and another who uses a store mannequin for this purpose. My method is quick and easy and works extremely well for me, both for children and adults.

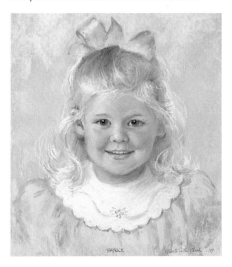

Patrice, age 4
Pastel on sanded pastel paper
20″ × 16″
Collection of Mr. and Mrs. Craig Kiely

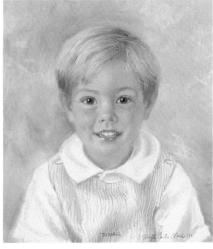

Russell, age 5
Pastel on sanded pastel paper
20″ × 16″
Collection of Mr. and Mrs. Craig Kiely

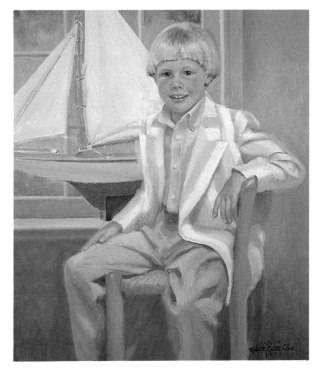

Aaron, age 5
Oil on canvas
30″ × 25″
Collection of Mr. and Mrs. Lee Tashjian

Accessories

Hats

The time may come when you will want to paint a child in a hat just because he looks so appealing in it. If the parents will go along with you on this, you'll have a most interesting painting in addition to a charming portrait. It is wise to draw the head first without the hat, then add the hat shape over the head. Otherwise you may have some difficulty making the hat appear to be on the head. Try to draw the hat in the round, an ellipse that goes all around the head form, even to the back. Be sure to choose a hat that does not hide the little face or cast a dark shadow across the eyes.

In these little watercolors, you can see that the hat adds color and a descriptive touch to each portrait. Hands, knees and feet aren't really necessary.

Emily, age 7 months

Elizabeth, age 4½

Penny, age 16

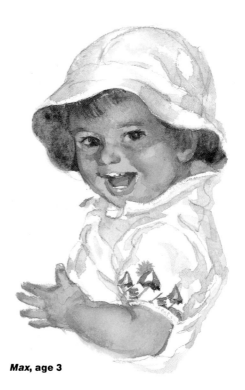

Max, age 3

Eyeglasses

To my mind, eyeglasses add special character to a face, even a young one. There is no doubt they make getting a good likeness easier, for they are an instantly recognizable feature on a child who habitually wears them.

Before you begin, ask the young person if he or she minds posing without the glasses for a sitting or two. It is vitally important that you paint the face without the glasses *first*. You need not completely finish the eyes, but you should have them about two-thirds done when you paint the glasses over them.

Assuming your head is two-thirds done, ask the child to put her glasses on. Hold your brush horizontally and align it with the top of the rims to see where the eyeglasses intersect the eyebrows. Using your small brush, make a light mark on your portrait for those spots. Then, repeating the process, align the brush with the lower edges of the glasses and see where they fall on the cheeks, and mark those spots.

Now concentrate on the earpiece and align your brush with that. This is important. Look for the spot where the little hinge is. No matter where it falls on the face, paint a dot with your brush and leave it. Make this decision with your eyes alone; it may fall way down on the cheekbone, or right on the edge of the eyelid. No matter that your brain is telling you "I know where glasses go!"—just paint that little dot where your eyes tell you it is. Then repeat the process and put in the other hinge. Now you have a sort of map of the way the eyeglasses relate to the parts of the face and head.

With the small brush and thinned out color, draw in the part of the

Larry, age 10
Oil on canvas
28″ × 24″
Collection of Mrs. Octavia Birney

Yates, age 7
Oil on canvas
28″ × 24″
Collection of Mrs. Octavia Birney

frame on the bridge of the nose. Extend the line out to the left and right hinges. From a sharp, distinct angle there, draw in the earpiece following the side plane of the face. If it is straight, paint it straight; don't curve it just because it goes around the face. Lightly draw in the lower, more circular part of the lens or frame, but break the line in places similar to a dot and dash line.

Now check it all in the mirror, improve your light drawing, and paint the frames in their proper color with firm, fine strokes. You need not indicate the glass in the eyeglasses. Leave it as it is and it will appear to be transparent. Finish painting the eyes and brows, and put in any shiny highlight you see on the frames, keeping it small. Above all, do not allow anything to obscure the direct gaze of the eyes, the pupils. Slow and careful does it.

Pets

I love putting pets—dogs, cats, fish or birds—in children's portraits. I normally do not charge extra for including them in the portrait. They add so much just by being there. Goya liked painting children with animals too; some of his most famous paintings portray these two friendly species together.

Backgrounds

Discussing backgrounds is like discussing the air or the wind. A background in a portrait has to be there, of course, but it should not call attention to itself or dominate the figure in any way.

Young artists starting out always love painting the person but inevitably arrive at a point where they say, "What shall I do with the background?" The best way to handle the background is to paint it along with the figure, at the same time. This background problem is unique to portrait painters. Artists working in other genres compose their paintings from side to side and top to bottom as complete entities from the start, but we portrait artists are interested only in the person sitting for us. You have to discipline yourself, but you'll be much more at ease if you plan the background before you begin to paint.

Some artists solve this problem by painting their backgrounds a plain solid color without much variation. There is no doubt that this concentrates the viewer's attention on the person portrayed, for there is nothing else to look at in the portrait. It's a safe approach, but the flat color does tend to flatten the painting. If you want to use one color, more depth can be achieved by varying the values, painting part of it dark and part light.

Background Awareness

I suggest that you start thinking about and studying backgrounds. Look at the backgrounds in the portraits in this book. Then look at other art books or at portraits in a museum. Because the artist purposely designs the background so you will not notice it, you usually don't. When you want the backgrounds in your portraits to be better integrated with the figure, or to set it off more, you will start to notice them. The only rule that matters is that backgrounds must recede. One way or another, the background must read as if it were behind the subject.

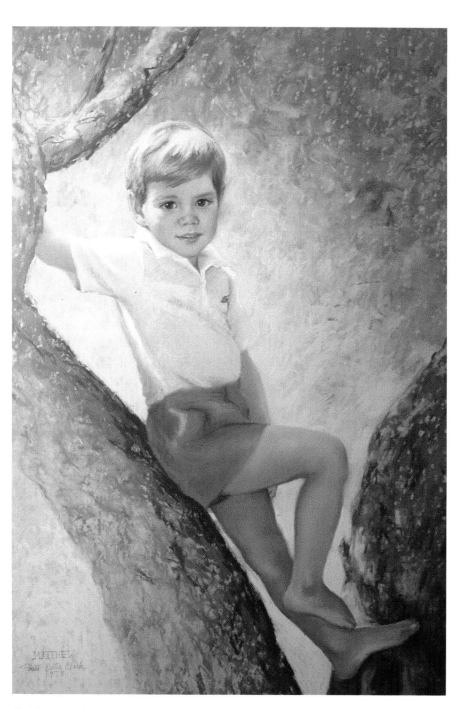

Matthew, age 5
Pastel on sanded pastel paper
28″ × 22″
Collection of Mr. and Mrs. Brock Saxe

Matthew is painted in the most simple clothing and bare feet, but the composition and background make the portrait more formal. I had been to see a Monet exhibition and I was influenced by his usage of color.

Indoors

Details of the family's home, such as interesting windows or furnishings, can add color and pattern to a portrait. Windows make excellent backgrounds in portraits (see the portrait on page 122). You can't really know how good they are until you see the portrait framed and hung on the wall. Then you discover that the window in the painting opens up the whole wall and brings a feeling of light and air where none existed before. Although the mullions are definite horizontals and verticals, I paint them very soft, so they do not advance ahead of the figure. And care must be taken to place the mullions so they do not align with the eyeline or cut the head in two in a bad place. Where they come in contact with the head they must be brushed out so as to be nearly nonexistent. They have to look as if they pass behind the head. Lay the mullions out with a yardstick and thinned paint; a pencil line is sometimes hard to get rid of later on.

Outdoors

The topography of the place or region where we live is meaningful for all of us. The ocean and the beach, with its dunes and blowing grasses, or the mountains, river, lake, or forest can all contribute meaning to the portrait of the child. However, I must caution you not to make these elements *too* representational, or the figure will no longer be the dominant motif. It is a matter of concept more than anything else. You must first consciously decide whether the painting is a landscape with a person in it, or a portrait with a landscape in it; then you can proceed.

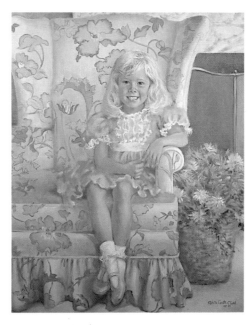

Carrie, age 4
Oil on canvas
32″ × 28″
Collection of Mr. and Mrs. Joseph Hemphill

I made several sketches to decide where I could trim off the chair yet still retain enough of it to show that it was a wing chair. If I had used the entire chair I would have had a portrait of a huge chair with a tiny girl in it. I was in the mood to create a highly decorative portrait.

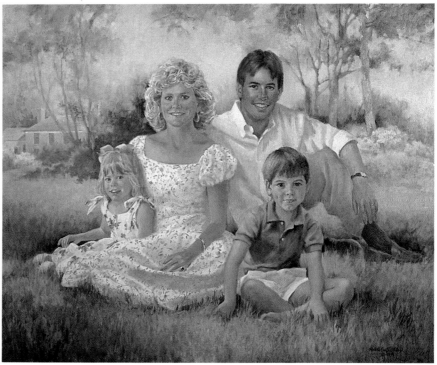

Mary and Jim, Stacy and Matt
Ages 4 and 6
Oil on canvas
42″ × 52″
Collection of Mr. and Mrs. J. W. Warshauer

This family's home, along with the large trees and flowers, was softly rendered to keep the family members the main focus of the painting.

Skies

I have enjoyed using the sky for a background in many portraits. It gives the figure air and space and it allows me to compose the colors and cloud shapes any way I like in order to enhance my subject. Cobalt blue, white and a touch of yellow ochre to warm it up make a good basic blue-sky mixture. Clouds painted with white and a bit of Naples yellow or a touch of orange look clean and non-threatening.

On occasion I have painted a sky in the manner of the French Impressionists, using small strokes—perhaps ¼ by ½ inch each—of rose, yellow, blue and lavender tints. These were laid side by side, with a minimum of blending. This gives a quite distinct feeling of air, much more than any flat color ever could.

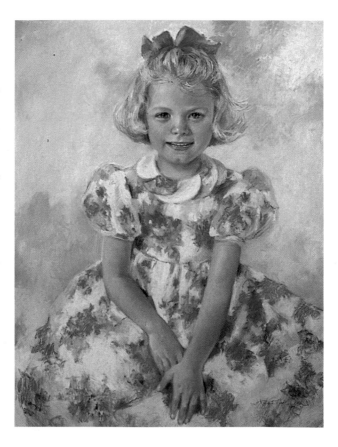

Adele, age 5
Pastel on sanded pastel paper
28″ × 24″
Collection of Mr. and Mrs. Peter Beekman

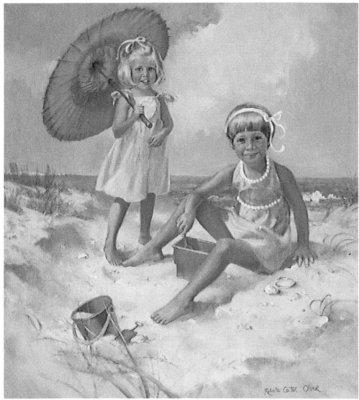

Katharine and Eliza, ages 3 and 5
Oil on canvas
40″ × 38″
Collection of Mr. and Mrs. Thomas B. Hovey

I chose a mid-value gray for the sky to make the sand and the figures look bright, as if lit by the sun, and to enhance the strong colors in the clothing and toys; a blue sky would not have done as well. I wanted it to appear as if a summer squall had just passed through.

Even though the horizon line of the ocean is straight the design of this portrait is made up of numerous diagonals; diagonal lines always suggest movement and, in this instance, keep the viewer's eye moving around within the painting.

Dark Backgrounds

The Old Masters, John Singer Sargent, Andrew Wyeth and many others, have used dark backgrounds at times. They do add drama. If you want to do this, be sure to vary your edges around the figure—some soft, some hard—so the child doesn't look cut out and pasted on. (See the portrait of Rawson, below.)

Flowers

In an earlier chapter, I suggested that even the portrait painter benefits from painting a landscape on occasion. You can also gain from painting flowers when you need a rest from portraits. Flowers are wonderful in portraits for they give you the opportunity to add almost any color note or shape you need. A boring area in the painting can be made interesting and beautiful. Tiny flowers in the grass can add sparkle to a dull green area. A flower or two in the hands of your subject can provide those hands with something to do and make them appear graceful. The type of flower you choose along with its container—a crystal vase, or a basket—can help convey the mood you are trying to establish in the portrait.

Let us say you are well into the portrait and it looks good. It's the morning of your fourth sitting. The figure looks fine and the likeness is really there. Before the child arrives to pose you check the portrait in your mirror. All of a sudden you see this great blank area in the composition and your heart sinks. Three days of work on this portrait and you never noticed that place before. What to do? It's time to bring out the flowers. They can really decorate a portrait. If handled properly, they can lighten, brighten and soften an area and still not compete with the head. Time spent working on your flower painting technique is not wasted. You will be ready to add them when you need them.

In the pair of large portraits on the next two pages, the flowers tie the two portraits together.

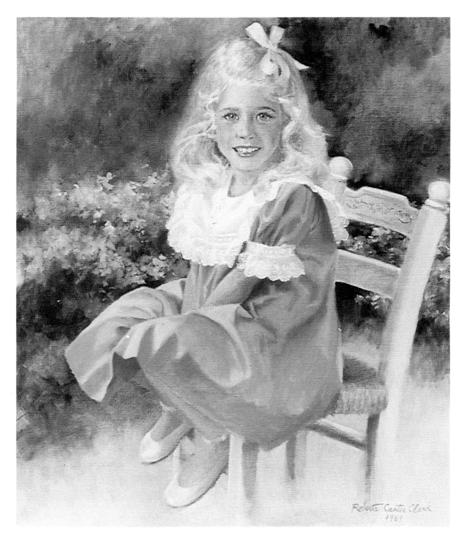

Rawson, age 5
Oil on canvas
38" × 32"
Collection of Mr. and Mrs. Robert Glover

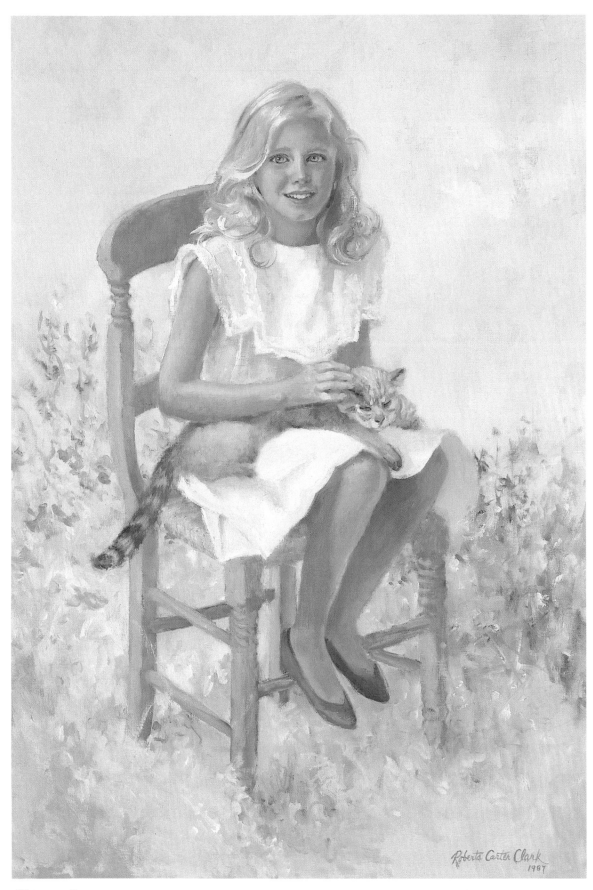

Alison, age 9
Oil on canvas
44" × 30"
Collection of Mr. and Mrs. Rodney Cobb

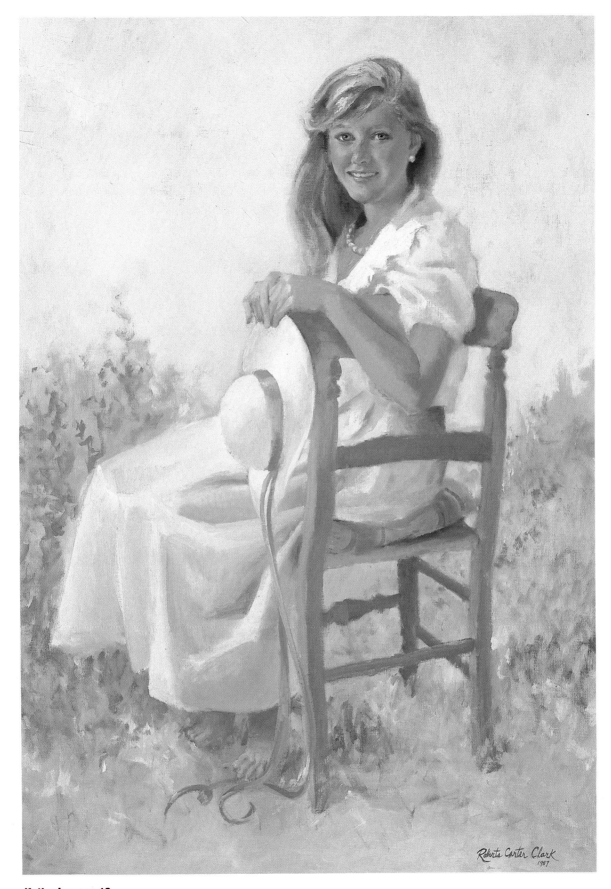

Katherine, age 13
Oil on canvas
44″ × 30″
Collection of Mr. and Mrs. Rodney Cobb

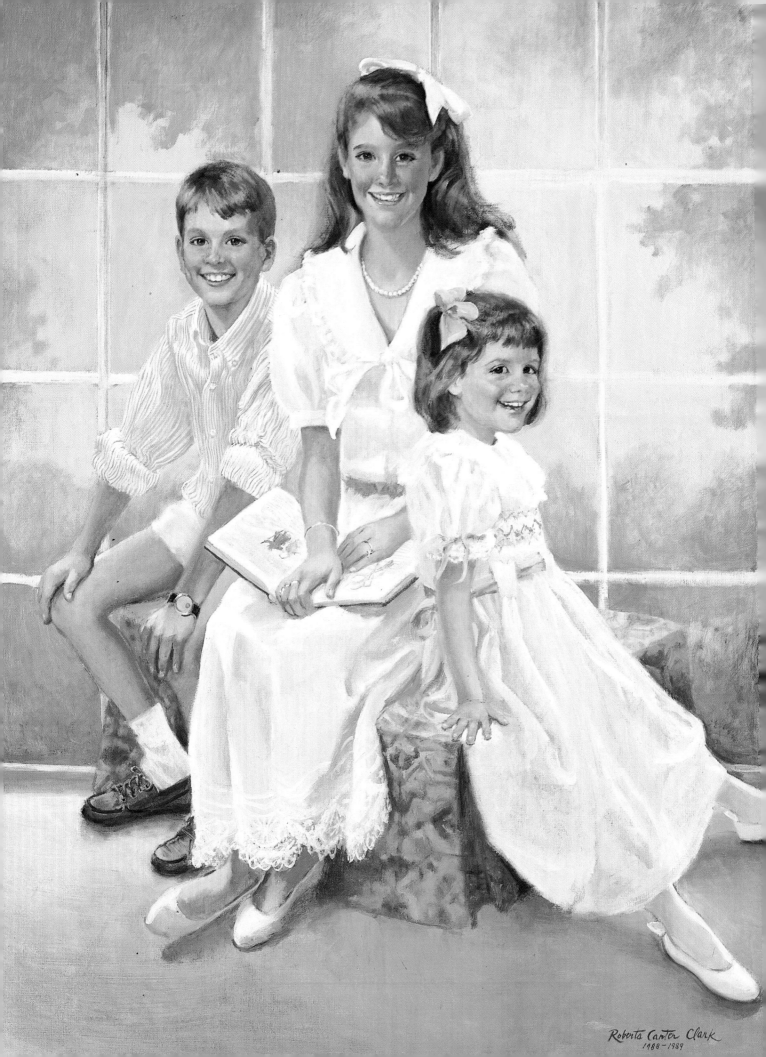

Using Photography Wisely

*James, Carter and
Katherine*, ages 9, 13 and 7
Oil on canvas
56″ × 38″
Collection of Mr. and
Mrs. J.D. McCaslin

Edgar Degas used it; Claude Monet used it; Thomas Eakins used it too. I am speaking about photography. The questions about it never end.

Picture-taking is a big industry. More versatile cameras and more functional types of film are introduced every year. We might as well face it: Photography is here to stay. And doesn't it strike you as peculiar, with all this camera activity going on, that there is a small segment of the population that still wants portraits of their loved ones painted by real live artists? I think it is safe to say that portrait artists are here to stay, too!

Some painters make their portraits look like photographs and some photographers make their photographs look like paintings, but I think most painters feel more comfortable with paintings that look like paintings.

But let's discuss using the camera, not as a crutch to support third-rate drawing or as a substitute for developing your artist's eye for color, form and personal interpretation, but as an assist where it is genuinely needed.

Photographs for Portraits

We all know that the most challenging aspect of painting children's portraits is the child's inability to pose for the length of time we need to accomplish our task. Some portrait artists refuse to paint a child younger than four; others won't paint anyone younger than seven! It is true that, by age seven, most children are able to pose quite well. But by dismissing all those other little people, you may miss some terrific portrait prospects. To paint these little guys, we'll have to resort to photographs.

I once thought that using a camera to assist in painting a portrait was a form of cheating. Now, however, I have a different perspective. Taking many photos of a young child allows you to choose from a much wider array of your subject's expressions. In a roll of twenty-four pictures there might be a wonderful smile, a laugh or some fleeting expression that reveals the very soul of this particular child. But the camera is not magic. Your eye and your skill with the instrument produce the natural and unposed photos you need and want. Cameras can be very frustrating, and after an hour spent taking pictures of a four year old in action you will be exhausted. Having good equipment and spending the time it takes to familiarize yourself with it are the first criteria.

I use a 35mm single lens reflex camera that does a great job, but I do have to focus it manually. Of course, some of the shots that I think will be my best are out of focus because my young subject is moving so fast. My remedy for this is to take many pictures, maybe two or three rolls. I take as many as I can before the child gives out or I do.

I use ordinary Kodak ISO 100 color print film because my camera has a 1.4 lens that allows me to take pictures indoors with existing light, so I don't need the flash or a special film.

I take pictures in various locations throughout the home, always conscious of the most important element, the light. Good daylight is essential as I never use a flash; the flash takes out all the shadows that I need to create form in my portrait. It flattens the face and makes the photographs look unnatural, so of course the portrait looks unnatural, too. I also think the flash going off over and over again annoys a small child. My best photos seem to be taken with the child near a window or an open door.

I try to take my photos of children for portraits between 10:00 A.M. and 2:00 P.M. when the light is brightest. Of course, I have to work around their nap time, nursery school hours, lunch and maybe a few other activities.

I prefer to use oversized prints rather than slides. They are easy to look at and I can tape the ones I am using right on my easel next to my canvas. The color is always off, but I use the fleshtones I am familiar with: those I have learned to mix by working from life. These combinations are discussed in the demonstration paintings in Chapter six.

One of the best things to happen to portrait painters everywhere is the advent of one-hour photo developing labs, which seem to have sprouted up in every town. I can find out right away if the photos are what I want, and if they aren't, I can take another batch while I still have access to the child. Usually their work is more than adequate. I don't require custom developing for I am only going to use two or three of the photos anyway.

Photographs have become important to my work, but no matter how good they are, I always prefer to finish my portraits from life. I use the photos to plan my composition and choose the pose, and sometimes I work from them until the portrait is perhaps two-thirds done. But no photograph can give me the color and subtle nuances of expression that I can get from a sitting or two at the end. It is challenging to work both from the photograph and the real child because they are not the same, but I can set aside any anxiety that may result because I know I will be able to see and work with the child again before I have to say the portrait is finished.

A Little Advice on Cameras

Be wary of the inexpensive "point and shoot" cameras on the market

now. It's true they have automatic focus, which can be so helpful for photographing children. But the lenses require a flash for indoor photography, and as I've explained, the flash is less than ideal for your work.

The Polaroid autofocus camera is great for photographing children outdoors. There is a lot to be said for being able to see the picture right after you take it. If it isn't what you need you can take another. I have used mine especially for capturing the poses of the children, the arms, legs, hands and feet. The prints are fine for this but not precise enough for the faces. Not for me anyway. I must admit the Polaroid makes the children more cooperative because they *love* seeing the prints right away!

If you are considering upgrading your photo equipment, ask at your camera store for a 35mm SLR (single lens reflex) automatic focus camera that has a lens sensitive enough to allow you to shoot indoors with existing light, that is, natural daylight without a flash or floodlights. These cameras are available now, but they are not inexpensive.

Getting the Most From Your Photos

Photography can help a portrait painter, but he or she must be an artist first. Anyone who thinks the camera can do all the work has never attempted the process. First, always try to take your own photographs for your portraits. Photographs by you, the portrait artist, are already filtered through your sensitivity to the child and your painting needs. You consciously take pictures seeking material for the portrait still to come.

Of course, my opinion comes from my experience, and my training and inclinations lead me to draw and paint my portraits from life. I worked this way for years before I saw any need to involve photography in the process. I still think the paintings I do from live models have more energy and life than those done with help from photographs. I taught myself photography when I began to paint little kids in oils and to receive commissions to paint family groups. Neither of these is possible for me working solely from life. Because of my desire to work both from the photograph and from the live child, I have had to devise a method to make the photographic image work for me.

To me, the secret lies in making a sketch from the photo image first, just like a sketch from the live child. I do this to see if the photo image "works" as a portrait. If it doesn't, I sketch another photo, and another and another until I get one I know will be a great start for a good portrait. I find it impossible to judge my photos until I draw them.

Also, I *never* let the parents see the photographs until I have studied them and weeded them out, and done my drawings and weeded *them* out. They see the drawings only—the ones I like—and we decide on the pose from those. I might show them a few of the photographs I am not using after that. However, because these people are not artists, I don't want to create difficulties by allowing them to select the photos from which I'll paint. I'm the artist; I must do the work and sign my name to it. So I am the best judge of the material.

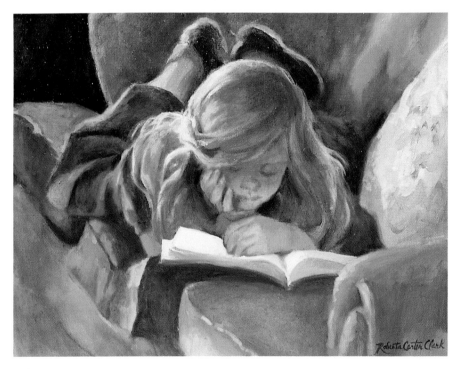

Carol Anne, age 6
Oil on canvas
18" × 24"
Collection of Mr. Hans Reuter

This painting was done from a snapshot taken while we were all indoors protecting ourselves from a Rhode Island hurricane. It was fun working out the foreshortened figure.

The Group Portrait

I know of no way to paint a group portrait without photography. For the portrait below, I took many pictures—perhaps four rolls of film—at my first visit to this family's home. They live some distance from me so I had to make my time with them count. Usually, I like to paint forty-five-minute oil sketches of each child first to familiarize myself with his or her face and coloring, but with four children there was not enough time, so I made notes on each individual instead.

When the photographs were developed and I was at home where it was quiet and I could concentrate, I spread them all out on the table. I chose the photos of each child that would give me something to work with. From these photos, I sketched the figures separately or, if they looked promising, with two figures together.

I had learned that these parents didn't like fussy things and that the colors in the room were blue and yellow. The painting was to go over the mantel and I had measured that space. With four children, it's all too easy to get them lined up like ducks in a row. Within the necessary horizontal shape, however, there were not many options; all I could do was to make sure the heads were on different levels. I always try to make the oldest child the star because the young ones are so cute they get lots of attention anyway. The older girl, Christina, became the key. In one photograph she was in an unusual pose, and this gave me the idea I needed to work out the composition for all four.

After the sketch was approved, I started the painting at home, took it as far as I could with the photos, then visited the family again for a week to finish it. All the trees were on their property and could be seen from their windows. The portrait looked great in their home—that's the real reward for the artist.

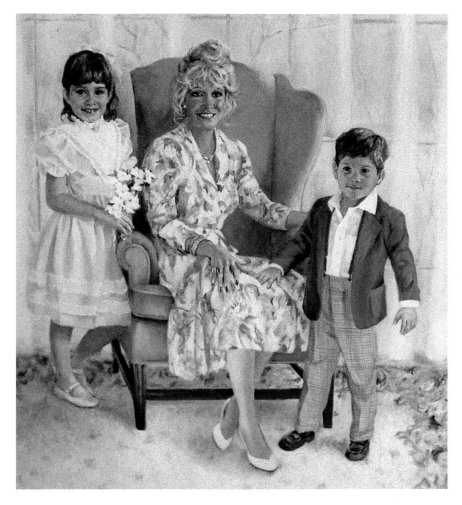

Shireen, age 6,
Judy and Robert, age 4
Oil on canvas
46″ × 42″
Collection of Mr. and Mrs. Victor Hatami

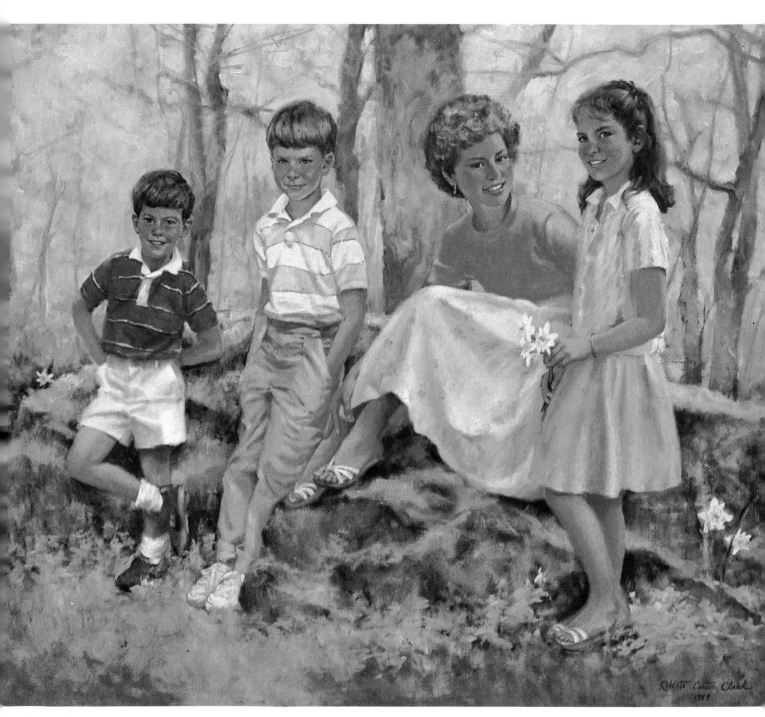

Brooks, Jonathan, Christina and Elizabeth
Ages 6, 9, 13 and 11
Oil on canvas
50″ × 40″
Collection of Mr. and Mrs. William Barrett

Other Painting Ideas From Photos

Here are some more paintings that could not have been done without photography. These are not exactly portraits, but studies of children doing everyday things, and there is a good market for paintings of this type. Also, some parents are delighted having a study of their child rather than a more formal portrait. When you work with children frequently you accumulate many charming photographs. Painting from these photos gives the portrait painter a break from commissioned work and the chance to do something she wants, just the way she wants to do it. You see, I love painting children for their families, but for relaxation and a challenge, and to develop new ideas, I like very much to paint them for myself.

Photographing Your Own Work

As soon as you feel you are ready to accept portrait commissions from people outside your family and immediate circle of friends, start photographing your portraits to include in a portfolio or album. This is an easy way to show prospective clients what you've done and also to keep a record of your work. Eight-by-ten-inch color enlargements are best. You can take the photographs yourself with your 35mm SLR camera. A good book to help you do this right is *Photographing Your Artwork* by Russell Hart (North Light Books, 1992).

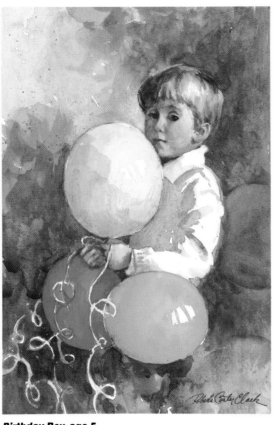

Birthday Boy, age 5
Watercolor
12" × 8½"

(Above.) I had previously painted this child's portrait in oils for the family. This snapshot was one I took at his home, and I just had to paint it for me. The serious face and hooded eyes are in sharp contrast to the gaiety of the colorful balloons.

Miss Ruth Kimball, age 8
Watercolor
8" × 7"

(Right.) I painted this portrait from an old photograph—I can never resist buying them when I see them in an antique shop. On the back of the photo someone had written the child's name, her age—eight years—and "To Aunt Katie, Xmas, 1898" in a flowery hand. I enjoyed painting this serious young face and fantasizing about what her life in Victorian times must have been like.

Baby Ross, age 2½
Watercolor
5½" × 4½"

(Above.) This is a young friend who is usually so active that I can't even take his picture. This morning he was a little under the weather and so was much quieter. I love this pensive pose.

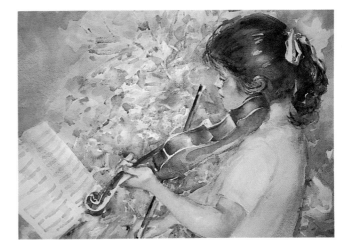

Patrick, Young Artist, age 4
Watercolor
11″ × 15″

(Above.) You might recognize this boy from his demonstration painting in Chapter six. When I'm painting, the children want to paint as well.

Fayne, age 9, and the Violin
Watercolor
22″ × 30″

(Above.) I was lucky to catch this exquisite snapshot of Fayne playing her violin. It makes a very romantic painting, doesn't it? I made up the flowery background.

The Listeners
Watercolor
20″ × 26″

(Below.) This watercolor has been accepted in several exhibitions and has even won an award. I wonder what is holding their rapt attention.

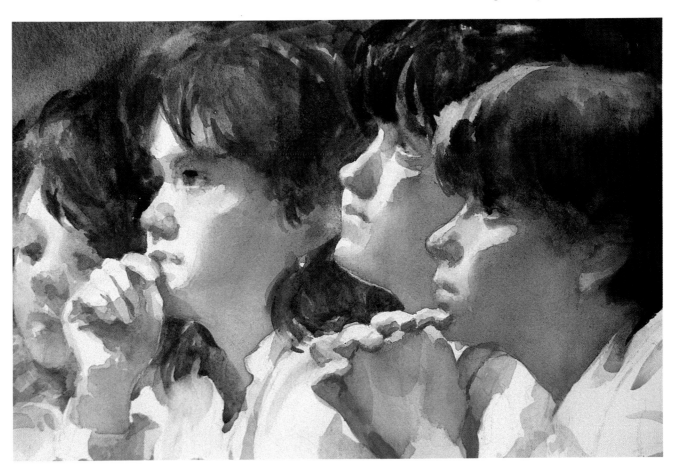

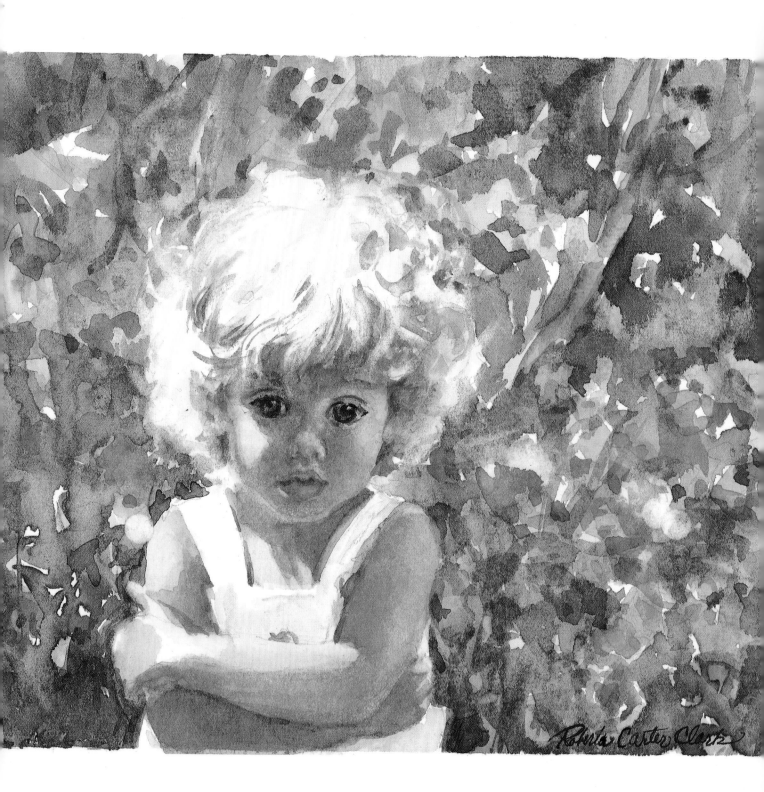

I've enjoyed painting children all of my adult life, and I've had a great time painting them for this book as well. I have also tried to write only about matters particularly relevant to painting young people. My first book, *How to Paint Living Portraits*, is far more detailed on the techniques of portraiture and mainly concerns painting adults.

Try to spend some portion of your time drawing and painting from life. Perhaps you can find a life class, or start one. You probably won't have children posing, but adult models will help you tremendously to understand all the things that happen to skin tones and various colors of hair and clothing under different lighting conditions. Some intangible connection is established between you and your sitters when you're painting them live. You will feel the warmth of their personality—something you'll never get from their photographs. If you work solely from photographs you may get too involved in unessential detail and may exaggerate the values.

Try not to be too hard on yourself. Painting people is a skill that takes time to develop. The next portrait—the one we haven't painted yet—is always our best. You may never be as good as you want to be. Few of us are. To me this thought is not negative; it's what keeps me going, trying a new color, a new pose, a new concept. Portrait painting is one of the few things you can do until your final days, a passion you can pursue for as long as you have your vision and can move the color around.

Some artists think it must be dreadful to have someone with you when you're painting and to have to please another person so much of the time. I enjoy these elements of portrait painting. I also love painting for myself to recharge my batteries and experiment with ideas that may not always turn out well. Remember, the reason the family wants you to paint their children is because they love them, and they are very grateful when you come to them. Is there a better way to live your life?

Let's go on together, then, side by side, learning, meeting new people, and expressing our feelings about these young fellow humans in a progression from one painting to the next and then the next. Here's wishing you happy painting!

Charles, age 2
Watercolor
6½" × 8"

Getting Started in the Profession

Portrait painters just starting out often ask, "Where do I begin? How do I get started?" Unless you live in a really isolated area, getting started as a portrait painter is easier than you may think. Portrait painting is now, and always has been, interwoven with the social world. The key is getting your work out of the house and somewhere where people who have some extra money will see it. Portraits are a luxury item, as are all paintings; there is no doubt about that. If you live in an area where there are well-to-do people who also appreciate the arts, this is even better. But remember, wealth and culture do not always go together.

The first thing to do is to paint some portraits of your children or those of friends or relatives and get them out where they will be seen by large numbers of the people who could afford to commission you. This means painting portraits as "samples" and, very likely, without remuneration. These samples should be of your best work, framed simply but well. Restaurants, country clubs, bookstores and upscale children's clothing shops are all places to gain maximum exposure for your work. Art galleries and art associations are all right, but I've never had much luck with them unless they are having some sort of benefit for which high-priced tickets are sold.

Letting People Know You're There

In the beginning, an excellent way to be seen and get some practice at the same time is to do half-hour sketches of children at church fairs, donating a third of your earnings to the church. The church committee will be glad to have you, for you add something special to their fair. If your work has any merit at all, you will be noticed and remembered by many parents. You should have cards ready with your name and phone number to give to anyone who inquires about having their child's portrait done. You can even make them yourself if you don't want to have them printed. One artist I know uses a small photograph of one of her portraits with the information on the back.

I knew a painter who started out doing portrait drawings in the window of a neighborhood frame shop on Saturdays, attracting a great deal of attention and, subsequently, portrait commissions. This artist was an exceptionally good business person. For example, she offered to paint one portrait free for anyone who would get her five portrait commissions. This brought her a great deal of work and many new clients. Any frame shop should be happy to have you because of the framing work your portraits will generate for them.

Another way to make yourself and your work known is to donate a portrait to a local fund-raising charity event, such as those organized by the Cancer Foundation, the Heart Fund, Art for Arthritis, or any of the numerous other groups with similar missions. Your beautiful portraits are prominently displayed at the party where chances will be sold on a portrait you will paint for the winner. You can donate the portrait entirely or stipulate that the proceeds be divided between you and the charity. You'll get to meet many new people and enjoy a wonderful party as well.

It's also a good idea to exhibit your portraits at a summer or winter resort. This works best if you can live there for a few months at the height of their season. You might set up your work in the lobby of a hotel or in one area of a really nice shop, or have a show in a gallery at the beginning of your stay. And you don't just display your work; you have to be there to talk to anyone who appears interested. You may have to give the proprietor a commission of anywhere from 20 to 40 percent on the work you do at any of these places.

It this appeals to you, be prepared to work very hard and quickly, for the whole idea of a vacation resort is that people are there for just a week or two at a time. This could develop into an arrangement where you work there part of each year, and every year you could depend upon getting more and more commissions.

These suggestions are *not* just idle daydreaming. I have tried almost all of these pursuits at various times in my life, and each one has worked for me. My first venture outside my home was in response to an ad in the newspaper: "Portrait artists wanted, Michigan State Fair." I took my two-and-a-half-year-old twin boys with me and parked them on a bench while I conferred with the man in charge of the concession. He had me sit right down and do a pastel portrait on the spot. I was terrified, but I scratched around and turned out something. When he invited me to return that evening, I'm sure he never thought I would. That night, without my children, I did show up. There were about ten artists sitting in a circle with their backs and their easels facing out so the passing crowds could observe them. And I was the only woman, of course. The fair lasted for about ten days. That first year I made hardly any money, but I really learned a lot from watching the other artists. I did this for five years, and the last year I was one of the two top moneymakers! I have never thought there was anything wrong with making money, and it's a heady feeling getting paid for doing something you love to do.

I've donated dozens of portraits to local and national charity organizations, drawn charcoal portraits at our church fair for thirteen years, and painted pastel portraits in a hotel in Palm Springs and on a cruise ship. I've had successful gallery shows of my oil portraits in Palm Beach and stayed for two months each winter doing the resulting commissions. All this makes for an interesting and challenging life, but the best part is meeting all the people. Every portrait you do is like an advertisement for you and will lead to two more, guaranteed. These days all my portrait commissions come from individuals who have seen my work in other people's homes, advertised, we say, by word of mouth.

Using Agents

Not every portrait artist wants to get out there and present her own work.

Some painters prefer to be represented by an agent, someone whose job it is to get portrait commissions for them. The representatives receive a percentage of the price of the portrait as their fee. This could vary from 10 to 50 percent of the net, or whatever the artist receives after her expenses are taken out.

To give you an example of how portrait agents work, let's look at a well-known one. Portraits, Inc., a gallery in New York City, represents about 150 portrait painters around the United States and in Europe. The gallery shows the artist's work, both an original portrait painting and a book of photographs of his other portraits, to the client. They help the client select the right artist for their portrait needs and also take care of billing. In other words, they sell the portrait and they take care of the business side of things. At present, Portraits, Inc. takes a 40 percent commission for their services from the portrait price. Travel expenses, framing and shipping costs, if any, are paid by the client. I have worked with this gallery for several years and have found this to be a very good way to get portrait commissions from people you would not otherwise meet.

Setting Prices

All artists wonder about how much they should charge for their portraits. This is the most difficult part of being an artist and necessitates some careful thought. Starting out, you don't want your work to be so expensive that you get no commissions at all. On the other hand, you would not want your work to be so inexpensive that no one would value it. Besides, you'd find yourself so swamped with work that you wouldn't be able to do your best on each portrait. A great deal depends on the area where you live and the income level of your neighbors.

One way to determine your fees is as follows: Decide on a base fee for a head and shoulders portrait on a 16 × 20-inch canvas. For the sake of easy calculation, let's say $100. Your 20 × 24-inch canvas can be one-and-a-half times that, or $150. Your next size, 24 × 30 inches, can be two-and-a-half times the base price, or $250. The larger size, 30 × 36 inches, can be three times the base, or $300.

You may also have differing price schedules for each medium you work in. I do my commissioned portraits only in pastel or oil. The pastel portraits are priced lower than the oils. The watercolors I do for shows and for myself, and they are priced as paintings, not portraits.

This is all quite simple until we include two or more people in the same portrait. It is far more difficult to paint two people on the same canvas than it is to paint two people separately—*more* than twice as hard. Some painters charge one-and-a-half times the single-person fee; some charge twice the single-person fee less 10 percent; and some, like me, just double the single-person fee, or triple it for three people, and so on.

After all, the composition must be carefully planned. The relationships between each member of the group must be correct; for example, who is the taller, the darker, the older, the heavier. The group portrait is quite an undertaking. However, I don't charge for pets. And all my fees for portraits of children are lower than they are for those of adults. I feel they must be lower because we are dealing with private families, not large corporations and the like.

It all comes down to what you want to do. If you like painting multiple portraits, price them so you'll get many to do. And, if you don't, you can make the fees so high that no one will request that you paint them. What you charge is always up to you. And when you find yourself so busy you can't keep up with the demand, *that's* the time to raise your prices.

Keeping Records

It is a good idea to keep a page in a notebook or a file card for every person you paint and their portrait. You should record the family name, the names of both parents, the child and all the siblings, their ages, the ad- dress and phone number, the date you were first contacted and the date the portrait was completed. Record the size of the portrait and the fee received and add a little sketch or a photograph of the portrait, anything that will jog your memory about this painting months or even years from now.

I am not the most organized person so I give each family a page in a spiral-bound 9 × 12-inch sketchbook. The pages are large enough to record any other expenses, like mileage, tolls paid, directions to the house, the name of the dog, the framer used and a description of the frame. The sketchbook has a hundred pages so it's useful for quite a while. I list the families' surnames on the cover so I know who is in which book (I have two). I can carry it with me easily.

You'll be amazed how often you'll refer to these pages or cards. You'll need this information for your income tax return, or when you want to send a Christmas card or an announcement of an upcoming show of your work or any other glad tidings. When another child is born into one of your families in years to come, you'll want to know the medium, the size and the fee for the first child's portrait. Many well-known painters, including Edward Hopper and Winslow Homer, have kept a record of their work in a notebook with small sketches and color notations of each painting.

Index

A

Aaron, 113
Abby and Baby Hannah, 66
Accessories, 114-115
Adele, 2, 25, 109, 118
Age
 best, for portrait, 14
 and proportion, 36-37
Agents, using, 132-133
Alec, 58
Alison, 120
Amanda Lee, 28
Annie, 112
Artists, various, approaches of, 92-95
Aurie, 16, 17, 77

B

Baby
 eyes of, 18
 profile diagram of, 4
 three-quarter view of, 6
 See also Newborn
Baby Ross, 128
Backgrounds, 116-119
 dark, 93, 119
Betsy, 101
Birthday Boy, 128
Block-ins, structural, importance of memorizing, 3
Body, practicing drawing, 29
Bonneau, 104
Braces, on teeth, problem of, 25
Brooks, Jonathan, Christina and Elizabeth, 127

C

C.B., age 10, and Shanghai, 106
Cameras, advice on, 124-125
Canvas, size of, 109
Carol Anne, 125
Carolyn, 84
Carrie, 117
Cassatt, Mary, 94
Charcoal, working with, 42
Charcoal portrait, number of sittings for, 54
Charles, 130
Charlie, 2
Children
 being pleasant to, importance of, 59
 getting acquainted with, importance of, 53
 See also Baby, Newborn, Subjects

Christopher, 7
Clark, 27
Clothes
 drawing, over body, 30
 selection of, 111-113
 stuffing, 113
Coleman, Hannah, Claire and Campbell, 60
Color substitution, avoiding, 113
Colors
 of extremities, 35
 for oil painting, 48
 range of, for pastels, 46
 for skin tones, for various media, 61
 warm, 63
 for watercolor painting, 50
Commissions, getting, when starting out, 132-133
Complexion, colors of, 11
Composition
 for double portrait, 68
 for multiple portrait, 133
 using viewfinder to determine, 102
Conté crayon, sanguine, 44

D

Dane, 9
Day, 107
Demonstration
 double portrait, in oil, 68-73
 formal portrait, in oil, 74-77
 oil portrait, from photo, 86-87
 pastel, 78-79
 two portraits, in oil, 80-85
Demonstration, watercolor, 62-66
 from photo, 88-91
Diagram
 profile, 4
 three-quarter view, practicing, 6
Drawing procedure, 5

E

Ears, drawing, 27
Edie, 107
Elizabeth, 55, 98, 114
Elizabeth and Caldwell, 54
Emily, 98, 100, 114
Eraser, kneaded, for charcoal work, 42
Eyeglasses, 115
Eyes, 18
 averted, vs. head-on, 98
 drawing front view of, 19
 drawing profile view of, 20
 drawing three-quarter view of, 21

expressive qualities of, 17, 21
laughing, 21
smiling, 21

F

Fayne, age 9, and the Violin, 129
Features
 of five-year-old, 9
 of newborn, 5
 of nine-year-old, 11
 of seven-year-old, 10
 of sixteen-year-old, 14
 softness of, in children, 1
 of toddler, 7
 of twelve-year-old, 12
 See also Ears, drawing; Eyes; Mouth; Nose
Fee
 agreeing on, with client, 54
 and size, relationship between, 109
 setting, 133
Feet. *See* Legs, and feet
Figure. *See* Body, Torso
Fingers. *See* Hands
Fixative, 42, 44
Flowers, using, in portraits, 119
Format
 four-square, 3
 vertical vs. horizontal, 102
Frame shop, getting commissions through, 132
Freckles, rendering, 10
Front veiws, 3
 of ears, 27
 of eyes, 19
 of mouth, 24
 of nose, 22
 of three-year-old, 8
 of very young subject, 98

G

Gordon, 85
Grace, age 4, in Her Easter Hat, 87
Graph paper, for profile diagram, 4

H

Hands, 31-33
Hats, 114
Head
 outer shape of, beginning with, 5
 views of, 3
Head lengths, measuring in, 36, 38-39
Highlights

in eye, 18, 21
on fingernails, 31
on mouth, 24
on nose, 22

I

Indoors, as background, 117

J

Jake, 56
James, Carter and Katherine, 122
Janell, 56
Jay, 10, 79
Jennifer, 110
Johnny, 31
Julie, 30
Julie, age 4, and Her Dolls, 91

K

Katharine and Eliza, 118
Katherine, 121
Katie, 98
Kelly, 57
Kristina, 105

L

Larry, 115
Lauren, 106
Layne and Slate, 99
Legs, and feet, 34-35
Light, outdoors, 103
Lips. *See* Mouth
Lisa, 58
Listeners, The, 129
Lynn, 14

M

Marketing, approaches to, 132-133
Mary and Jim, Stacy and Matt, 117
Mary Elizabeth, 112
Materials
 for charcoal portrait, 42
 for pastel portrait, 46
 for sanguine drawing, 44
 for watercolor painting, 50
 See also Paper
Materials, for oil painting, 48
 See also Canvas
Matthew, 116
Maturation, waiting for, in thirteen-
 year-old, 13
Max, 114
Measuring
 in head lengths, 36

visual, from life, 38
Media, working with variety of, 41
Medium, setting fee based on, 133
Melissa, 18
Michael, 5
Miss Ruth Kimball, 128
Model, for class, difficulty in finding,
 29
Molly, 12, 96
Morgan, Polly, Diedre and Katie,
 108
Morisot, Berthe, 95
Mouth
 difficulty of rendering, 17
 drawing front view of, 24
 expressive, 25
 profile view, 26
 three-quarter view, 26
 See also Teeth
Multiple portrait, setting fee for, 133

N

Nancy, 31
Newborn, features of, 5
Nick, 30
Nose
 drawing front view of, 22
 three-quarter view of, need for
 photos with, 23
Nupastels, 46

O

Oil portrait, number of sittings for,
 54
Oil study after Berthe Morisot, 95
*Oil study after John Singer
 Sargent*, 93
*Oil study after Pierre-Auguste
 Renoir*, 92
Oils, 48-49
 double portrait in, demonstration
 of, 68-73
 formal, demonstration of, 74-77
 mixture of, for skin tones, 61
 portrait in, from photo, 86-87
 two portraits in, demonstration of,
 80-85
Orthodontia. *See* Braces, on teeth
Outdoors
 as background, 117
 posing, 103

P

Painting children, patience needed
 for, 1

Paper
 for charcoal work, 42
 for pastel work, 46
 for sanguine portrait, 44
Parents, as observers, 59
Pastel portrait, number of sittings
 for, 54
Pastel study after Mary Cassatt, 94
Pastels, 46-47
 combinations, for skin tones, 61
 demonstration of, 78-79
Patrice, 113
Patrick, Young Artist, 129
Patrick and Robert, 73
Pencil, sanguine, 44
Penny, 114
Pets, in portrait, 115
Photos
 combining, with live subject, 75
 head length proportions from, 39
 painting studies from, 128
 using, for body, 29
 using, for oil portrait, 86-87
 using, for portraits, 124-126
 using, for three-quarter view, 23
 using, for watercolor portrait,
 88-91
 See also Cameras, advice on
Pictures. *See* Photos
Portfolio, photographing work for,
 128
Portrait
 double, in oils, 68-73
 formal, in oils, 74-77
 full-length, 108
 group, 126
 informal, 62-66
 miniature, 109
 multiple, setting fee for, 133
 oil, from photo, 86-87
 pastel, 78-79
 size of, 104-107
 watercolor, from photo, 88-91
Portraits
 exhibiting, 132
 painting, as "samples," 132
 pair of, in oils, 80-85
 paired and multiple, 99-101
 using photos for, 88-91, 124-126
Portraits, Inc., 133
Portraiture, getting started in,
 132-133
Pose, determining size by, 104
Posing, 55-60
 for full-length portrait, elevating
 subject for, 108
 outdoors, 103-104

Price. *See* Fee
Profile, vs. front view, of sixteen-
 year-old, 14
Profile diagram, 4
Profile views, 3
 of ears, 27
 of eyes, 20
 of mouth, 26
 of three-year-old, 8
 of very young subject, 98
Proportion, age and, 36-37
Proportional scale, 39

R

Rachel, 8, 52
Rawson, 119
Ray, 30
Recordkeeping, importance of, 133
Redhead, features of, 10, 15
Renoir, Pierre-Auguste, 92
Richard, 13, 105
Robert
 charcoal, 43
 oils, 49
 pastel on sanded pastel paper
 (detail), 40
 pastels, 47
 sanguine Conté crayon/pencil, 45
 watercolors, 51
Rondia, 11
Russell, 113
Ryan, 98

S

Sabrina, 105
Samples, painting, for beginning
 artist, 132
Sanguine, Conté crayon or pencil,
 working with, 44

Sarah, 106
Sargent, John Singer, 93
Shape, and structure
 of body, 30
 of eyes, 18
Shireen, Judy and Robert, 126
Simplicity, in work of Berthe Morisot,
 95
Sittings, number of, 54
Size
 and fee, relationship between, 109
 deciding on, 104-107
 specific, 105-107
Sketches
 for determining pose, 97
 from photo, 125
Skin tones, colors for, for various
 media, 61
Sky, as background, 118
Square diagram, 3-4
Strokes, sideways, in work of Mary
 Cassatt, 94
Structural block-ins, importance of
 memorizing, 3
Structure. *See* Shape, and structure
Stuart, 6
Studies, from photos, 128
Subjects
 age six to twelve, posing, 57
 age thirteen to sixteen, posing, 58
 elevating, for full-length portrait,
 108
 very young, posing, 55-57, 98

T

Teenager, features of, 14
Teeth
 losing baby, importance of, 10
 painting, 25

with braces, problem of, 25
Thirteen-year-old, as subject,
 unsuitability of, 13
Three-quarter views, 3
 diagram of, practicing, 6
 of eyes, 21
 of mouth, 26
 of very young subject, 98
Toddler, features of, 7
Toes. *See* Legs, and feet
Torso, 30

V

View, front. *See* Front view
View, profile. *See* Profile view
View, three-quarter. *See* Three-
 quarter view
Viewfinder
 illustrated, 102
 using, 102
Views, head, 3

W

Watercolor, 50
 demonstration, 62-66
 informal portrait in, 62-66
 mixture, for skin tones, 61
 portrait in, from photo, 88-91
Watercolor portrait, number of
 sittings for, 54
Will, 15
Windows, as background, 117
Witt, 103

Y

Yates, 115